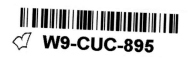

Living
Mirrors

This is dedicated
to all children.

They will inherit
only what we leave.

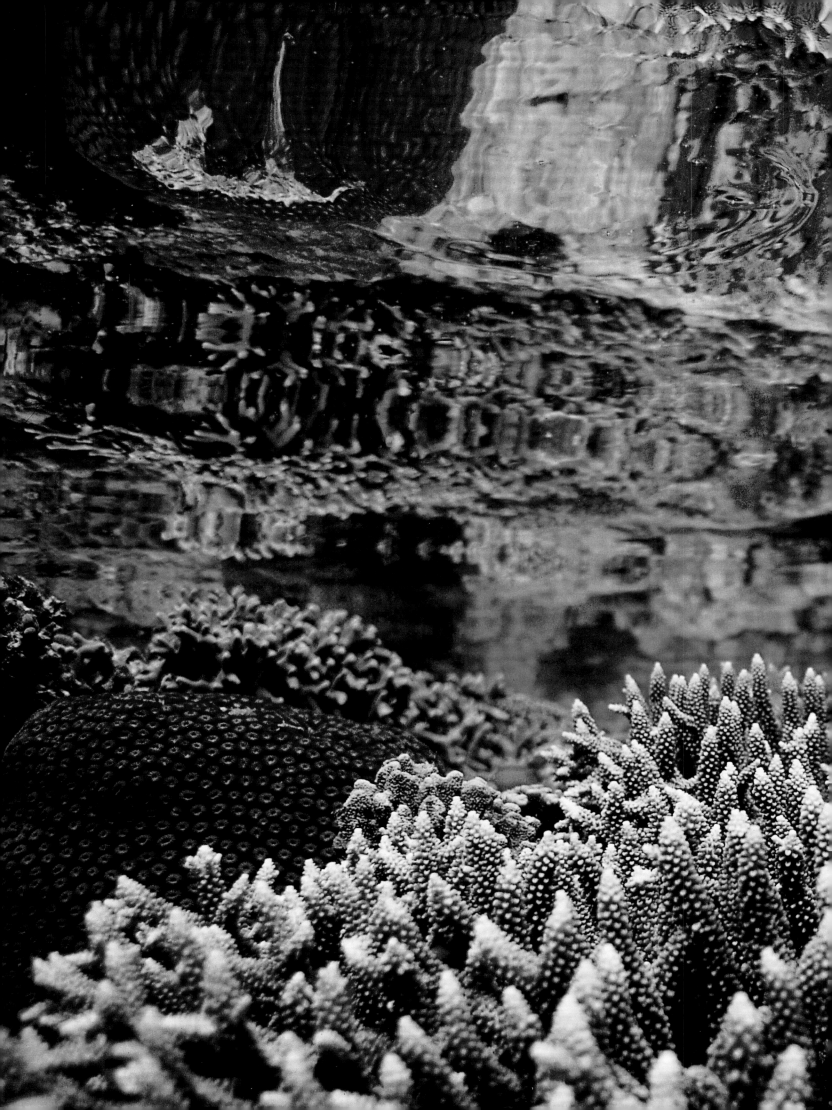

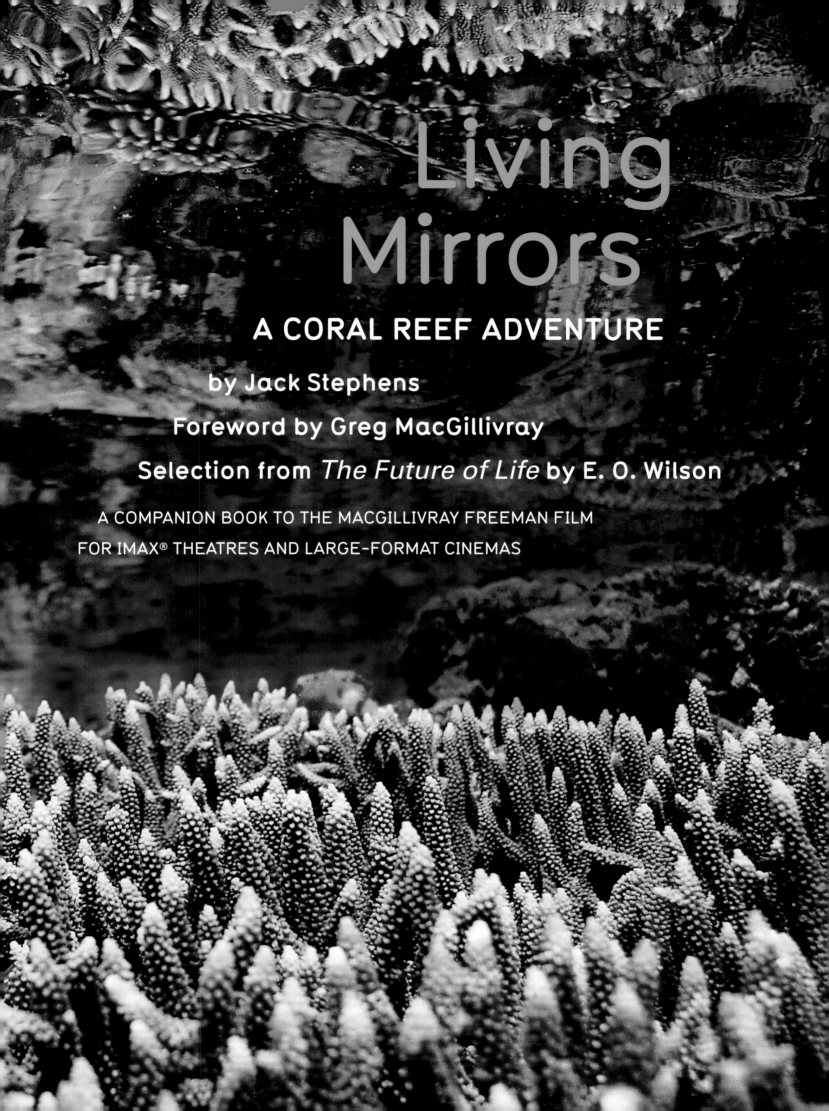

Living Mirrors

A CORAL REEF ADVENTURE

by Jack Stephens

Foreword by Greg MacGillivray

Selection from *The Future of Life* by E. O. Wilson

A COMPANION BOOK TO THE MACGILLIVRAY FREEMAN FILM
FOR IMAX® THEATRES AND LARGE-FORMAT CINEMAS

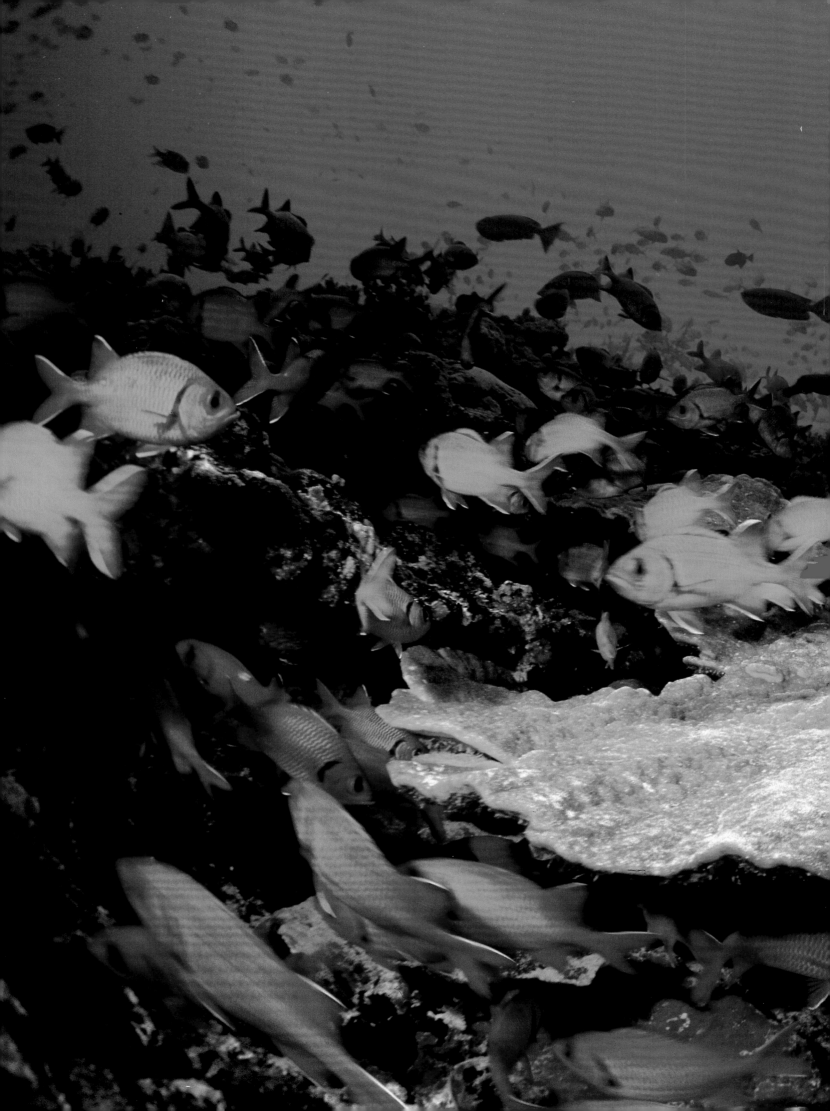

contents

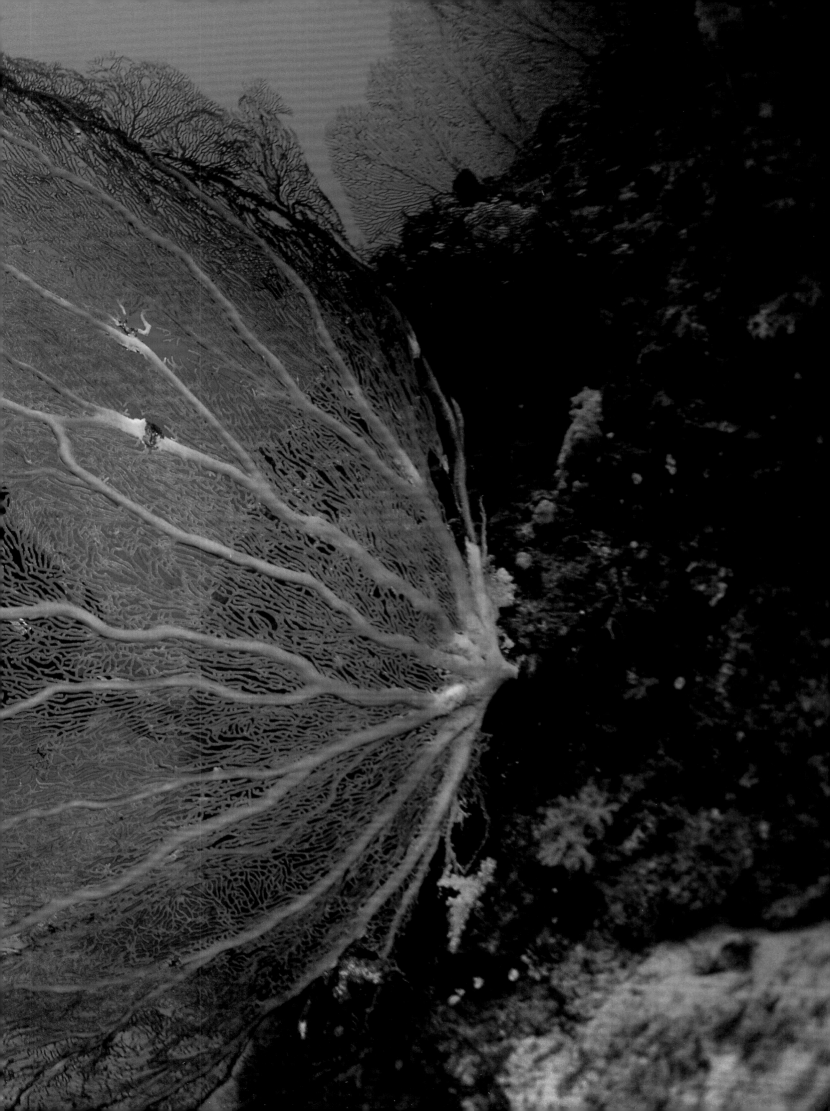

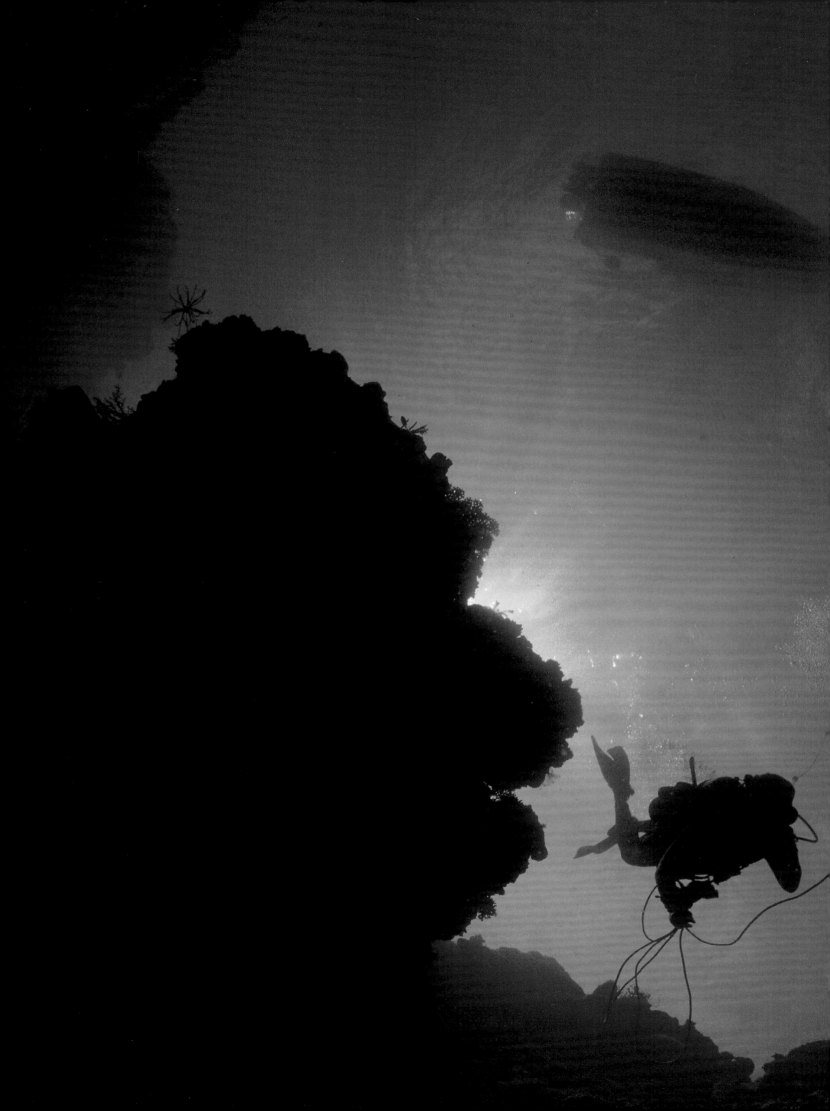

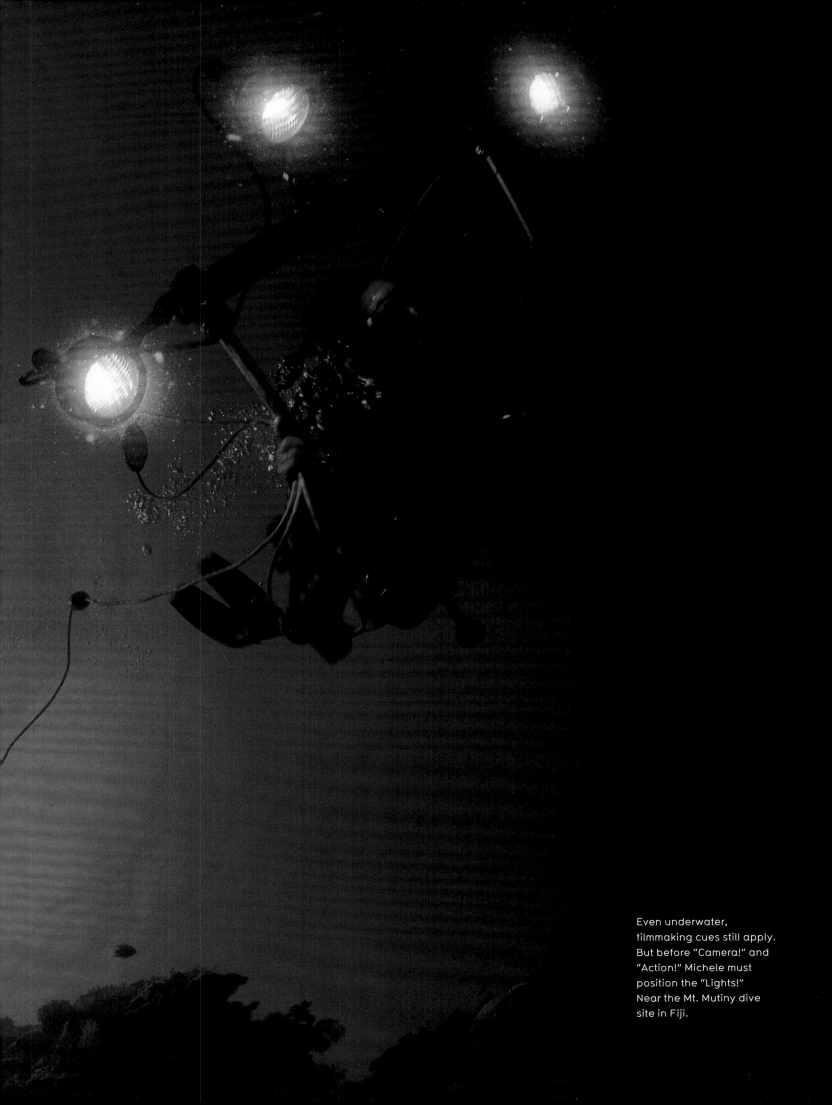

Even underwater,
filmmaking cues still apply.
But before "Camera!" and
"Action!" Michele must
position the "Lights!"
Near the Mt. Mutiny dive
site in Fiji.

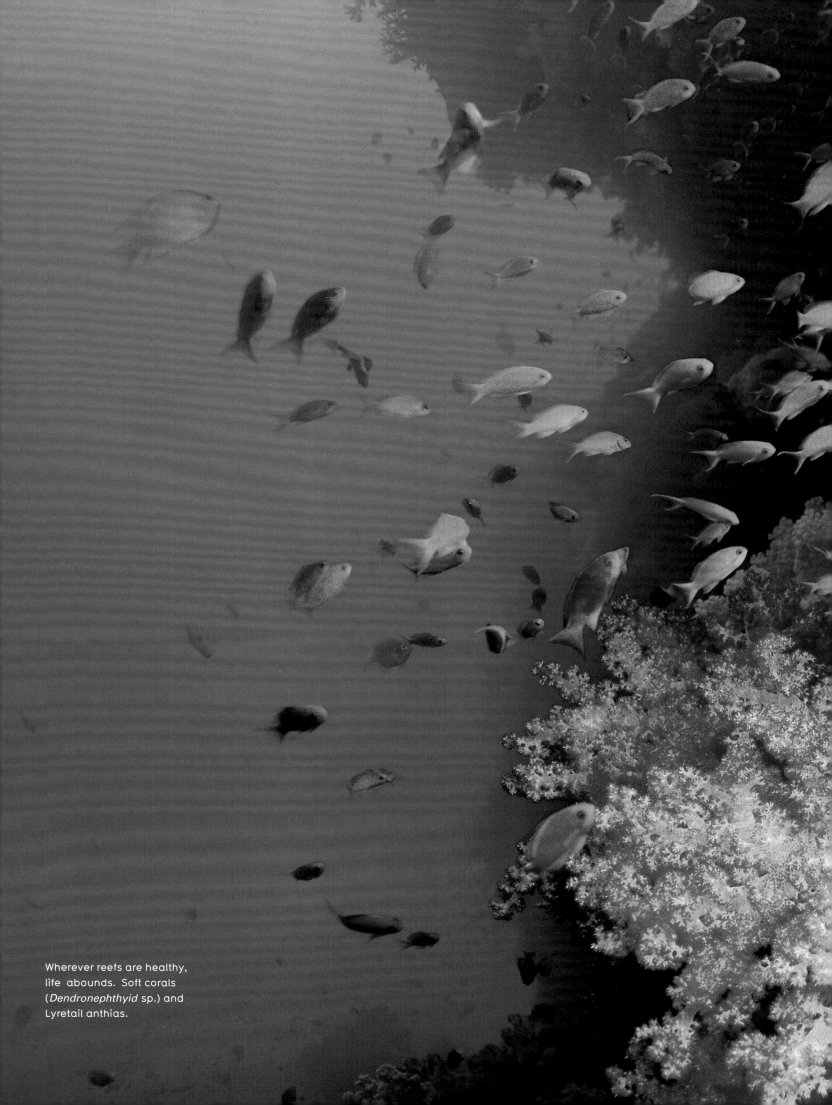

Wherever reefs are healthy, life abounds. Soft corals (*Dendronephthyid* sp.) and Lyretail anthias.

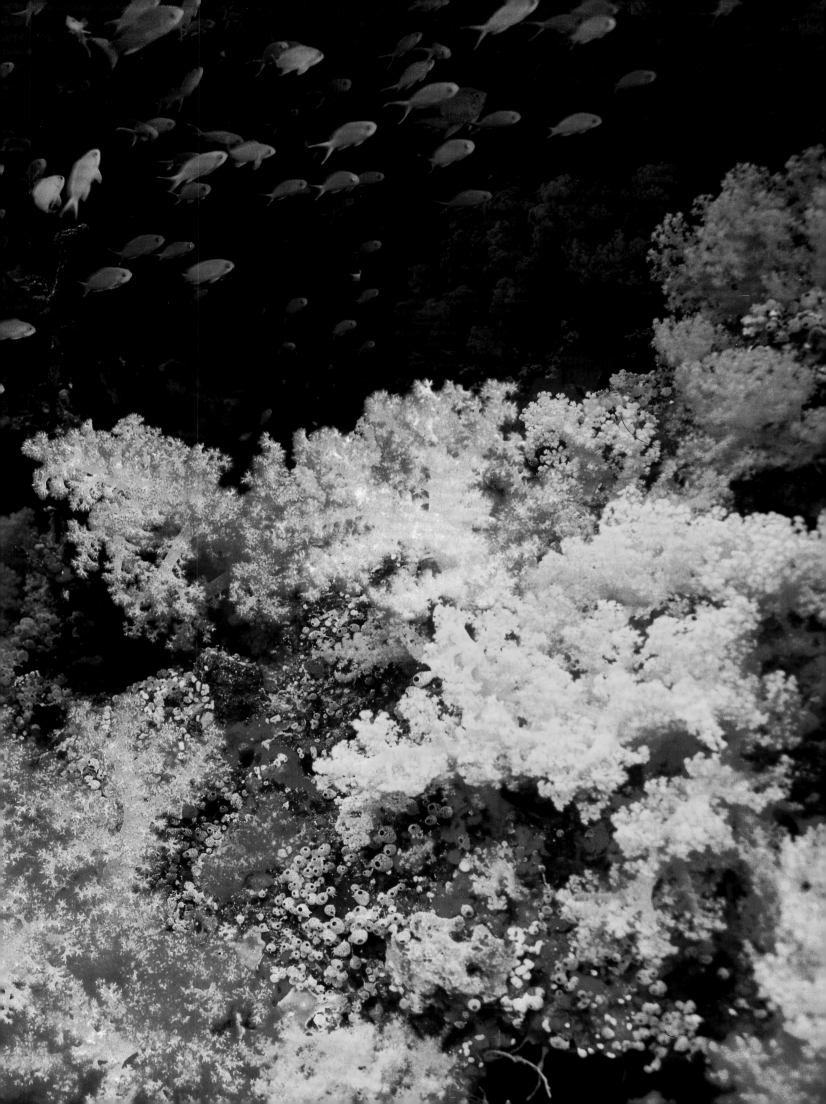

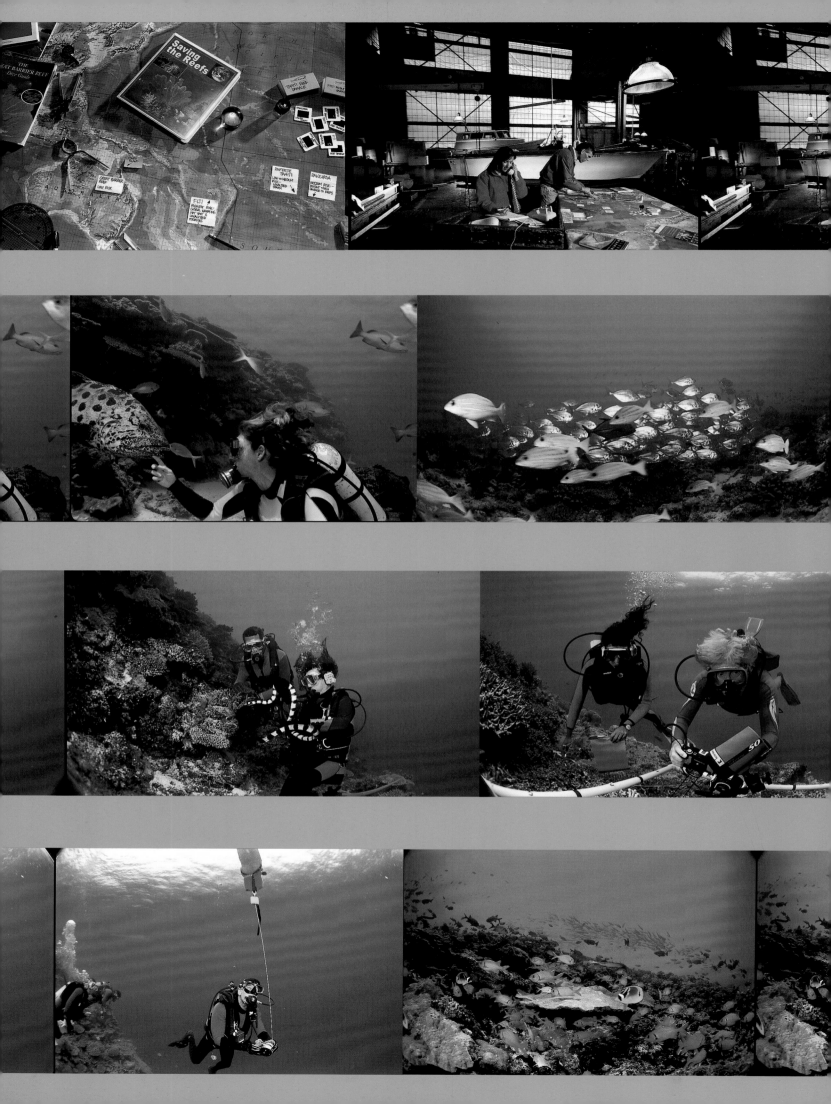

Coral Reef Adventure

by Greg MacGillivray

PRODUCER/DIRECTOR, *CORAL REEF ADVENTURE*

At the heart of any lasting work of art is love.

It was a love for the spectacular color and overwhelming biological richness of coral reefs, those amazing communities of life, that inspired me to embark on a life-changing odyssey, one that took four years to complete and resulted in my most personal film yet—*Coral Reef Adventure.*

I have been diving for over twenty years, and making IMAX® theatre films for only slightly longer, and I have always considered coral reefs a cinematographer's dream—always colorful, astoundingly beautiful and overwhelmingly rich with life. Beyond this, they are absolutely essential to the natural balance and well-being of our planet. Nicknamed "rainforests of the sea," they harbor more biological diversity than any other ecosystem on Earth. Reefs supply food to hundreds of millions of people in the developing world, while an increasing number of pharmaceuticals derived from reef species make healthy reefs crucial to the treatment of industrial-world ills, like cancer.

But they are also in trouble. Coral reefs are disappearing faster today than at any time in the last three thousand years. Sixteen percent of the world's reefs have been destroyed in the last five years alone. Another 30 percent are threatened by over-fishing, pollution and coastal development, as well as larger processes linked to human activities, such as global warming. In one region alone, Southeast Asia, where marine diversity is high and millions of people depend on coral ecosystems for food, over 80 percent of reefs are endangered.

In 1998, a devastating episode of ocean warming caused the bleaching and death of an unprecedented number of coral reefs worldwide. It was, in coral terms, a sort of Armageddon, demonstrating the extreme fragility of these ancient treasure-troves of biodiversity. As a filmmaker and surfer whose life has revolved around the ocean for over fifty years, I was shocked and deeply saddened.

As I pondered the enormity of the situation, I asked myself, What could be done? Was there something I could do? I met with Howard and Michele Hall, close friends and respected underwater film-makers who had helped me film *The Living Sea* in 1995. They were equally stunned and dismayed by the events unfolding beneath the waves. Together, we vowed to produce an IMAX theatre film about the world's coral reefs—*Coral Reef Adventure*—to immerse audiences in the wonder of these ecosystems, and to inspire people of all ages to protect this magic for future generations. We would begin immediately. I would produce and direct the film, and Howard and Michele would lead the expedition.

And so our coral reef adventure began.

We chose to film in the South Pacific, and for good reason—here corals are still relatively intact. This made for stunning images, and it established a sort of baseline for documenting the status of reefs elsewhere. We started at Australia's Great Barrier Reef, the largest structure on Earth built by living things, and a model of coral reef protection. Howard was pleased to discover that the reefs here looked as good—and in some cases better—than when he had dived there twenty years before.

But as the Halls' journey continued across the South Pacific, signs of decline became more common. In Fiji, Howard and Michele surveyed sixty reefs, many of which are thriving, but here also, warming oceans and island deforestation are wreaking havoc on coral communities. In fact, one of Howard's favorite reefs died just prior to his arrival. Reading statistics about reef devastation is an intellectual exercise, but seeing a cherished site bleached and broken can break your heart, and your spirit.

But *Coral Reef Adventure* is not an undersea obituary. It is a voyage of discovery and hope. Around the world, people are working hard to save reefs, and in the course of making our film, we were privileged to meet and work with many of them. Marine scientists and conservationists helped us really "see" the reefs we were filming, and assured the film's accuracy throughout its production. Among others, we were pleased to be joined by Jean-Michel Cousteau, whose love for the ocean is a family legacy and a personal mission, and Richard Pyle, an ichthyologist

who dives to depths of over 350 feet to discover species of fishes unknown to science—a reminder that there is always more to discover, and to learn, in the world of nature.

Coral Reef Adventure took IMAX technology to a realm never before seen on camera—the deep reef. It was an immense technical challenge, fraught with serious risks, full of unparalleled rewards. It nearly cost Howard his life—but perhaps this is a good place for me to stop, and leave that story to the capable hands of Jack Stephens. In addition to writing this book, he contributed to the film's script. Jack is a published poet and fiction writer, but in his early college years he aspired to be a scientist. He brought to the complex subject the perfect blend of research acumen and gifted storytelling. His effort, *Living Mirrors*, is an accurate chronicle of our film expedition, an insightful exposé on the causes of coral reef demise, and a beautiful reminder of what it is we're trying to save.

Our film and this book are part of a growing global effort on the part of divers, scientists, conservation groups, and some governments to save the world's reefs. I would hope that our images, whether on the big screen or in these pages, inspire individuals to do what they can to help. One of the interesting things about reefs is that most of the threats to their existence come not from the sea, but from land, where we all live—in other words, you don't have to be an expert diver or travel across the planet to make our world a better place. I will have met my goal if I can inspire filmgoers and readers to love coral reefs as much as I do.

TOP ROW, FROM LEFT TO RIGHT
The *Undersea Hunter* resupplying on the island of Nadi, Fiji.

Howard and his dive team return to their floating base of operations in the skiff.

SECOND ROW, FROM LEFT TO RIGHT
Moving like a "herd," these Convict tangs graze on algae on the reef crest of Rangiroa Atoll, French Polynesia.

Branching corals and soft corals (foreground) draw an abundance of basslets, parrotfish, and Golden damsels to the reefs of a dive site called Kansas, near the island of Namena, Fiji.

THIRD ROW, FROM LEFT TO RIGHT
On a scouting dive amid schooling Lyretail anthias, the prismatic diversity of the Cat's Meow dive site in Fiji is evident to Rob Barrel, of the diveboat *Nai'a*.

Ichthyologist Richard Pyle enunciates carefully into his underwater communications system, informing the crew in the support skiff overhead of his plan to collect fishes for identification as new species.

BOTTOM ROW, FROM LEFT TO RIGHT
An octopus-eye view of Fijian children swimming the waters near their protective barrier reef for the first time.

Exploring a cave mouth in the dimly lit realm below 200 feet, known to divers and biologists as the "twilight zone."

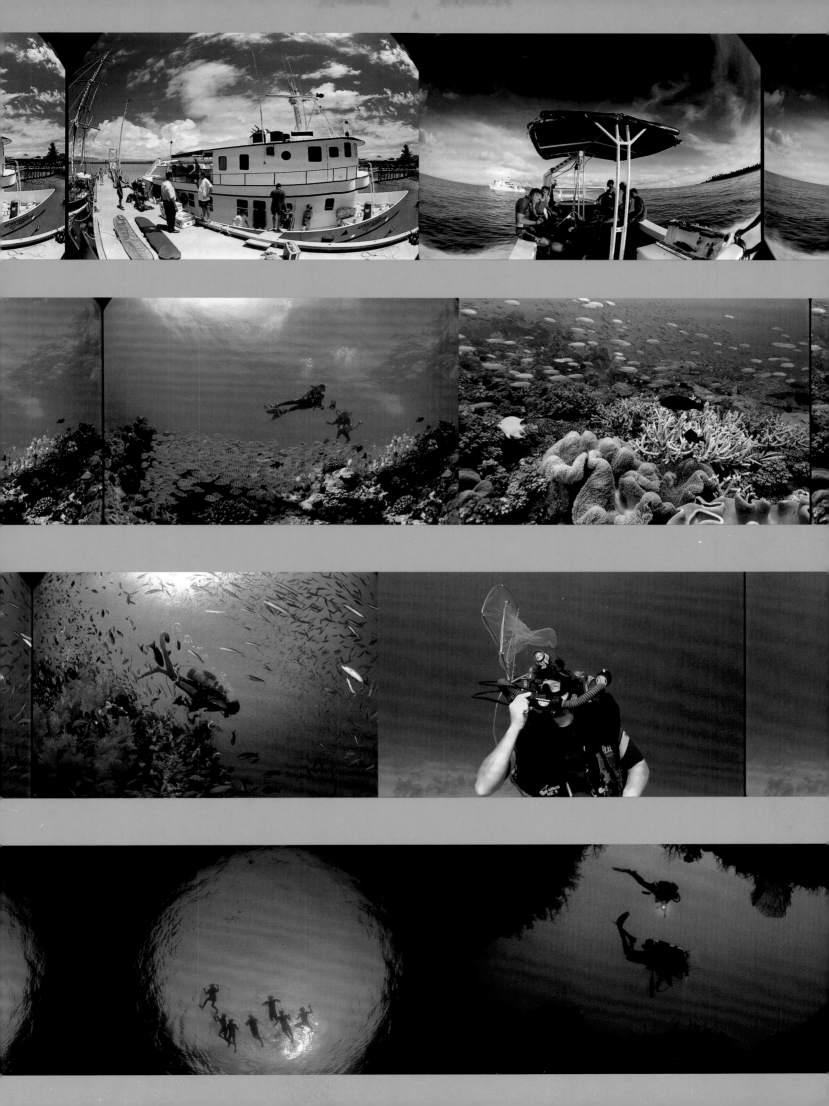

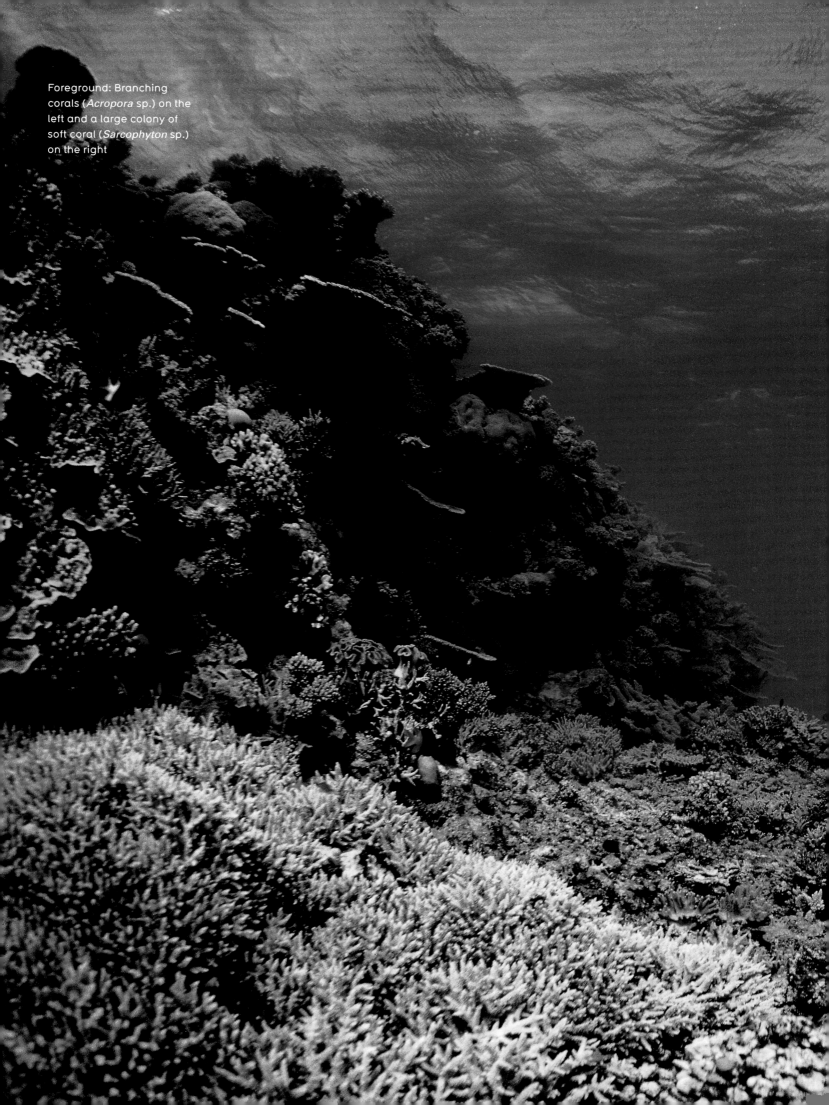

Foreground: Branching corals (*Acropora* sp.) on the left and a large colony of soft coral (*Sarcophyton* sp.) on the right

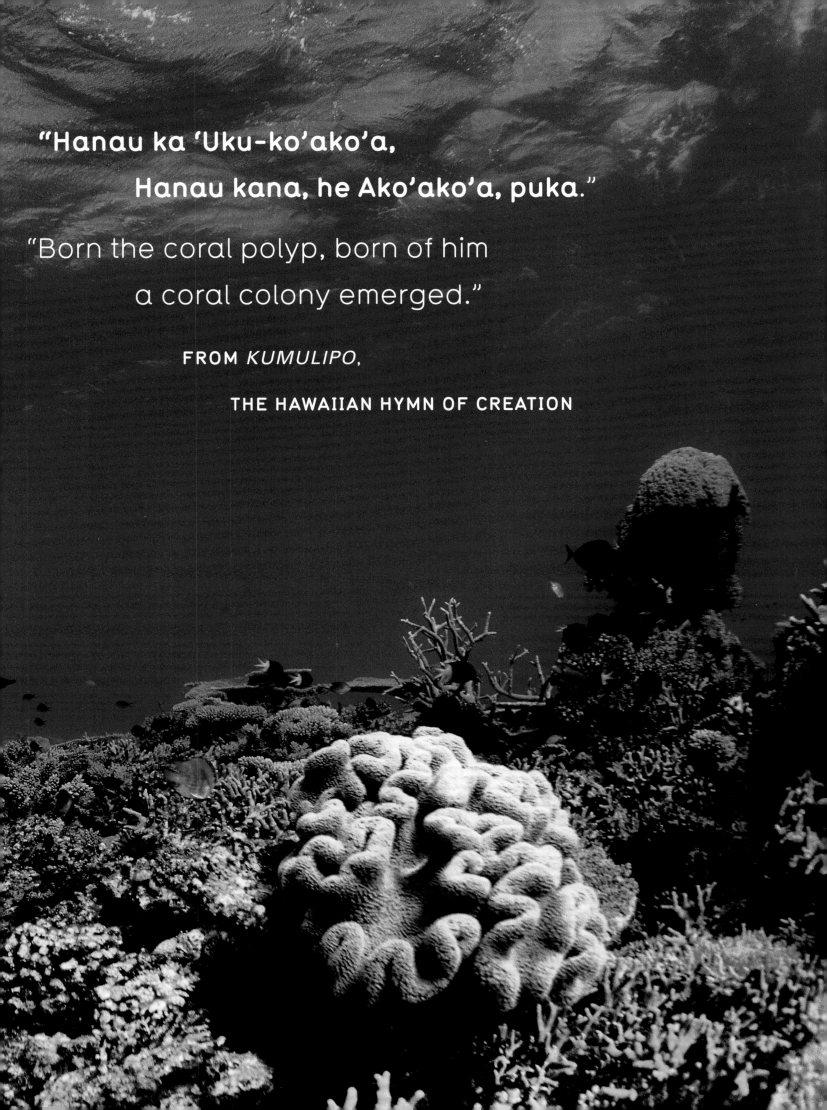

"Hanau ka 'Uku-ko'ako'a,
 Hanau kana, he Ako'ako'a, puka."

"Born the coral polyp, born of him
 a coral colony emerged."

FROM *KUMULIPO*,

THE HAWAIIAN HYMN OF CREATION

I | Wonder of the Natural World

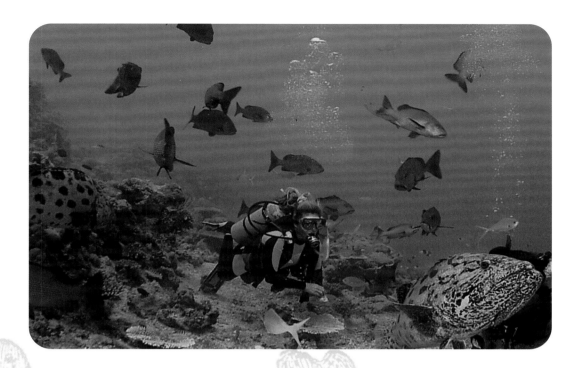

The Pyramids of Egypt; the Hanging Gardens

at Babylon; the Colossus of Rhodes; the Lighthouse at Alexandria.... So begins the brief list of monuments to human endeavor which the Greek traveler who first compiled it in the second century B.C. called The Seven Wonders of the World. Were that awestruck ancient alive today, he would find only the pyramids still standing, the rest of these wonders long ago demolished by the elements or torn apart by human hands.

The Grand Canyon; Mount Everest; Victoria Falls.... These are the monuments to geophysical processes that anchor the compendium known as The Seven Natural Wonders of the World. Separately, each of these works-in-progress is far longer lived than any human endeavor could hope to be; together they would stand incomplete without the inclusion of Australia's Great Barrier Reef—the longest and most fragile natural wonder of them all.

More than anything, wonder is what brought acclaimed underwater wildlife cinematographers Howard and Michele Hall to the top of Cook's Look, the highest point on Lizard Island, seventeen miles off the Australian coast, one windy day in early May 2000. Like all adventurers at the outset of an undertaking, they wanted a vantage where they could anchor themselves in the present in order to set their sights beyond it and glimpse clues to the shape of the world they were about to enter beneath the surface of the sea.

For most of us, sea life makes itself evident when nervous water reveals the presence of schooling fish, or when the dolphins or predatory fish that are chasing them break the surface. Otherwise—except for what ends up on our dinner plates—we'd have little clue that a vibrant world exists under the sea. This is where intrepid explorers like Howard and Michele come in, men and women who descend into the sea and return with photographic evidence that, yes, there is a vital world down there.

For those of us who dive, Howard is certainly a hero. For those who don't, he

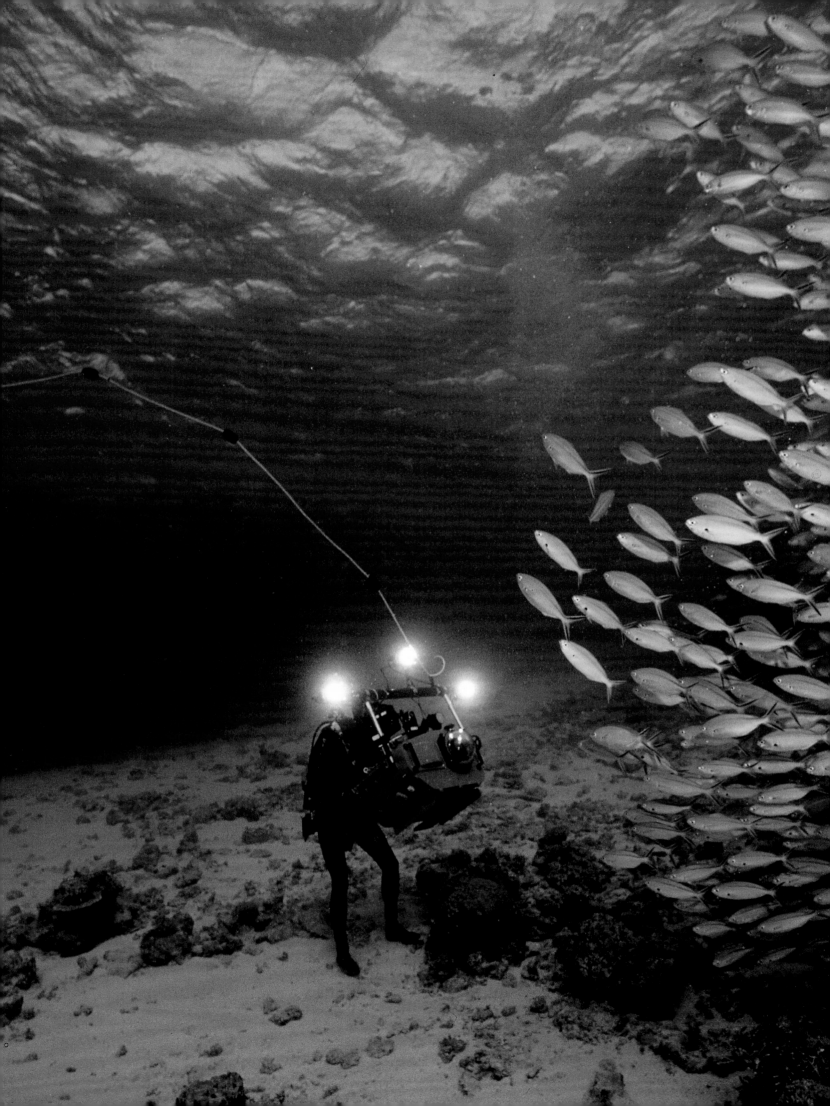

ought to be. Diver, explorer, marine biologist, and cinematographer, in less than two decades, he and Michele—his wife, dive partner, and collaborator—have earned seven Emmys and two Golden Pandas by creating films for television and screen such as *Seasons in the Sea, Secrets of the Ocean Realm*, and the 3-D IMAX theatre feature *Into the Deep*. In early 1999, renowned cinematographer Greg MacGillivray—director of fourteen IMAX films and two-time Oscar™ nominee for *The Living Sea* and *Dolphins*—approached Howard and Michele Hall with an idea. Greg felt that it was crucial to record the state of the world's coral reefs and the seas around them in high-resolution 70-millimeter IMAX film, which, when projected onto the giant screen, would bring the reef world to viewers with unsurpassed vividness and clarity—not just for posterity, but as an aid for preservation and future scientific comparison. He proposed a joint endeavor and the Halls readily agreed. It would be called *Coral Reef Adventure*. Greg would undertake the direction and filming of all topside footage and Howard would direct and film all the underwater sequences. At Greg's insistence, the movie would feature "a marriage of ocean life and human behavior." This meant it would include not just interesting undersea creatures, but Howard's attempts to film them in the reef environment. It would also describe the attempt of a Fijian diver, Rusi Vulakoro, to understand why the reefs his people rely on are suffering and what they might do to stop the deterioration. But Howard wanted to go even further. He proposed a sizable risk: He would take the ponderous IMAX camera down to record-breaking depths on unexplored reef and document forms of life no human eye had ever seen before. Greg could hardly disagree. He immediately commited every available resource to the expedition, which would result in MacGillivray Freeman Films' *Coral Reef Adventure*.

Now, standing on the brink of the odyssey which had brought them from their home in Southern California to Australia's Great Barrier Reef and would propel them to

Fiji, then Tahiti, then on to Rangiroa Atoll, Howard and Michele had only some idea of what was in store. It would be a journey not just measured in the tens of thousands of miles traveled, but in 140 miles of $1,000-a-minute, 70-millimeter IMAX film they and the MacGillivray Freeman production team would expose, and in the 200,000 cubic feet of bottled oxygen, nitrogen, and helium they would breathe, and in the nearly 3,000 hours the dive team would spend immersed among the corals and fishes they hoped to help save.

Somewhere beyond eyesight the aptly named Ribbon Reefs writhed toward the horizon, contributing to the Great Barrier Reef's complicated maze. "Finding your way through it," says Howard, "means dead end after dead end after dead end. If you're a sailing boat, it's a nightmare"—exactly why 18th-century navigator Lieutenant James Cook named it "The Labyrinth" on his charts. While Cook was the first Western explorer to discover the Great Barrier Reef, to navigate its entire length, and to nearly perish when his ship, the *Endeavor*, accidently rammed into it, he could not have known that it is actually a 2,000-mile-long series of 2,900 individual reefs, 300 cays, and 600 islands covering an area larger than Great Britain. Nor did he realize that it is built upon a single limestone foundation laid by the industry of countless organisms over hundreds of thousands of years, making it the largest **biogenic** structure in the world.

Satisfied with the view, the Halls headed back down to the water where the real work would begin. Their destination was a place called Cod Hole on Ribbon Reef #10. Cod Hole is home to a population of friendly, 100-pound groupers ("cod," if you live down under) which Howard hoped to catch on film receiving the equivalent of a dental flossing from a plucky little fish known as a Cleaner wrasse. As they walked, Michele worked the two-way radio, shepherding the arrival of film crew personnel, the boat charter, the transportation of film stock, the timing of critical events at the dive site—not just in

biogenic
Materials produced by living organisms. Usually refers to the skeletal remains or structures built by social organisms.

LEFT Howard focuses the almost 300-pound IMAX camera dubbed "Big Blue" on a school of fusiliers on the Great Barrier Reef.

Australia, but for the course of the entire one-year adventure. Howard, on the other hand, was just itching to get in the water. He had dived Cod Hole more than two decades earlier, and he wondered not if things had changed, but how.

After more than three decades of diving, Howard has a personal theory about the seas and how we view them. "The Ten-Year Rule," he calls it, speaking in the measured, deliberate manner of someone aware of the value of every breath. "What you see the first time you dive a place is an abundance of sea life. But it is already in a state of decline. You can't see this in a short span of time. It takes about ten years to see." As an example, he'll describe a place called the Marisla Sea Mount, in the Sea of Cortez, which he first dove in 1981: "There were huge schools of hammerhead sharks. You'd see two or three manta rays on every dive. Big schools of tunas and jacks. It was a fabulous, fabulous place. But now the mantas are gone, the hammerheads few and far between. You seldom see big schools of fish there anymore." To drive home his point, he goes on to cite an even earlier Marisla diver's report of "hammerhead dorsal fins as far as the eye could see," ruefully concluding: "Wonderful as it was when we got there, we never saw that because it was already in a state of decline."

If Howard's observation about the untrustworthiness of first glimpses (which scientists call **shifting baseline syndrome**) seems bleak, consider this: Over two-thirds of our planet is covered by water and one-

half of that lies within the tropics. Of that, only a scant 113,720 square miles (about half the area of France) is occupied by living coral reefs. That's less than one-tenth of one percent of all oceanic waters. Yet reef communities are extremely robust. They are home and nursery to a quarter of all marine species, making them inch for inch and species for species the most biologically productive and genetically diverse ecosystems on earth, rainforests notwithstanding. It's no wonder that diving magazines feature coral reefs or their denizens in a majority of their illustrations. No wonder, too, that of the 138 natural locations on the United Nations Educational, Scientific, and Cultural Organization's World Heritage List, thirteen specifically feature coral reefs.

Yet, today, these natural wonders are under siege. It is estimated that 27 percent of the reefs that existed thirty years ago have already been lost, and if they keep dying at the current rate there will be another 32 percent fewer reefs in the next thirty years. This decline has everything to do with the way our exponentially expanding human population is using, abusing, and neglecting Earth's resources—whether we live near reefs or not. Cumulative human activity, from overfishing to pollution to rampant coastal development, is adversely affecting coral reefs. Given the nature of human activity, the problem will not stop on its own.

Just as with the health and well-being of humans, what applies to one reef generally applies to them all. More and more scientists

shifting baseline syndrome
Introduced by biologist Daniel Pauly in 1995, this term describes the problem of establishing a reference baseline for assessing changes in fish stocks in constantly degraded seas. Since changes in a system or area are usually compared to a reference point within the assessor's lifetime, it is impossible to know the true starting condition. This relative reference point tends to shift down with each generation of scientists, lowering our standards of what natural— i.e. "baseline"— population levels should be. The result is an insidious and gradual accommodation to the disappearance of species and stocks.

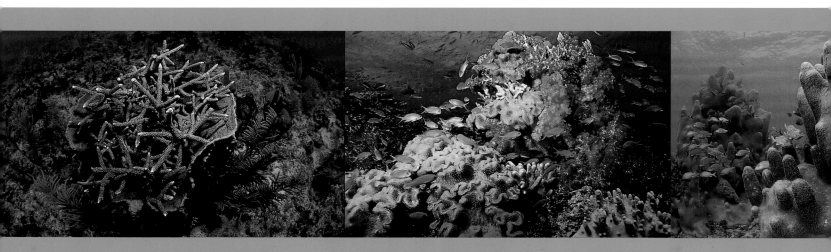

hermatypic

A term applied to any organism that forms stony deposits, particularly hard corals containing zooxanthellae, symbiotic unicellular alga, which builds reefs by secreting calcium carbonate—limestone

PAGE 26, FROM LEFT At a depth of 50 feet, a colony of healthy Staghorn Coral (*Acropora cervicornis*) grow inside of a giant barrel sponge (*Xestospongia muta*) off Key Largo in the Florida Keys National Marine Sanctuary.

Soft corals and schooling Lyretail anthias, Fiji.

PAGE 27 FROM LEFT An eight foot tall formation of Pillar coral (*Dendrogyra cylindrus*) and two French grunts. Key Largo, Florida Keys National Marine Sanctuary.

Pink gorgonian soft coral colonies filter feeding in the current. The dark feathery shapes on top are feather stars. Manado, Indonesia.

A Knobby Sea Rod soft coral with its polyps retracted. St. John, the U.S. Virgin Islands.

are seeing coral reefs as the "canary in the coal mine" whose the catastrophic deaths herald the degradation of the entire global ecology. But perhaps coral reefs are more reflective than indicative—like mirrors. It is Greg and Howard's goal to hoist a few of these powerful, fragile, living mirrors above the waterline, to let us see on screen what they reflect of the greater world, now and in future generations, even if it takes Howard's proverbial ten years to see this point.

While Howard was diving the Marisla Sea Mount for the first time in 1981, UNESCO's World Heritage Convention—whose central goal is to designate and protect "places that are of such outstanding universal value that their disappearance constitutes a harmful impoverishment of the heritage of all humanity"—was naming the Great Barrier Reef as one of the first natural sites on its list because of its uniqueness, beauty, and diversity. Over 4,000 known species of mollusk and 1,500 species of fish make their homes among the Great Barrier Reef's 450 different species of coral, not to mention various algae, worms, nudibranches, sponges, protozoans, arthropods, and other critters in a census of millions. On certain individual reefs, the species tally is above 3,000, and counting. Jacques Cousteau was certainly onto something when he called these ecosystems "countries in the sea"; his son Jean-Michel isn't far behind to call them "cities." But these designations may be a little too anthropocentric, and too short-term.

Some 450 million years ago, there was only one megacontinent girdled by one great ocean. While living things had existed for almost 2 billion years, land plants had not yet evolved and true fish and reef-building corals were still millions of years off. Yet, marine cyanobacteria and algae—two of the earliest successful life forms—had been living and dying in collective mounds called stromatolites for hundreds of millions of years, amassing huge bioherms (life-formed structures) through their knack for secreting calcium carbonate. While these were technically limestone reefs, they were hardly diverse ecosystems. It wasn't until sponges—the world's first multicellular animals—began allowing calcium-secreting algae to live in their flesh, that construction of the first diverse reef ecosystems began. And these were very simple affairs.

About 200 million years ago, the first hermatypic (reef-building) corals began their roles as master builders of the seas. Yet Australia, as we think of it today, didn't even exist. First the megacontinent Pangea split into two smaller supercontinents, one to the north and a southern one that included Australia, Antarctica, New Zealand, and South America. Eighty million years ago, much of Australia remained within the Antarctic Circle covered by vast tracts of conifers. Dinosaurs ruled. Flying reptiles and proto-birds plied the skies by day, while early mammals began to show their snouts at night. Yet the sea around Australia was too cold for the reef-building corals.

Sixty-five million years ago, a meteor smashed the earth with such force that it radically changed the global climate, caus-

23

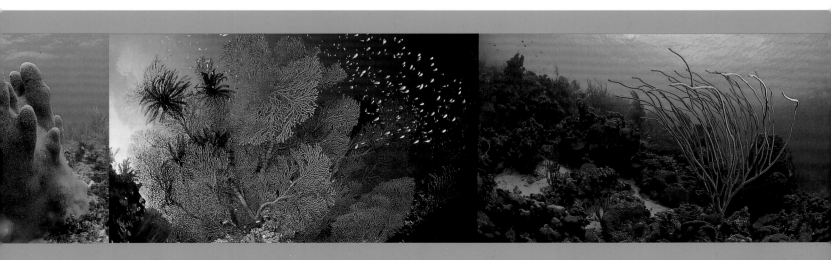

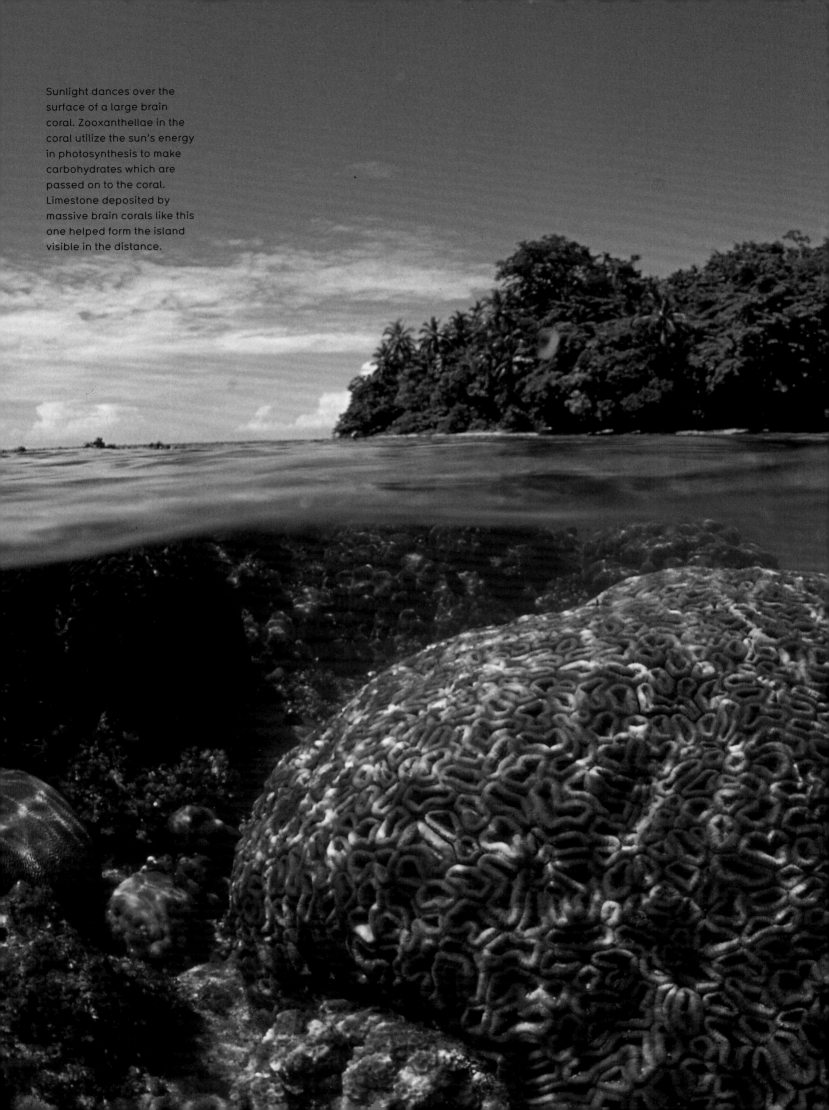

Sunlight dances over the surface of a large brain coral. Zooxanthellae in the coral utilize the sun's energy in photosynthesis to make carbohydrates which are passed on to the coral. Limestone deposited by massive brain corals like this one helped form the island visible in the distance.

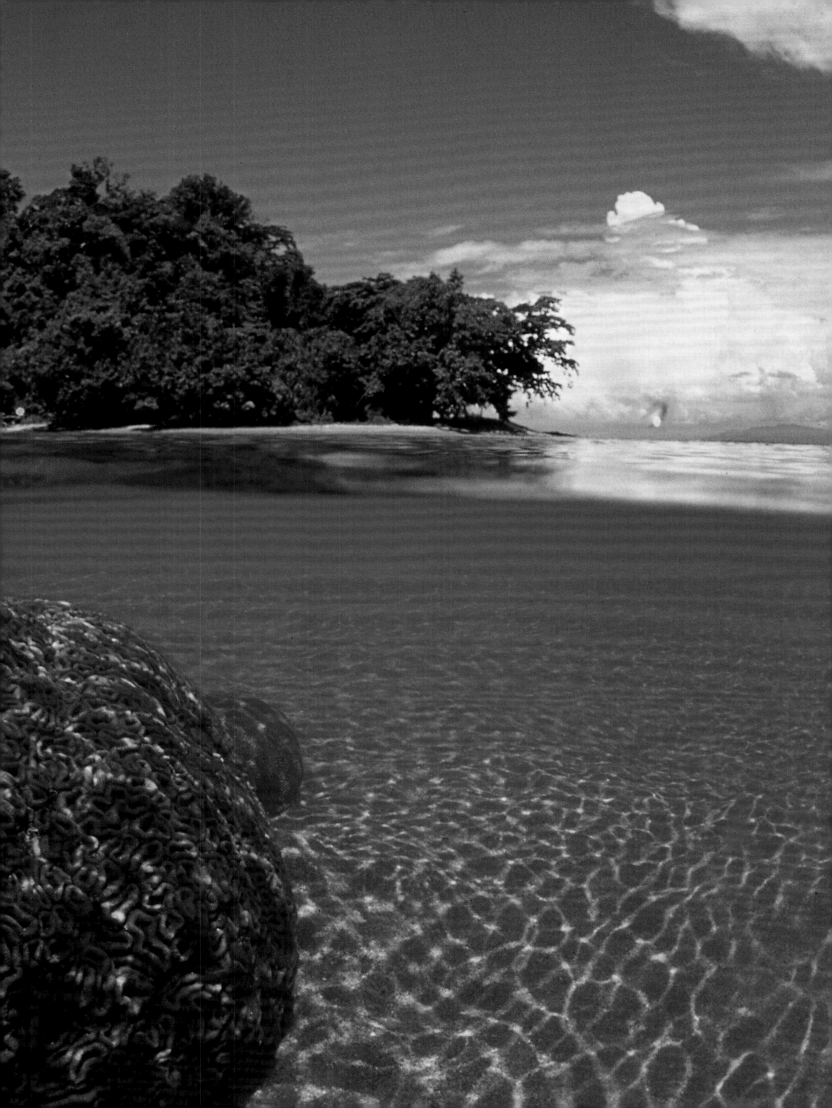

ing the great mass extinction of dinosaurs and most other groups. With the dinosaurs annihilated, mammals flourished, yet still no hard corals lived in Australia's sub-polar waters. Plowing slowly north, pushing the islands of New Guinea ahead while India crashed into Asia and began to heave up the Himalayas, Australia saw its climate cool and warm dramatically several times. In a rainforest rivaling today's Amazon, egg-laying mammals and large flightless birds crept about, avoiding marsupial lions and flesh-eating kangaroos until another cooling period 5 million years ago caused temperatures and sea-levels to drop, just as Australia's subsiding continental shelf reached tropical waters. Then, sometime around the moment ancestral humans appeared in Africa's Rift Valley, the corals that formed the basement of today's Great Barrier Reef got their toe-hold.

Today's reefs, many of them built on foundations hundreds of thousands of years old, compose the oldest continually inhabited multicellular communities on Earth and are the addresses of some of Earth's oldest living beings (like the 415-feet diameter, 4,500-year-old mushroom coral colony on Fiji's Astrolabe Reef).

In very real ways, our planet's geography begins and ends with coral reefs. Besides being the only living structures found on maps, no other geological features (except volcanoes) are so active and accretive. Corals are nature's quintessential builders and manufacturers. By binding calcium with carbon dioxide, corals effectively remove 1,400 billion pounds of this greenhouse gas from the atmosphere each year, producing limestone at rates of up to 100 tons per square mile. Slowly and quietly corals have helped create vast areas of our continents, as anyone from Coralville, Iowa, or working the quarries of Lacoste, France, can tell you. A living veneer of coral polyps only millimeters thick has sculpted the face of the Earth over eons in limestone structures—almost a mile deep in places like Eniwetok Atoll and 1,200 miles long on the Great Barrier Reef.

Tens of thousands of coral islands, atolls, and re-emergent limestone islands exist on this water planet only because of corals. Many of our buildings, beaches, and often the ground we walk on, we owe to the industry of polyps whose abandoned homes are the stuff (when ground, heated, and mixed with water) that dream-homes are made of—cement. No other life form has contributed so significantly and continually to the shaping of the earth's character, physically and biologically. Yet we are only beginning to understand what corals are.

Ever since we humans first began to record our thoughts about coral, we have been mainly mistaken. Greek poet Pindar pronounced coral "the flower of the ocean dew." Roman naturalist Pliny the Elder described it as looking like "a shrubby tree with a green trunk and soft white berries," and Greek physician Pedanius Dioscorides said, "Coral, which some call the tree of stone (*lithodendron*) is really a marine plant which grows hard when it is taken from the depths of the sea into the air." Even fifteen centuries later, Ong de la Poitiers, making the first serious observations of coral in 1613, was blinded by literary tradition when he described coral as a "plant" harboring a milky sap. Francis Bacon couldn't shake the myth either, describing coral almost precisely as Pliny had. Not until 1726 did a medical botanist to Louis XV, a man named Peysonnel, break away from

TOP This single interconnected colony of branching coral covers several hundred square yards. Cod Hole, Great Barrier Reef.

BOTTOM A diverse range of branching corals (*Acropora* sp.) colonizes every square inch of available substrate on this section of the Great Barrier Reef. Coral colonies display a wide spectrum of protective pigments, even within one species. The white tips are the actively growing regions of the corals.

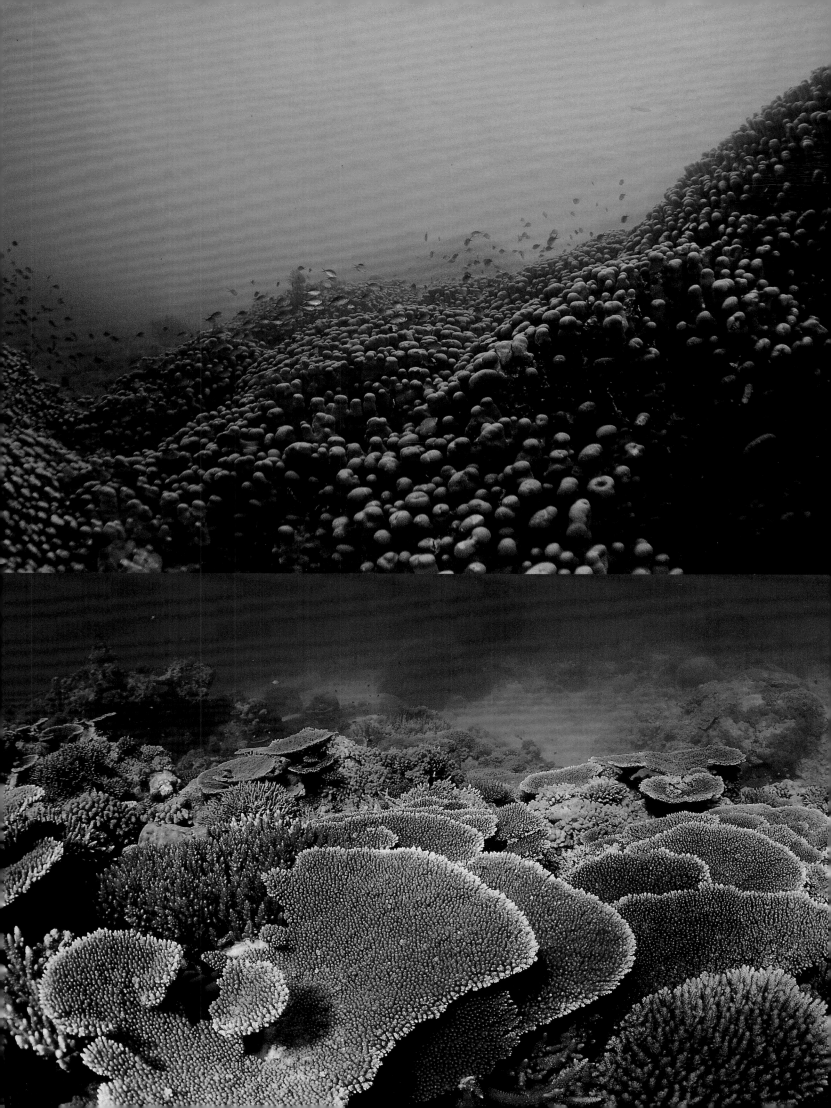

tradition with the aid of actual observation. "This insect," he said, "opens out in the water and closes up again in the air. ..." His conclusion left room for correction.

Thanks to the increasing use of the microscope, by the time a twenty-six-year-old naturalist named Charles Darwin found himself reef-hopping in the Indian Ocean, we had inched somewhat closer to the truth. Naturalists then understood that hard corals are animals, polyps with six tentacles (or multiples of six), living in stony homes of their own making. But even as late as 1951, about the time our love affair with reefs was really taking off thanks to the development of scuba, Rachel Carson, in her landmark book *The Sea Around Us*, only mentioned the coral animal twice, and briefly at that.

Near the outer edge of the Great Barrier Reef, the dive boat Michele had chartered for the expedition was carefully moored to a permanent anchor at Cod Hole. Howard and Michele suited up and dropped into the water. Because of his Ten-Year Rule, Howard expected some disappointment. Yet, after twenty-two years he found Cod Hole surprisingly unchanged—to his eyes at least. Here, in lush evidence, were the shimmering mists of tiny purple anthias fish, the balletic phalanxes of juvenile batfish, and the vigilant muzzles of moray eels hunkered among the table corals and bushily branching *Acropora*. "There are very few dive sites you can return to after two decades and find them unspoiled," Howard insists. But here, the Great Barrier Reef Marine Park's well-enforced protection policy gives the fish and the corals the peace they need to do their job.

Above all, that job is reef building. It starts when a coral larva—a worm-like microscopic zooplankton bearing little resemblance to coral as we think of it—ceases its oceanic drift and attaches itself to an algae-free piece of dead coral, a clean rock, or a sunken steel hull. Soon after settling, the growing larva morphs into a polyp, looking something like a tiny sea anemone with a squat trunk and a crown of

tentacles ringing its mouth. Now it begins to secrete pure calcium carbonate, limestone. Both its castle and its armor, this elaborate form-fitting exoskeleton protects the polyp's body and provides niches into which its tentacles can retract. Once established, the polyp buds and splits in the marvelous periodic self-cloning that expands the colony; all members remain attached to the founder polyp by thin layers of tissue through which they share nutrients. If the polyp is a massive boulder type, like a brain coral, its girth will expand at a slow 0.5 to 4 centimeters a year when conditions are good. That's a maximum of about 1.5 inches; so it may take a 12-foot coral head at least 200 years to get that tall. A branching coral, like a staghorn, can grow as much as 10 centimeters, or almost 4 inches, in a year. Both coral types contribute to the building of the reef, but they can't take all the credit.

Living and dying among the reef's corals, sponges, clams, and other creatures with calcium-based skeletons, dwell single-celled *Foraminifera* (more casually called "forams" by scientists). It is estimated that the tiny calcium carbonate shells of ancient forams compose as much as 50 percent of the earth's limestone. Today, the shells of modern forams continue to fill the nooks and crannies of the reef, while parrotfish—nature's gravel crushers—nibble away at dead and diseased coral with their hard beaks, extracting nutritious algae and excreting pulverized limestone sand (2,000 pounds a year!) that drifts down to the reef basin—the so-called "rubble zone"—where it joins the foram shells. There, the fast growing coralline alga *Porolithon* secretes the glue (calcium carbonate, yet again) that binds the coral sand and skeletal remains together into beachrock, the perfect place for young polyps to attach themselves and continue the cycle.

When Howard and Michele found several of the 100-pound, 4-foot-long Potato cod (named for their potato-shaped spots), the contented groupers were moving through the plankton-rich water with the speed and

Hard corals are animals, polyps with six tentacles (or multiples of six), living in stony homes of their own making.

Insect, Flower, or Tree of Stone?

Coral reefs rival rainforests in biodiversity, providing homes for thousands of species of fishes, mollusks, algae, sponges, and other forms of marine life–not to mention the corals themselves.

To date, over 1,500 species of coral have been documented in the world, 450 in Australia's Great Barrier Reef alone. But until quite recently, we weren't exactly sure what coral is. Until the 19th century, scientists and explorers had trouble understanding what hard corals are, partly because of their hugely various and fanciful appearance. Although to the naked eye corals may resemble flowers, shells, trees, vegetables, or stones, corals are, in fact, animals. The basic unit of the coral animal, called a polyp, is a small, cylinder-shaped body with tentacles encircling its mouth. The polyp secretes calcium carbonate to form a protective limestone exoskeleton. Most corals grow by splitting into multiples or forming new polyps to create a colony. Polyps in the colony are connected to each other and share resources. Many coral species are identified by the distinctive shape of their colonies, such as brain, staghorn, cabbage, elkhorn, pillar, sea fan, sea fern, or boulder coral; but there can be a broad range of shapes even among members of one species, depending on habitat.

Polyps in this boulder colony of *Montrastraea cavernosa* contain high densities of zooxanthellae, giving a rich brown color to the coral. The green fluorescent areas around their mouths are animal pigments. The polyps in the upper part of the colony are retracted. Bermuda.

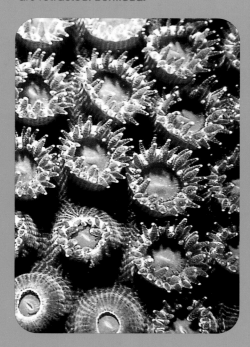

A close-up of the massive calcium carbonate exoskeleton of the hard coral *Meandrina*. The tissues of the polyps contract into the spaces between the wall-like, vertical elements, called *sclerosepta*. The high volume of polyps aligned in these long grooves contributes to the furrowed appearance of the colony and gives this coral the coman name of "brain coral."

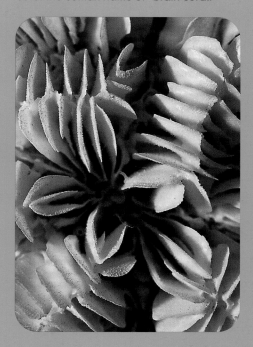

The feeding polyps of soft corals, like the one shown above, are easily distinguished from those of hard corals: those of soft corals have eight feathery tentacles (with side branches called pinnules) while hard corals have six smooth tentacles (or multiples of six).

Close-up of the *Alcyonarian* soft coral, which contains small skeletal elements called spicules. The shiny white spicules are visible in in the tissues of the colony's branches. The polyps are clustered on the tips of smaller branches.

grace of zeppelins. Occasionally, one would flick its tail and turn with surprising agility to inspect some potential morsel. Then, after it opened its mouth and sucked in a fish or crustacean, it would straighten its massive body and return to blimp mode. Joining the groupers, the Halls found them cooperatively indifferent to their presence. Howard picked one to shadow. Michele picked another and stayed with it.

At one point, Michele's cod paused beneath a large anvil-shaped coral head to posture oddly, tipping almost drunkenly and opening its mouth like a tourist gawking at a skyscraper. That's when Michele glimpsed it—contrasted against the cotton white of the grouper's maw—the slender 2-inch ribbon candy of pitch black and neon blue which is one of the reef's most dedicated groomers, the Cleaner wrasse. This coral head was its "cleaning station;" like a barber shop, this was where it worked. Had it not been for the service it was performing, the wrasse would have been swallowed in a gulp by the bigger fish. Instead, the Potato cod allowed it to flit into its mouth and dart about plucking its meal of dead tissues, fungal growths, and parasites like sea lice from the big cod's lips and gills. Through this natural agreement, on reefs throughout the world, wrasses get their meals and groupers, manta rays, or any other fishes that visit cleaning stations get healthy once-overs from these undersea dermatologists. Pleased with what she found, Michele surfaced and snapped a satellite fix of their exact coordinates with a handheld GPS device, so Howard could return to this precise spot to shoot the following day.

In nature, two beings in close proximity to each other, will react in only one of three ways: competitively, cooperatively, or indifferently. A lion and a gazelle, two lions, two gazelles—if they are close enough to each other, they will react. So indifference, it turns out, is rare to the point of nonexistence. This leaves competition and cooperation. A close look at any reef reveals cooperation is at least 50 percent of the rule, with mutually beneficial **symbiosis** (the intertwining of lives by direct contact) being its highest expression. The relationship between the Cleaner wrasse and Potato cod is just one of many examples.

Long ago, a 3.5 billion-year-old cyanobacterium capable of photosynthesis, took up residence within the cytoplasm of another primitive cell and took on the job of making food for the cell in return for a home. Thus, in a spirit of cooperation known as **endosymbiosis**, cyanobacteria became the chloroplasts without which no photosynthetic plant can feed itself. The same kind of mutually beneficial union occurred when an ancestor of the bacterium that causes typhus fever squatted in a primitive cell and became the origin of the mitochondrion, the power center of almost every complex cell. Every plant and animal relies on one or both of these evolutionary associations to live. Corals and their relatives added a twist to this trick when they began incorporating into their tissues helpful single-celled **dinoflagellates** called zooxanthellae.

symbiosis
A relationship between two or more organisms belonging to different species and living closely together

endosymbiosis
A symbiotic relationship in which one organism resides in the body of an organism of a different species, called a host

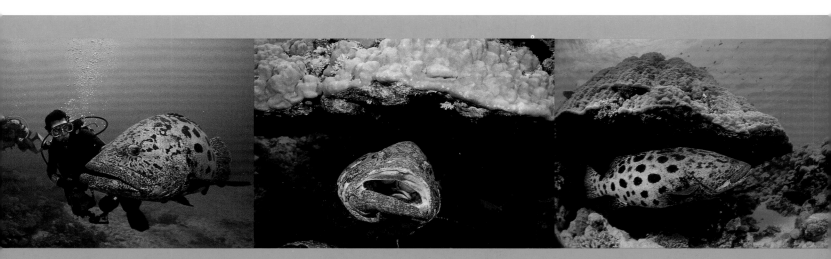

dinoflagellate
A single-celled plant-like aquatic organism characterized by two flagellae positioned at right angles to each other and used for propulsion

BOTTOM, FROM LEFT TO RIGHT
Michele photographs a Potato cod waiting its turn at a "cleaning station." In one of the great examples of symbiosis that characterizes coral reef communities, the Cleaner wrasse darts into the Potato cod's mouth and gingerly plucks a meal of parasites from the fish's soft tissues. The film crew patiently stands by to capture this symbiotic exchange in IMAX.

superorganism
A group of organisms that functions as a social unit, such as an ant colony

Like green plants, zooxanthellae use sunlight, carbon dioxide, and nitrogen-rich waste from the plankton-eating polyp, to create the oxygen, sugars, and amino acids that the polyp uses as its main source of metabolic energy. It is one of nature's most successful alliances, one that allows the coral animal enough energy to expand its colony and exude its limestone home. Just as importantly, the extra energy provided by the zooxanthellae allows corals to build reefs and reproduce. Thanks to eons of cooperative interdependency, this arrangement is so finely tuned that without the zooxanthellae, even for a short time, the polyps cannot do both, and if the zooxanthellae remain absent too long they can't do either. When it comes to zooxanthellae and their coral hosts: united reefs stand, divided they crumble.

While the Halls dove into their work with a passion, director Greg MacGillivray, film editor Stephen Judson, and two of the film's science advisors, Richard Pyle and Dr. Gisèle Muller-Parker, found themselves sitting at the MacGillivray Freeman offices in Laguna Beach, California, viewing some of the footage Michele had already rushed back for processing. While Richard, the ichthyologist, named and characterized the fishes swimming across the screen, Gisèle, the algae and symbiosis specialist, made notes about the corals, sponges, and other sedentary features of the reefscape. Suddenly, Gisèle requested the film be paused. "Do you realize," she piped, with an almost proprietorial glee, "that almost everything here is symbiotic?" Her hand, already a shadow puppet, darted enthusiastically among the riot of sponges, tunicates, giant clams, and corals on the screen. "This clam has zoox. And this sea slug, same. And these sponges, we've just discovered, have another kind of algae in their centers.... The wonderful thing," she said, savoring each example, "is just how common symbiosis is."

Wonderful indeed. Each reef is, in fact, a complex association of relationships built one on top of another. Yes, the living eat the living to survive, but for a reef to thrive it must rely on the intricate beauty of mutualism in which the cooperation of any two or more reef dwellers is intricately interlinked with the cooperation of many others in an evolving system of give and take. We haven't a clue of most of these interlinkings. How could we? We've only just begun to carefully study this marvelous ecosystem.

When it comes to a reef's high level of cooperation, the word ecosystem may not be big enough to signify everything a reef really is, biologically speaking. With most plant and animal cells being the evolutionary result of past partnerings between primitive individuals, and with the human body understood as a federation of specialized cells into an organism, maybe we should see an entity like Ribbon Reef #10 as a **superorganism**. This hardly seems far-fetched when we bear in mind our ability to remove organs from our bodies and to keep them alive with pumps and temperature controls, just as we can remove corals and

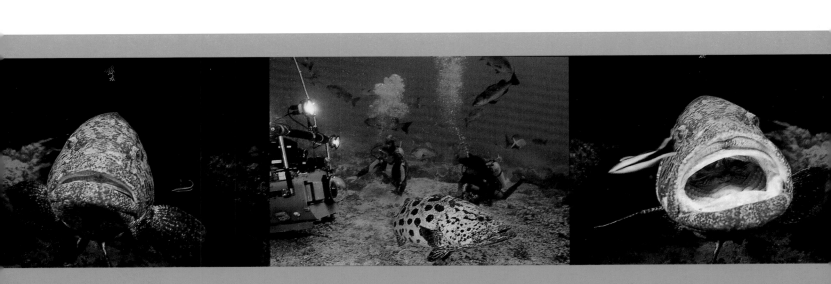

SYMBIOSIS:
We Can All Get Along

The story of the reef is the story of cooperation. The world's coral reefs are home to one quarter of all marine species; this diversity is supported by an abundance of symbiotic relationships. Symbiosis—the close, prolonged association of members of two or more species—often enables organisms to share resources and cooperate in novel ways. The tiny Cleaner wrasse, for

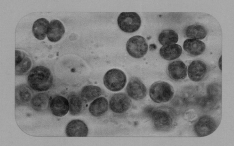

example, coexists with the Potato cod grouper and other fish by offering its services as a groomer; in exchange for performing this necessary act of hygiene, the wrasse obtains its meals, dining on dead tissues and parasites lodged in the larger fish's mouth. Hundreds of such mutually beneficial interactions have evolved in the reef community. The corals creating the reef depend on their symbiotic partners, the zooxanthellae. The coral animal provides a home in its cells for the zooxanthellae, which in turn use sunlight, carbon dioxide, and animal waste to make sugars and other high-energy foods needed for coral growth and reproduction. Our own survival is linked to the reef's in many ways. Both depend upon how well we learn to cooperate with these ancient communities.

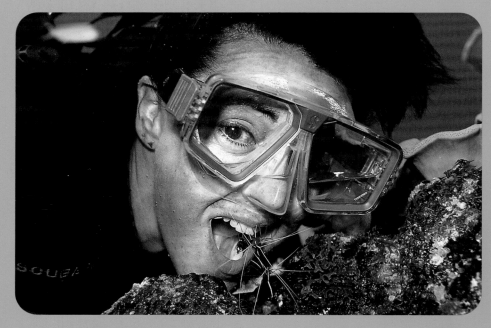

ABOVE Michele experiences symbiosis firsthand by mimicking the posture of a fish ready for a dental check-up by a cleaner shrimp during filming in Fiji. And yes, it tickles!

LEFT At less than 10 micrometers, zooxanthellae (*Symbiodinium* sp.) are easily viewed under a microscope. Millions of these single-celled photosynthetic algae can live within a coral polyp, producing nutritive carbohydrates and oxygen in exchange for a home. Bermuda.

BOTTOM ROW, FROM LEFT TO RIGHT
An alpheid shrimp (*Alpheus* sp.) excavates the burrow it shares with the vigilant shrimp goby who stands guard. At any sign of danger, a flick of its tail sends both partners scurrying into the safety of the burrow.

Moray eels are among the many carnivorous fish whose dental health depends on the Cleaner wrasses they might otherwise eat.

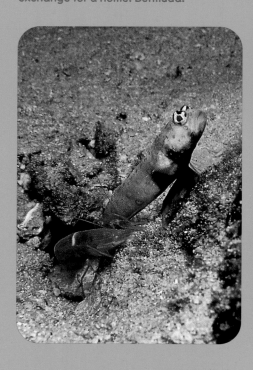

Remove a single fish and nothing much will happen, but remove an entire species, especially a critical one, and it's possible to send the entire system into collapse.

fish from reef and keep them healthy in glass aquaria. On the other hand, what happens to the reef or a body if what is removed is not replaced? On the reef, it is the species, not the individual fish, which function like organs. Remove a single fish and nothing much will happen, but remove an entire species, especially a critical one, and it's possible to send the entire system into collapse. Luckily, nature is full of redundancies, so this doesn't occur often. There is usually another species of a similar role around to serve as back-up (kind of like our kidneys). But remove by overfishing too many species with a similar function (say, the seaweed-eating species like reef-grooming surgeonfish and sea urchins), and the reef will choke and die.

Ecosystem also seems too boxy and mechanical a term to use when speaking of the intricate network of systems within systems that reefs really are. In fact, reefs are more like small universes, microcosms incredibly whole unto themselves, which remain inextricably linked to everything else in nature. Perhaps, then, we should call them ecocosms (combining the Greek word for house, *oikos*, with *cosmos*, an orderly, harmonious world)—a home for harmonious relationships. What could be more appropriate?

At first, from a fish-eye view, the crew of flippered, begoggled creatures crashing into the water could have been monstrous birds diving for a meal, except that instead of wings they had big metal bottles on their backs. Despite notorious currents and a 30-knot wind kicking spray over the Ribbon Reefs, the specially sealed 250-pound, aluminum-housed IMAX camera, "Big Blue," was winched into the water of Cod Hole. And down they went.

Almost immediately, Howard came upon two Potato cod engaged in a territorial competition he had never seen before.

While he filmed them, the grouper changed color, paling, then darkening, then paling again, as they butted each other like rams during rutting season—except that instead of horns, they butted their rubbery lips. In a sense, such competition is an optimistic behavior; it is evidence of cooperation's bounty. In this case it indicated the reef community had achieved a healthy population of Potato cod, one of the predators near the top of the food chain. Along with the abundance of other indicators—such as the numerous "ornamental" species like butterflyfish and Triton trumpet snails (which are usually over-collected for the aquarium and curio trades), and the lack of smothering seaweed (which would indicate stresses like pollution)—the signs were that Cod Hole was in very good health indeed.

Now it was time to get the shot of the Potato cod being cleaned by the wrasse. Howard gingerly positioned the camera on its heavy tripod near the coral head where the wrasse maintained its cleaning station. Assistant diver Mark Thurlow hovered off Howard's left shoulder with a bank of three strong electric lights to help the film expose properly. Almost as if on cue, the cod came along and tilted with its mouth open. Out of nowhere came the wrasse, and Howard adjusted the focus.

Sounding very much like a cartoon duck, Howard squawked "Lights!" over the underwater communications system. Mark hit the switch. Minutes passed as the wrasse flitted about the cod's mouth. But for some reason, it wouldn't go in. At first Howard thought he might have an imposter in view. He'd seen them in action before. Sometimes, a Potato cod or other fish opens wide for what appears to be a Cleaner wrasse, only to receive a sudden jolt when one of nature's great mimics nips a chunk from its lip before zipping out of range of the flinching fish's wrath. Another Blue-lined fangblenny has just snuck a meal!

But this fish was the real McCoy. And it wasn't like the wrasse didn't want to go in. It flitted about the grouper's head, repeatedly

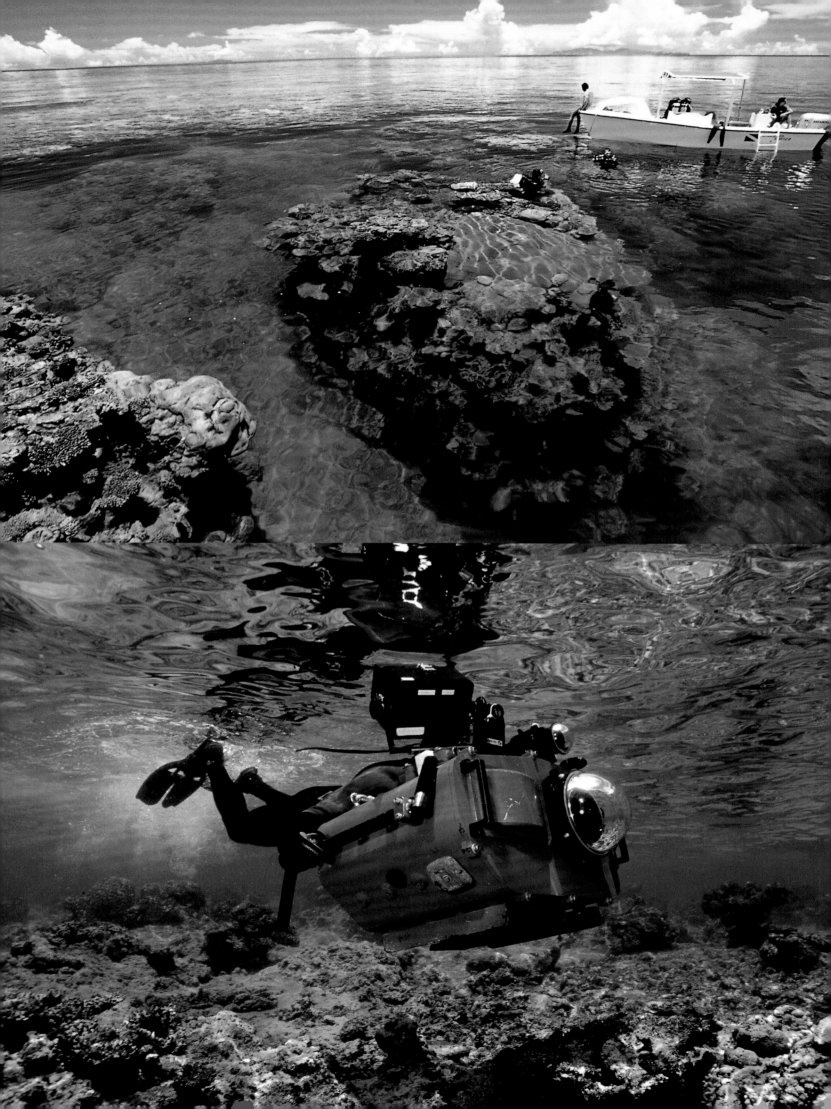

charging forward and recoiling as if smacking into an invisible shield. After twenty frustrating minutes focusing and refocusing with his finger on the shutter release, Howard shook his head and told Mark to cut the lights. And as soon Mark did that, the wrasse entered the Potato cod's mouth and went to work.

Australia's very first bumper sticker appeared in 1968. Sporting neither the name of an acid rock band nor a political candidate's motto, its message was simple: "Save the Barrier Reef!" No one at that time called himself an "environmentalist," but there was a growing number of citizens concerned about the impact of foreign fishing vessels and covert government leases to sugar cane growers and petroleum companies who wanted to mine and drill on the reefs for fertilizer and oil. At the same time, outbreaks of the exquisitely named and previously deemed rare Crown-of-thorns starfish—the only large organism known to feed exclusively on living coral polyps—were gobbling up tracts of healthy reef at an alarming rate. The first reef-related battle of its kind was getting underway between those who wanted to profit from the reef and those who simply wanted to preserve it.

Australia's first conservation NGOs (non-government organizations) were formed, including the Australian Conservation Foundation, the Wildlife Preservation Society, and the Littoral Society of Queensland. In the United States, the state of Florida had recently created the world's first protected reef at John Pennekamp Coral Reef State Park, and murmurs to do the same with the Great Barrier Reef began to percolate. And while the Australian government argued in favor of reef-exploiting "progress," petition campaigns by the conservationists were so effective that even the mining and petroleum supply unions agreed to threaten strike if drilling or excavation began on the reef. Then, when both major candidates for Australian Prime Minister placed the reef at the top of their parties' election platforms, the movement to save the Great Barrier Reef really gained momentum.

In February 1969, a disastrous offshore oil rig blowout blackened the beaches of Santa Barbara, California, killing sea life and showing the public what oil, unleashed, could do to the environment. No one wanted that to happen to the Great Barrier Reef. It took five more years of debates, but by 1975, a decade after citizens had taken up the cause, the Australian government passed the Great Barrier Reef Marine Park Act, formally establishing a substantial part of the huge reef complex as a protected marine park, and allowing no commercial fishing, drilling, or mining there of any kind.

Just months after the reef was declared protected, in 1976, the Halls found themselves on a Great Barrier Reef dive boat that happened upon a Taiwanese junk whose crew was illegally gutting giant clams of their sweet, scallop-like muscles, leaving them to gape and rot by the hundreds on the reef. Armed with a single .38 revolver and lot of resolve, the dive skipper made a citizen's arrest, confiscating the junk and escorting its crew to port authorities while Howard and Michele looked on.

Three decades later, such grassroots policing isn't necessary at this World Heritage site, but there are many other reefs that are not so well protected. In a 1963 television interview, environmentalist Rachel Carson challenged the world to change the way we approach the environment when she said: "I truly believe that we in this generation must come to terms with nature, and I think we're challenged as mankind has never been challenged before to prove our maturity and our mastery, not of nature, but of ourselves." In the nearly forty years since she voiced this now obvious truth, we have made considerable headway, protecting the Great Mayan Reef in Belize (the second largest barrier reef in the world), Cabo Pulmo Reef in Baja California (the only reef in the North American Pacific), and portions of reef in sixty other countries through acts of legislation.

TOP These "bommies" (an informal Australian term for isolated reef pinnacles) show how corals build on top of past generations of corals to form the shallow diverse habitats of coral reefs. Mt. Mutiny, Fiji.

BOTTOM Maneuvering "Big Blue" safely above the fragile reef in shallow water takes all of Howard's skill, care, and strength.

Recently, a diverse coalition of Hawaiian fishermen and environmentalists convinced President Bill Clinton, in his final days of office, to issue an executive order establishing the Northwestern Hawaiian Islands Coral Reef Reserve. At 1,200 miles long and 100 miles wide and covering 3.3 million acres of coral reef habitat, it is the largest protected area in the entire United States and, after the Great Barrier Reef, the second largest Marine Preservation Area (MPA) in the world. But as Howard and Michele have seen, there is still much more we must do.

Seventeen separate dives and fifteen submerged hours later, Howard had begun to suspect that the camera's intense artificial lights were "bleaching" the perceived color of the Potato cod's mouth to an unnatural hue which the wrasse did not think safe. He asked Mark to leave the lights off until the wrasse was comfortably working away inside the grouper's mouth. Then, once the camera was running at full speed, he was to snap the lights on at the last moment. It worked, and now the wrasse can be seen swimming in through the gills and out of the mouth of the satisfied Potato cod in the finished *Coral Reef Adventure*.

After a bubbly sigh of mixed relief and satisfaction, Howard's voice was heard to quack once over the underwater communication system: "Guck the bites. Rebleed the carrot." Translation: "Cut the lights. Retrieve the camera." It was time to pack up and go.

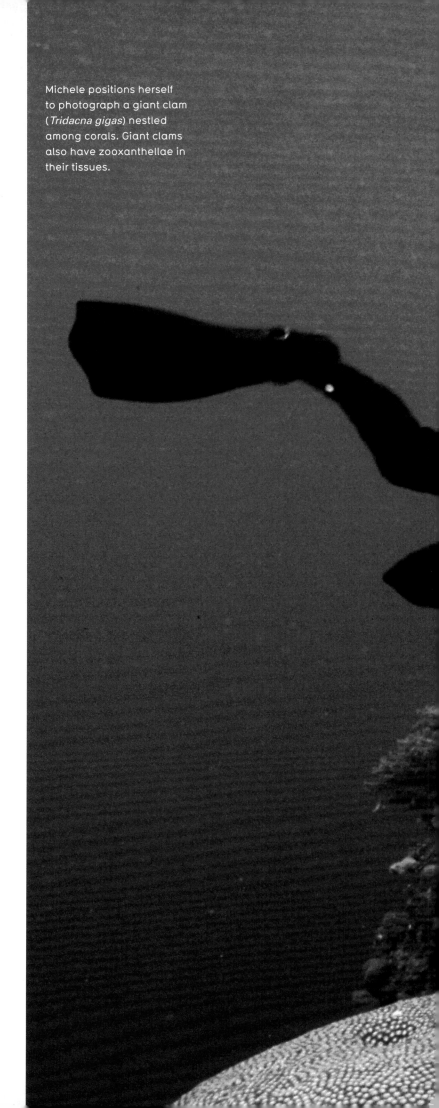

Michele positions herself to photograph a giant clam (*Tridacna gigas*) nestled among corals. Giant clams also have zooxanthellae in their tissues.

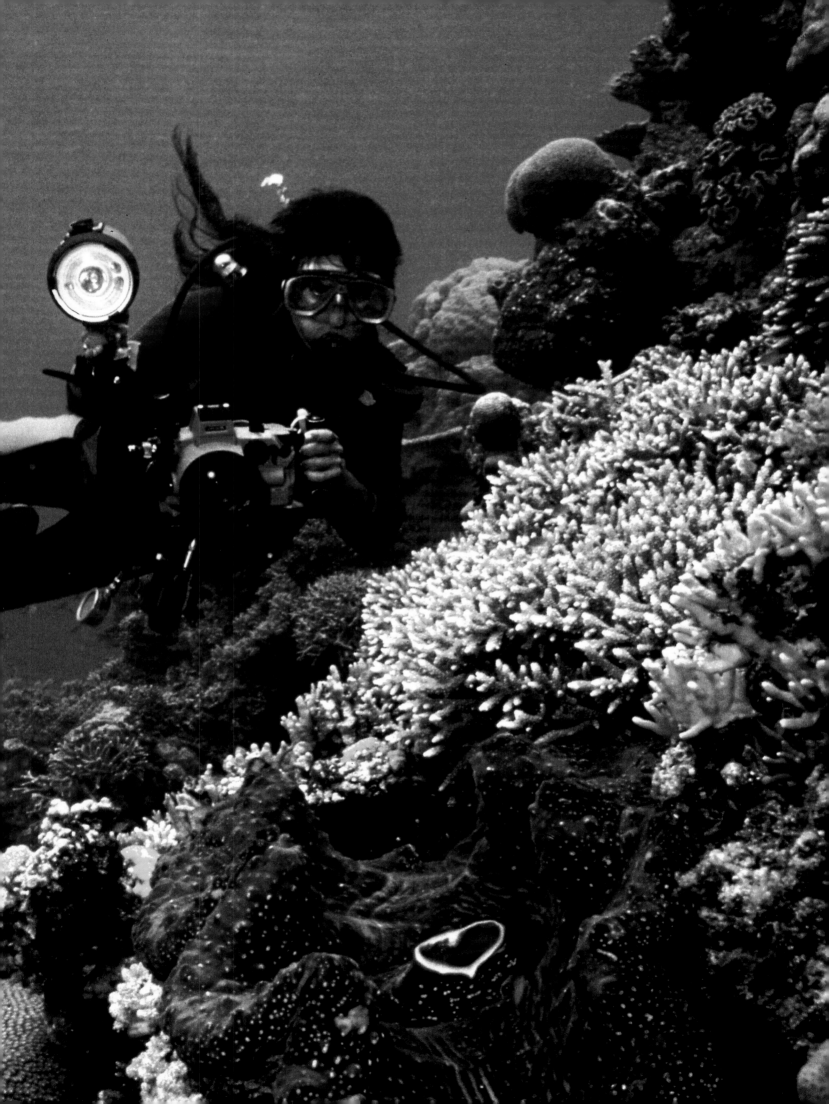

THE SPIRIT
OF COOPERATION

What is a coral reef but a harmonious interplay of diverse individuals, each with an indispensable role and a unique part to play in the creation of a complex work of monumental proportion and kaleidoscopic beauty? A fitting description, too, of the MacGillivray Freeman film expedition where the cooperative spirit thrived and whose product far exceeds the sum of its individual parts.

To bring back the images seen in the giant screen film *Coral Reef Adventure* there were two expeditions, both mounted simultaneously. One expedition, undertaken by Howard and Michele Hall and their underwater film team, documented the reefs and their inhabitants. The other, embarked upon by Greg MacGillivray and his team of topside experts, filmed the efforts of the underwater team and also captured the life of an island culture whose well-being and spiritual identity depends upon the reefs and their resources. Like Mohammed and the mountain that could not come to him, these adventurers traveled halfway round the world to bring the far-flung coral reefs of Fiji, Australia, and French Polynesia back on film for the rest of us. To document these reefs on behalf of reefs everywhere, these talented specialists—divers, cameramen, sound recordists, navigators, aviators, technicians and support personnel—applied courage, commitment, purpose, altruism, and artistry over an intense two-year period to accomplish what few others could. While bringing their individual talents and passion for the natural world to bear in the creation of *Coral Reef Adventure,* they managed to bring together the reef community and the human community like never before—not only in the field but on film and in the eyes and minds of IMAX theatre audiences everywhere.

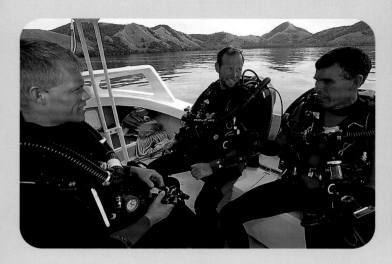

LEFT Richard Pyle with new species of anthias, Cardinalfish, and Velvet wrasse he collected during the filming of *Coral Reef Adventure*, headed for the Waikiki Aquarium.

ABOVE, LEFT TO RIGHT
Safety diver Peter Kragh, underwater cameraman Bob Cranston, and Howard wear 80-pound rebreathers, on their way to a deep dive at Mt. Mutiny.

RIGHT Director Greg MacGillivray likes what he hears as he checks sound levels during filming in Fiji.

ABOVE Fijian conservationsists like Rusi Vulakoro (right) and Sakiusa "Zac" Qereqeretabua helped guide the film crew to local dive sites in Fiji.

LEFT Michele Hall and Australian marine biologist Tracey Medway consult before diving down to Cod Hole.

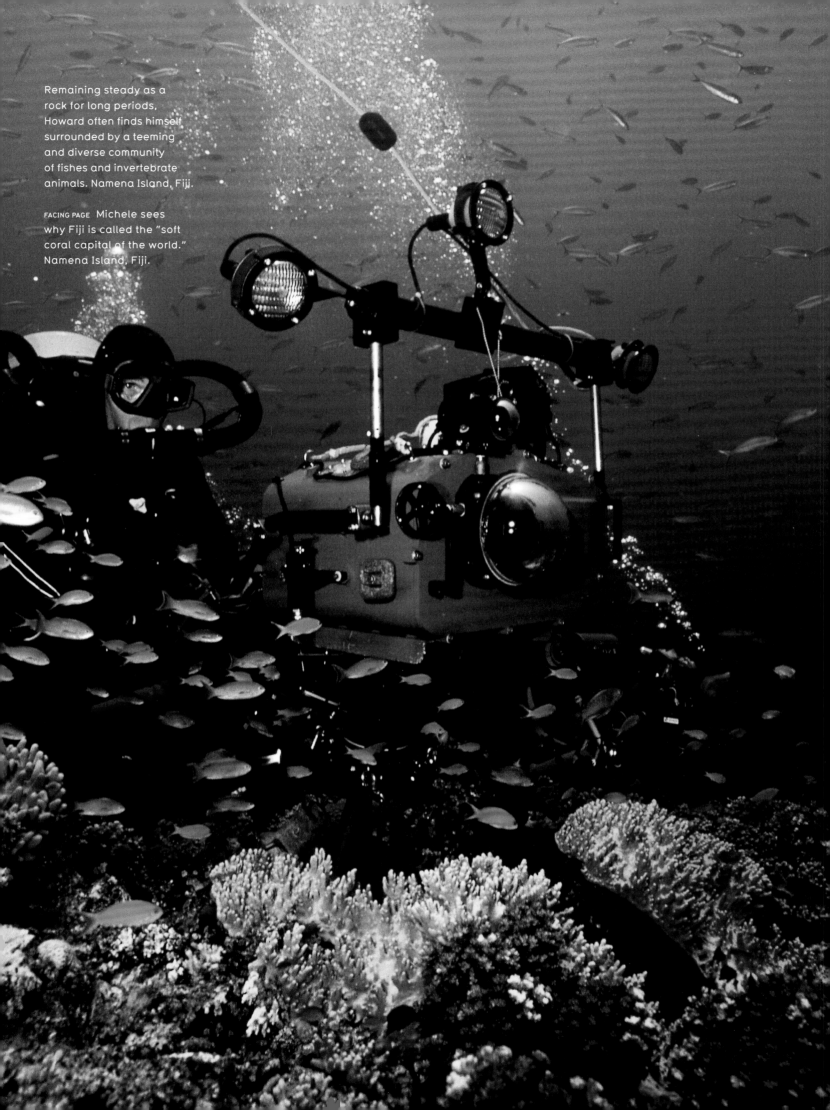

Remaining steady as a rock for long periods, Howard often finds himself surrounded by a teeming and diverse community of fishes and invertebrate animals. Namena Island, Fiji.

FACING PAGE Michele sees why Fiji is called the "soft coral capital of the world." Namena Island, Fiji.

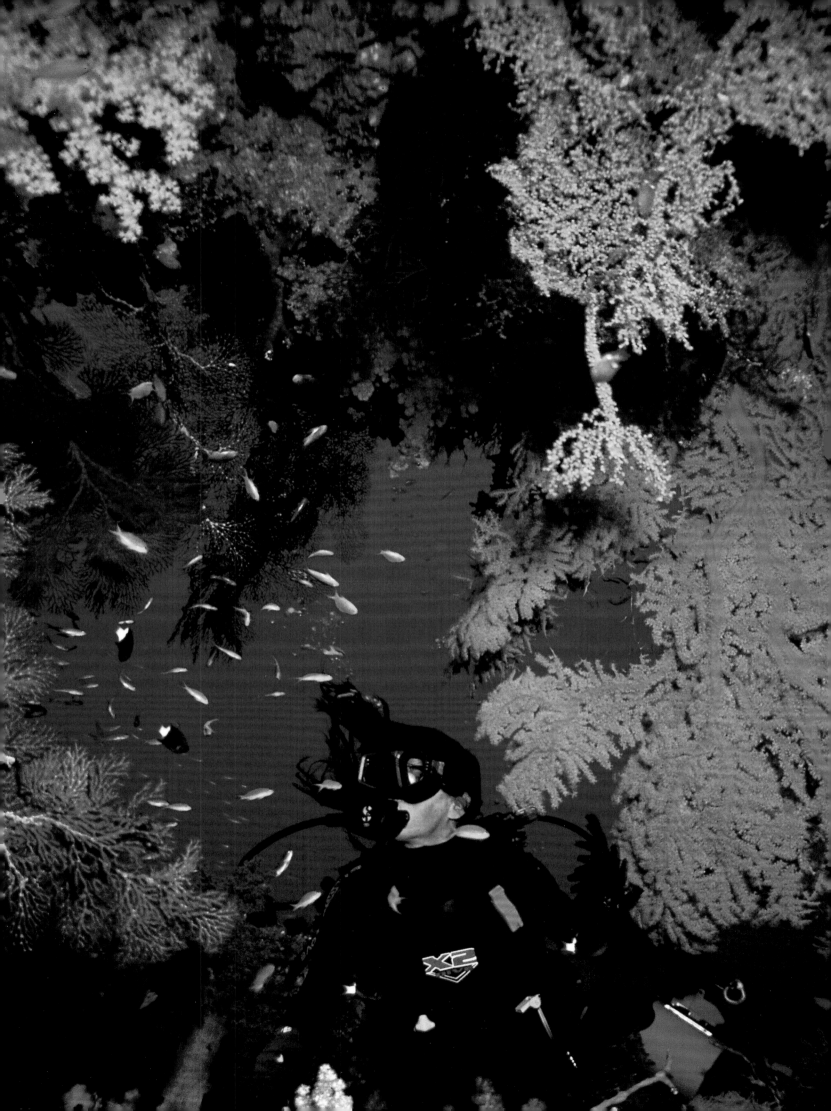

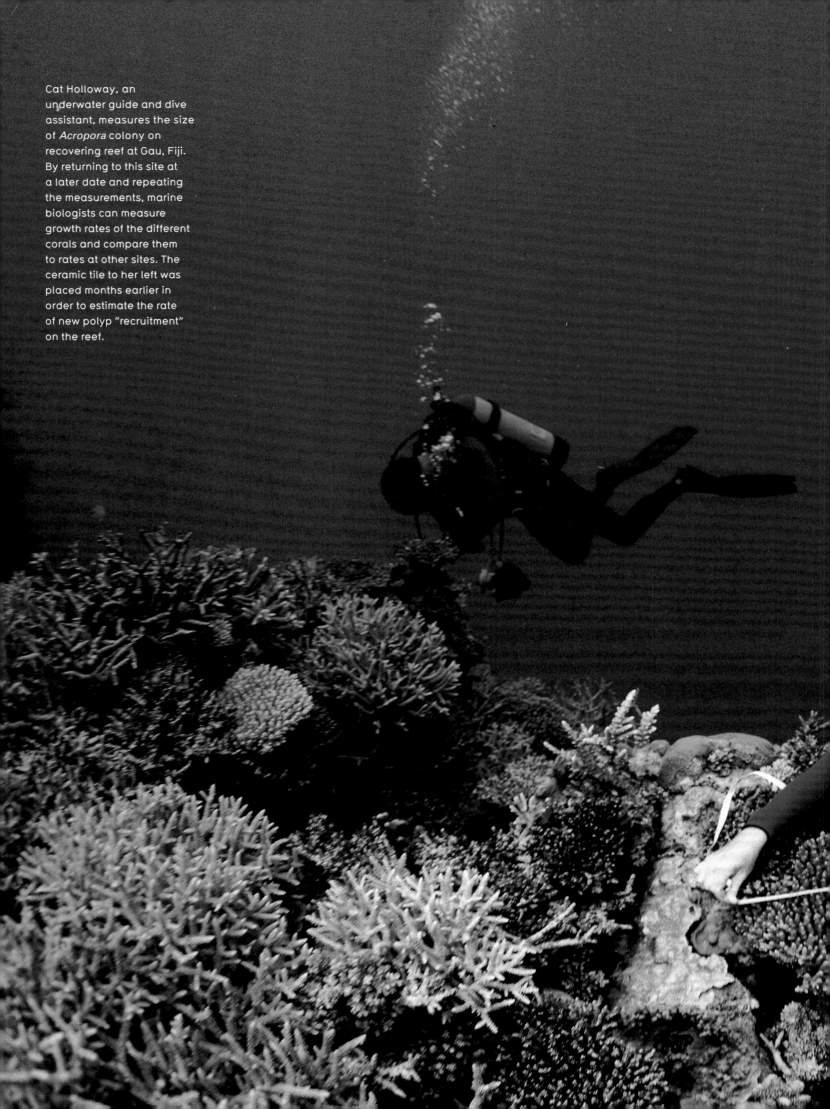

Cat Holloway, an underwater guide and dive assistant, measures the size of *Acropora* colony on recovering reef at Gau, Fiji. By returning to this site at a later date and repeating the measurements, marine biologists can measure growth rates of the different corals and compare them to rates at other sites. The ceramic tile to her left was placed months earlier in order to estimate the rate of new polyp "recruitment" on the reef.

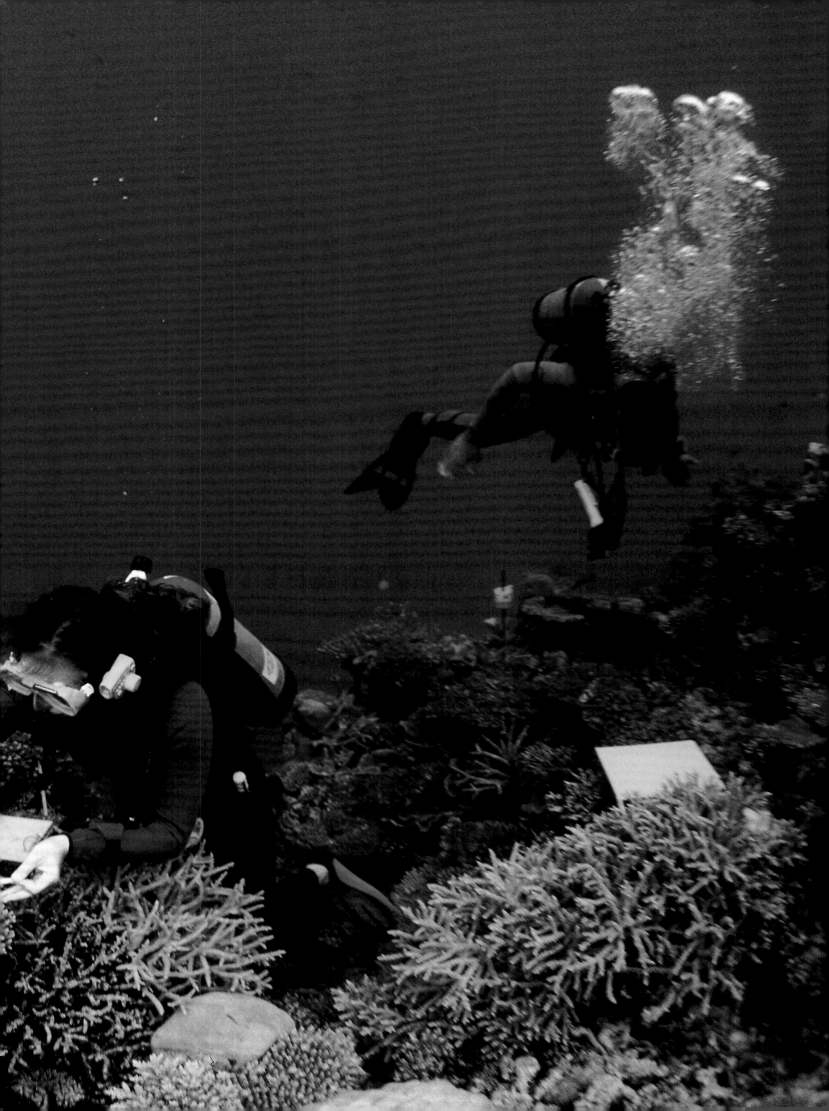

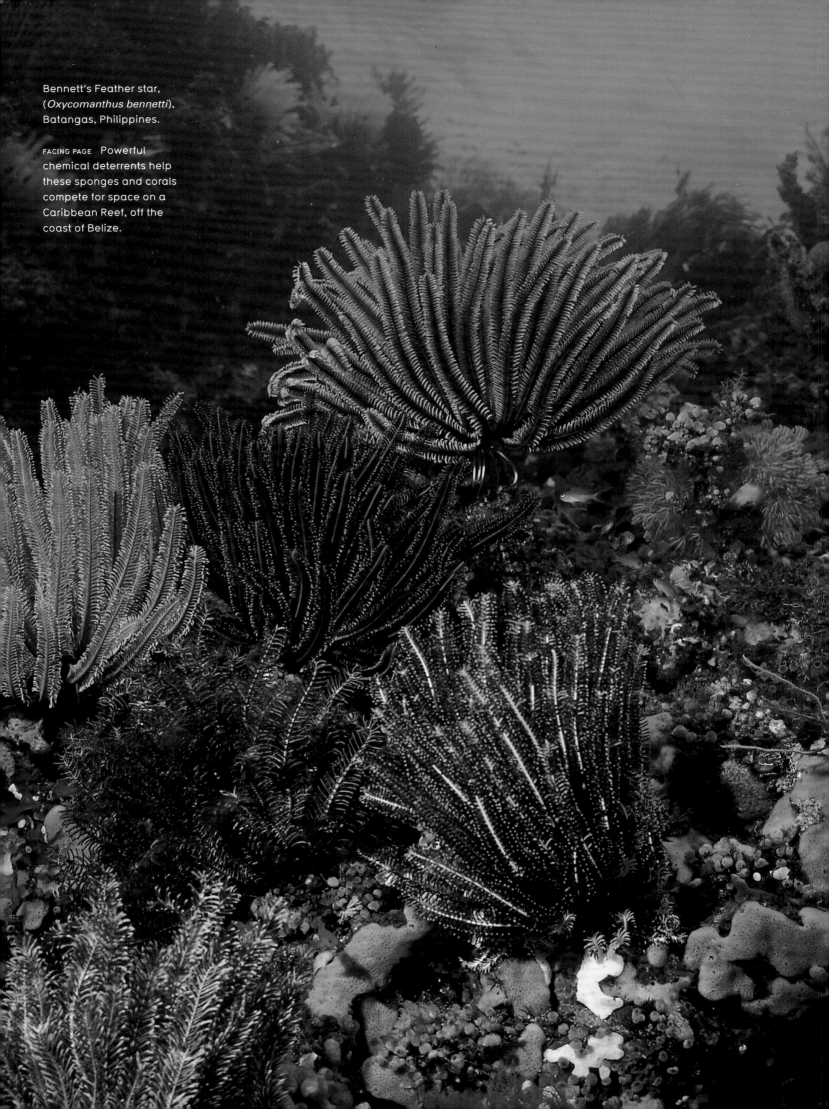

Bennett's Feather star,
(*Oxycomanthus bennetti*),
Batangas, Philippines.

FACING PAGE Powerful
chemical deterrents help
these sponges and corals
compete for space on a
Caribbean Reef, off the
coast of Belize.

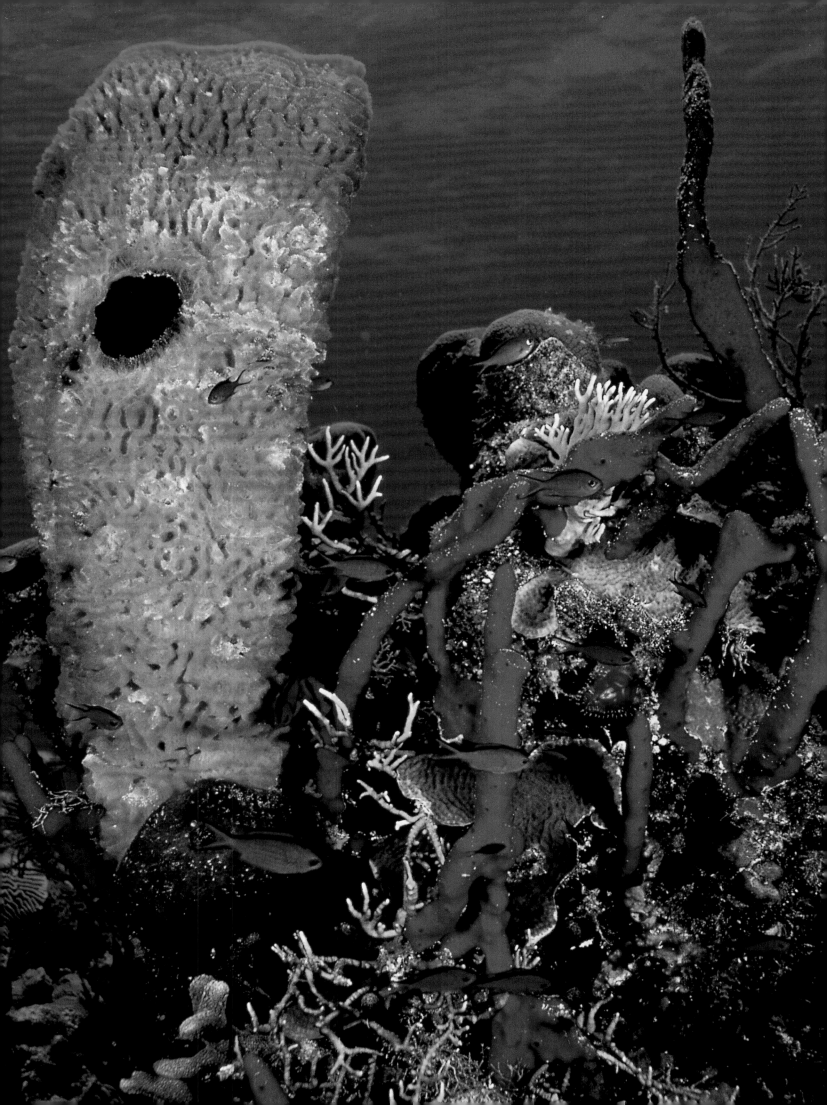

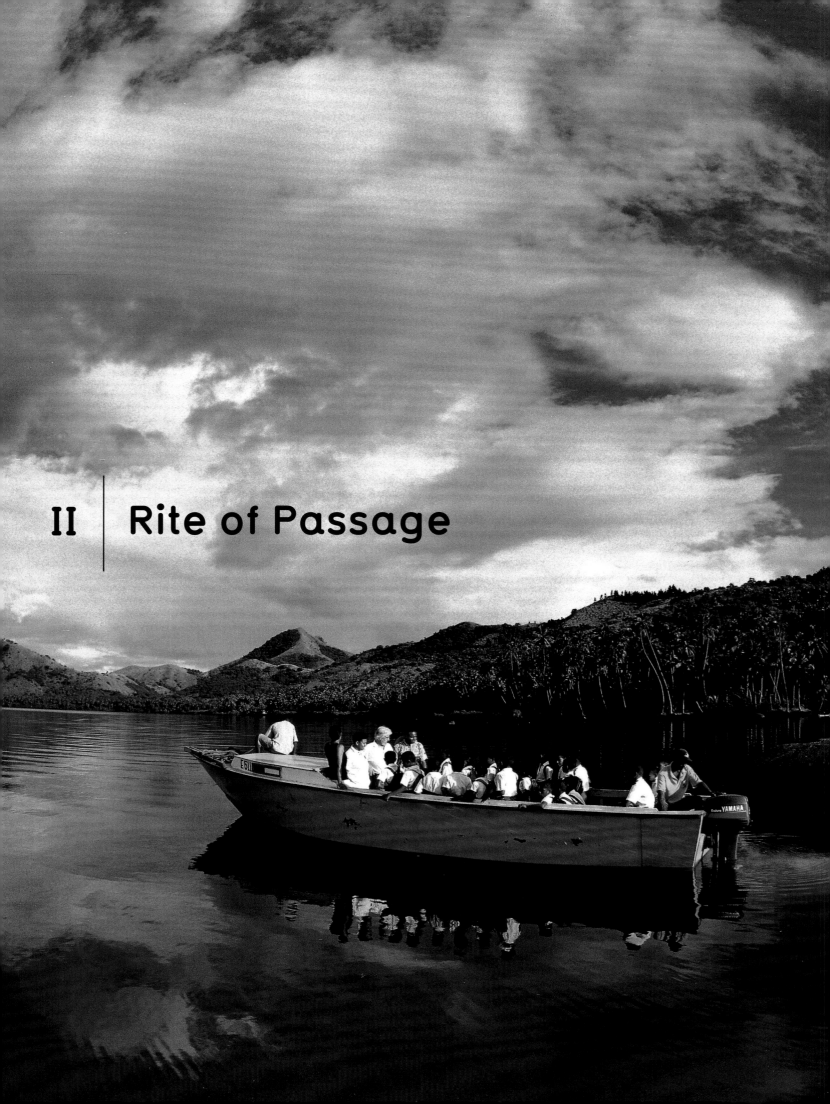

II | Rite of Passage

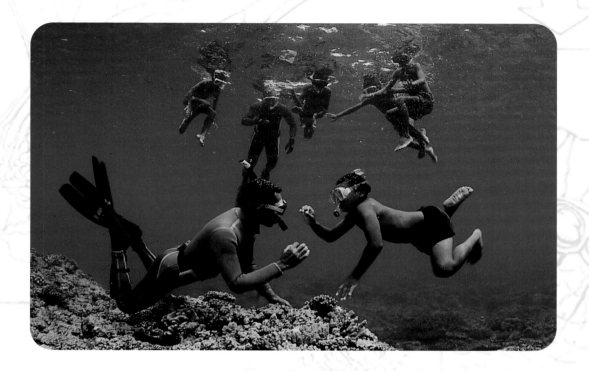

On January 12, 2001, at the height of cyclone season,

the live-aboard dive boats *Nai'a* and *Undersea Hunter* came to anchor at the Fijian island of Gau (pronounced "now") in a bay formed by the remnant of an ancient volcanic crater. Each vessel held a film team—Greg MacGillivray's topside crew and Howard Hall's underwater one—but it wasn't until a sea plane arrived carrying the last few members that the party of three dozen filmmakers, divers, environmentalists, and marine biologists was complete. Then, with everyone respectfully wrapped hip-to-ankle in bright sarong-like sulus, the inflatable rubber Zodiacs were winched into the water, and the entire contingent headed ashore.

At the dock of the village of Nawaikama, environmental advocate Jean-Michel Cousteau and other members of the landing party were hailed with a hearty *Bula!* (the Fijian form of Hello!) by village women who placed fragrant plumeria blossoms behind their ears—left if married, right if not. It was rainy and stifling hot, as native diver Rusi Vulakoro led the growing procession slowly along the lush shore past the banana and breadfruit and

coconut trees toward the heart of the village. In the distance the *tling, tling* of a steel car axle striking the sides of an iron crucible announced that yaqona roots were being pounded to the right consistency for ceremonial grog.

At the village center, just a few paces from the gently lapping water, everyone stopped before the town meeting hall, a long cement block building with no windows or doors in the open frames. Removing their shoes in turn, the filmmakers were ushered through the entrance and asked to sit opposite the villagers on the woven pandanus—mats strewn upon the uneven dirt floor. It was hot as a sauna, and fearless flies buzzed about as the ritual *sevusevu* began.

Rusi—who would guide Howard and Michele to both healthy and ailing local reefs—acted as intermediary between the villagers and members of the expedition, who he hoped would help him understand the alarming degradation taking place on sections of the local reef. On his knees, he respectfully passed the traditional *waka*

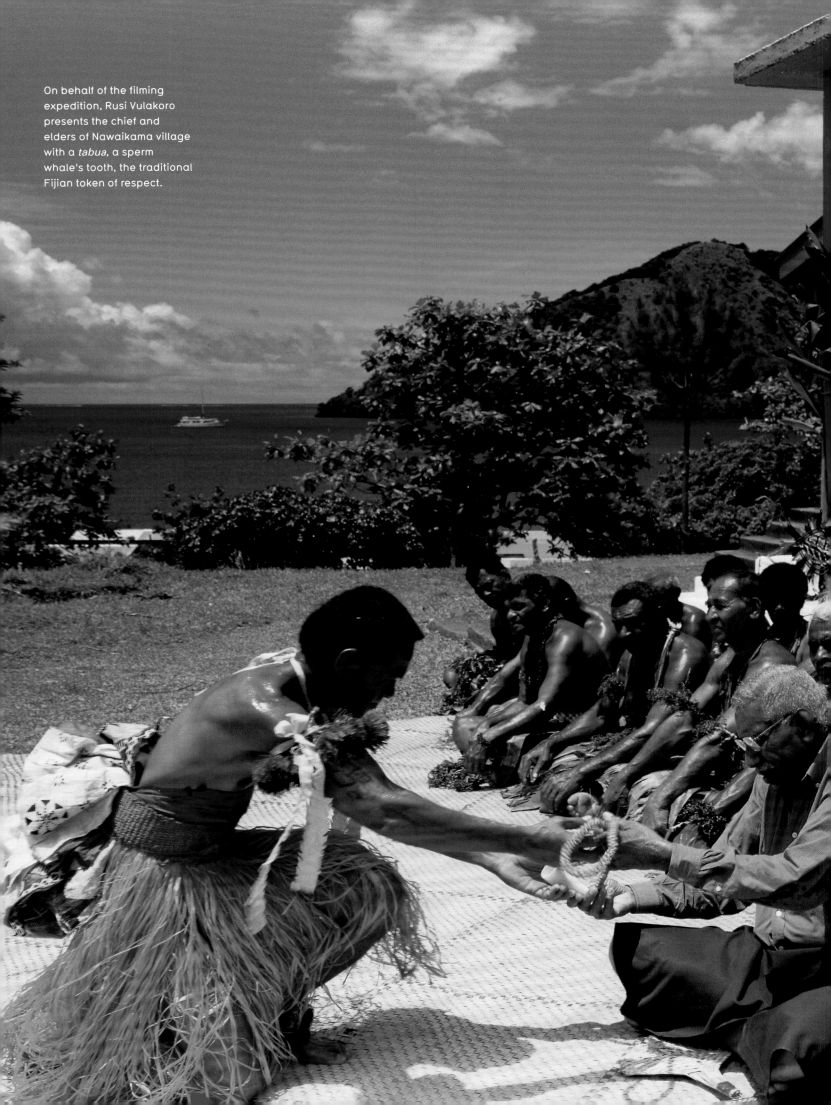

On behalf of the filming expedition, Rusi Vulakoro presents the chief and elders of Nawaikama village with a *tabua*, a sperm whale's tooth, the traditional Fijian token of respect.

(yaqona root bundle) tribute offered by the outsiders, into the hands of Takalaigau Ratu Marika, the village chief. Accepting the waka, the chief launched into a welcoming speech in the sonorous clack and swell that is the Fijian tongue, raising his voice like a gathering wave to emphasize a point as the village men and women counterpointed him with a chorus of affirmative murmurs and claps. Several times this wave of chiefly rhetoric and village approval crested and fell until fifteen minutes later the chief ordered grog prepared, and the two men sitting behind the broad, wooden, three-legged *tanoa* went to work mixing the slurry of water and ground yaqona (elsewhere known as kava) by hand.

Now it was the filmmakers' turn to speechify. After the introduction in formal Fijian by Rusi, Rob Barrel (the skipper-owner of the local dive boat *Nai'a*, who had set up this meeting), Greg MacGillivray, the Halls, Jean-Michel Cousteau, and the rest of the expedition introduced themselves in turn and apologized for disrupting the rhythm of daily village life. They had "come for the reef," explained Rob, and they wanted permission to dive and film the best and worst of it in order to help scientists and other concerned people find ways to protect reefs all over the world. The chief nodded solemnly. Then Greg asked the cooperation of the villagers, and the chief nodded again. It was agreed that over the next week, the Fijians and the filmmakers would work together on behalf of reefs everywhere. To celebrate, the chief ordered the grog served.

The yaqona—a slightly clove-tasting gum-numbing social lubricant far less intoxicating than alcohol—was dipped up, one coconut bilo per serving, and passed to one drinker at a time. When it was Michele's turn, she clapped once with cupped hands in appreciation of the gift, then, with a slightly reserved *Bula!*, tipped the bilo and drank. In spite of its bland, slightly herbaceous taste, Michele could not completely restrain a grimace as she gulped the muddy-looking water. Yet, the mixers were pleased; her "womanly" reaction

told them the infusion was generously hearty. The bilo was returned, dipped, and handed to the next expedition member. And so went the sevusevu, an ancient bonding ritual practiced long before white men ever sailed into these waters.

In 1642, Abel Tasman became the first European to see Fiji, sailing into and then quickly out of the region of lurking reefs that nearly wrecked and killed him. A century later, James Cook, sobered by his brush with the Great Barrier Reef, sailed right past Fiji, choosing to avoid its reefs altogether. In May of 1789, Lieutenant William Bligh, cast adrift in a ship's launch by the mutineers of the *H.M.S. Bounty*, became the first European navigator to sight and log Gau as he drifted through the 320-island archipelago on his now famous 3,618-mile journey. Early charts called Fiji "Bligh's Islands." But they were hardly his.

The true discoverers and first explorers of these islands and reefs were the Polynesian and Melanesian ancestors of the Nawaikamans, over 2,400 years ago. Using bamboo stick charts studded with cowrie shells for islands and arched wickers representing the direction of prevailing oceanic swells, these ancient seafarers literally felt their way east across the sea on 90-foot long double canoes lashed together with bamboo platforms and powered by plaited pandanus sails. The first obstacle they encountered when they reached an island was always its surrounding reef.

Like any good barrier, reefs protect what stands behind them. Fringing reefs guard coastlines and buffer beaches from erosion, protecting buildings and inshore areas from severe wave and storm damage. By tempering the tides before they enter Nawaikama Bay the reef makes it a haven for villagers and snug harbor for visiting boats.

But reefs are more than natural barricades. They are tropical cornucopias and often the greatest single resource for those who live near them, especially on remote or isolated islands. In the shallow Mangrove

flats between Nawaikama and its fringing reef, women gather clams at low tide while young boys and girls fish for small grouper from slender bamboo rafts called *bilibilis.* In thigh-deep water, a circle of men slowly approach each other gripping a hand seine. While their seine is woven of modern nylon mesh, it wasn't that long ago that the whole village joined in fish drives, using a scareline of liana vine plaited with coconut fronds to encircle, corral, and concentrate fish, as men and women sang and stamped a harvest dance. The dance would end when the constricting circle was small enough for the fish to be stunned with *duva* (a mild poison derived from the same vine that yields the organic insecticide Rotenone) and placed in baskets.

The reef is the origin of mythology and a source of cultural identity. To Fijians—and in some variation throughout Oceania—the reef is inhabited by the ancestral spirits of slain warriors who've become sharks and by faithful women transformed by untimely death into turtles. Protective pacts between powerful reef creatures, like the octopus and the shark, are said to be made on behalf of the people who use the reefs, ensuring that locals remain respectful and poachers wary. For this reason fishermen pay tribute by pouring bilos of grog into the sea before ever setting a net or casting a hook. And this is why, when an important islander dies, village chiefs decree a moratorium making it taboo to fish the local reefs for as long as one hundred days and nights, and giving the reef a chance to rejuvenate.

Reefs provide in so many ways. Islanders like the Nawaikamans have recognized and valued the restorative properties of underwater organisms for centuries, and it's no wonder. Like rain forests, coral reefs are a megasource of unusual chemical compounds, thanks to their great biodiversity. Take the half-million years a single reef may have been around, multiply by the half-million species that might call that reef their home, and you get 250 billion years of evolutionary experimentation. And that's just one

reef. With only one in every 5,000 new chemical compounds concocted in pharmaceutical labs standing a chance of becoming a drug of some effectiveness, that's a lot of free and innovative compounding waiting somewhere among the corals.

One key to unlocking the biochemical potential of the reefs is found in the questions we ask. How do shallow-water corals thrive in the region with the world's highest incidence of skin cancer? How do healthy corals remain seaweed-free? The answers to these and other questions are leading researchers to natural sunscreens and herbicides which will soon be found in helpful products courtesy of the corals' natural ability to protect themselves. Why don't coral colonies glom onto each other as they struggle for precious space on the reef? Because corals and other sedentary reef organisms have evolved a good neighbor policy, enforced with powerful toxic irritants that keep fellow reef dwellers at a peaceful and resource-sharing distance. This same chemical deterrent—which also renders corals unpalatable to most would-be predators—is the primary reason the National Institute of Health and the National Cancer Institute are focusing more than half of their anti-cancer bioprospecting research on marine organisms.

With **conotoxins** from the lethal dart of the cone snail proving effective in drug trials against previously untreatable chronic pain, and **prostaglandins** derived from soft corals inducing and easing childbirth, modern medicine is only beginning to fill prescriptions from the reef pharmacopoeia. The calcium composition of coral's unique skeleton is so pure and finely pored it has eclipsed other materials as the preferred medium for bone transplants. AZT, the most widely dispensed treatment for HIV infections, is based on compounds extracted from a Caribbean reef sponge. Viral infections, ulcers, cardiovascular disease . . . the list of reef cures is growing fast. The great thing about this new resource is that once each chemical secret has been unlocked by lab-

conotoxins
Short peptide neurotoxins found in the venom of cone snails, tropical marine snails with beautiful, distinctive shells

prostaglandins
Hormones (chemical messengers) constructed from polyunsaturated fatty acids known to influence such body functions as circulation, smooth muscle contraction, and kidney regulation

A feather star perches inside the barrel of a filter-feeding sponge. An encrusting soft coral forms the pedestal for this sponge. Other sponges, of a different species, filter the water column below. Bonaire, Netherlands Antilles, Caribbean.

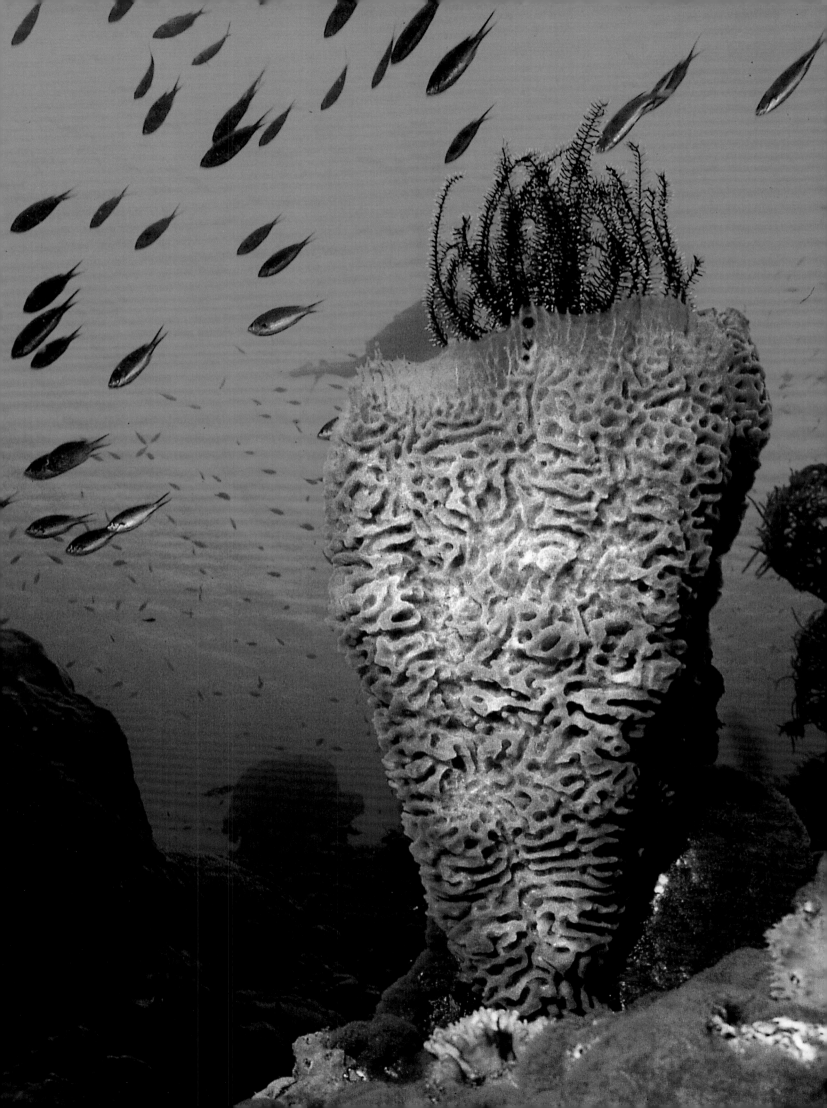

oratory analysis, it can then be reproduced in a lab or in growing tanks, leaving its reef of origin relatively unperturbed and unchanged. In this way, we may treat reefs not as a kind of pharmaceutical mine to extract from, but as a great library whose volumes of knowledge we will only get better at reading.

Yet the promises of the reef have a dark side fueled by that age-old human defect: greed. On a preliminary scout to Fiji, Howard and Michele were asked by another village chief to help retrieve the corpses of two local divers. "Apparently," said Howard, "the Fijian Navy had been on the site and had attempted a dive, but the bodies were too deep for them to reach." They were last seen well below 300 feet. The dead divers, it turned out, were sea cucumber collectors.

Living in the rubble zone erroneously referred to by some as the "dead" part of a reef, sea cucumbers are quiet deposit-feeders that spend their lives processing the sediments like great aquatic earthworms, improving the quality of both the water and the coral sand. Called *iriko* in Japan, *hai-som* in China, *trepang* in Indonesia, and by Darwin that "slimy disgusting Holuthurie which the Chinese gourmands are so fond of," sea cucumber, or *Bêche de mer* as it's known in Fiji, is one of the blandest things you could ever put in your mouth. Boiled, gutted, and sun dried, sea cucumbers—which native Fijians prefer not to eat—have been the salt cod of the South Pacific for almost two centuries, earning handsome profits for American

whaling ships who traded guns for them, then sold them in Manila in the early 1800s. Today in the South Pacific alone, 80,000 tons of sea cucumber are harvested, processed, and sold each year to Asian buyers for soup, with tons more ground into powders for the anti-inflammatory qualities they are supposed to possess and sold by companies often specializing in as-yet-unproven remedies like powdered deer velvet and shark cartilage.

Though the Fijian government has banned scuba for sea cucumber collecting, the money offered by the Asian market is so tempting that some locals are willing to dive clandestinely, often descending past 150 feet with no training, poor equipment, and deadly consequences. Although Howard wanted to help, he was relieved when the Navy captain asked him not to risk his life to recover the bodies of the divers.

When outside commercial interests with no concern for local consequences, or centralist governments naïve to those consequences, override traditions of local use and management that have worked for millennia, reefs and their reef-reliant communities become destabilized. On Fiji's "mainland" island of Viti Levu—where miles and miles of reef along the so-called Coral Coast are suffering from **siltation** and the other effects of logging, land development, and gold mining—people are beginning to lose touch with the reefs. At the same time crime, suicide, domestic violence, and other social maladies are on the rise. Coincidently perhaps, martial law was decreed on Viti

siltation
The deposition of very fine particles intermediate between sand and clay on surfaces due to run-off from terrestrial sources

BOTTOM, FROM LEFT TO RIGHT

Preparations for the filming begin in the village of Nawaikama on the island of Gau; in the village meeting hall *yaqona* (kava) is prepared in the *tanoa* for the ceremony honoring the filmmakers' arrival.

Greg MacGillivray and his crew ready the IMAX camera to capture the details of village life.

The villagers of Nawaikama have built a sturdy bamboo shooting platform for the IMAX equipment.

Outside the village church, Howard, Michele, and the other representatives of the expedition ask the village elders for permission to dive and film their reef.

Greg MacGillivray waits patiently for rain clouds to pass so he can properly expose the film.

Bilibilis are the preferred mode of transportation and fishing on Gau.

Levu shortly before the expedition's arrival, because of a recent coup and social unrest. Yet, other than the sea cucumber incident, the Halls found little discord on Gau and neighboring islands where the people live grounded by nature and in tune with the rhythms of the reef.

After the welcoming sevusevu, happy gangs of children marched through the village, banging on kerosene tins and bamboo lalis, pausing to belt out "Happy New Year!" in Fijian and in English, while the village men hauled, sawed, and lashed green bamboo logs into the towering platform upon which the heavy IMAX camera could capture the details of their community. In the meantime, the village elders gave Howard and Michele the royal tour, showing off their homes, their taro paddies, the new high school—all sources of pride and, to their minds, forms of wealth.

Yet these islanders did not know how valuable a reef might be in dollars and cents. And why should they? Except for the occasional contributions from the visiting dive boat *Nai'a*, and a donation Greg would make on behalf of the expedition to the schools, almost all of Nawaikama's income is earned through the sale of pandanus matting plaited by the village women for export. Yet for other island nations like, say, Palau in the Pacific, reefs help distribute $13 million a year to a population of 14,000 through diving and snorkeling revenues alone. Half the gross domestic product of Caribbean countries like Bonaire comes from low-impact reef tourism, and Florida's

reef sanctuaries bring $1.6 billion a year to local communities. Add a reef's capacity to produce such income to its real estate protection and pharmaceutical potential, and the value of $2,833 per square meter, arrived at during a recent trial for damage to a reef by ship grounding, doesn't really seem so extreme. Nor does the fact that it cost taxpayers in another locale over $9 million to replace what was once a free, self-repairing breakwater when they allowed their existing coral reef to be mined away. Top this off with the incalculable value of a reef's stabilizing effect on the social structure of a community geared to its rhythms, and units beyond the merely monetary become necessary to estimate reef worth.

While it's true that the Nawaikamans have a low economic standard, they are hardly impoverished. Thanks in great part to the reef, there is plenty to eat and drink, living is simple and healthy, and their houses are safe. The reef focuses their lives; it entertains, it enlightens, and it provides. Yet recently, something beyond their fundamental understanding had been hurting their great provider, and they wondered if they alone could be to blame.

Of the many things that can damage and kill a reef, the list of natural culprits is short: coral disease, violent storms, Crown-of-thorns starfish. The list of human harms, however, is long.

When asked what he believes is the greatest long-term threat to sea life in general, Howard levels his gaze: "Without a doubt, commercial fishing." With one-fifth of

all human-consumed animal protein coming from the sea and as many as 2 billion people in subtropical and tropical countries—many of them among the world's most impoverished citizens—depending on coastal fisheries for protein in their diets, there is indeed heavy pressure on the world's reefs. Additionally, stun fishing with cyanide for the reef aquarium hobby—an industry employing hundreds of thousands of people and worth tens of millions of dollars annually—does more than immobilize the target species. Many of these fish don't even make the initial journey from reef to wholesaler alive, while less desirable species are left crippled or dead on the reef.

Add to this poisoning (by cyanide from gold mine leakage as in Fiji, oil spills, sewage and industrial effluent, herbicide and pesticide run-off, and anti-foulant hull paints), suffocation (by silt runoff from logging, mining, land development, and overgrazing) and assault and battery (by drag nets, anchors, beach trash, ship grounding, and the blast fishing which is turning reefs in Indonesia and the Philippines into rubble piles), and the coral reefs of the world begin to look pretty resilient in the face of it all. But there's a more insidious threat bearing down. One whose manifold causes and effects reach far beyond the reefs themselves.

In June of 1989, marine biologist Randy Kosaki brought an *Acropora* specimen, a table coral, back to the Waikiki Aquarium from Johnston Atoll in the Pacific. One night, in a tank with a clear view of the sky, the colony spawned, releasing tiny pink packets of egg and sperm into the water. It was a remarkable occurrence for several reasons. For one, it had only been recognized one year earlier that corals mass spawn (when every member of a species on a reef releases all its eggs and sperm into the water at the same instant). For another, it happened at exactly the same moment that the coral's relatives on Johnston Atoll spawned. But perhaps most remarkable is the fact that the spawning event was cued not by some signal from other corals in the tank, or by water chemistry or day length, but by the moon.

In much the way certain bamboo species flower at the same instant no matter where they are planted in relation to each other on the planet, corals mass spawn in brief synchronized periods lasting minutes—usually just one night a year. Corals of all ages and origins are triggered at the same instant to release billions of pink egg and sperm packets, making the coral heads seem to smoke as the entire reef is engulfed in a blizzard of sperm and eggs. The fertilized eggs develop into larvae, which are dispersed by the currents in search of a clean surface to call home. This journey can be brief or very long, depending on the coral species, but one thing is certain: If for any reason the corals miss this night, there is no second chance. Not for an entire year.

Hoping to capture this marvelous event on film, Howard and his team waited underwater from just after sunset until midnight for seven long nights. The predicted window of yearly opportunity opened and closed, but the Fijian corals skipped the mass spawn. No smoking reef. No pink blizzard. No polyps born to start new colonies where others had died. This was no small failure. Howard had a hunch it might have something to do with a meteorological event of global proportions.

In his famous account of the five-year circumglobal voyage of the *Beagle*, Charles Darwin pauses to digress while relating a day he spent wading around a reef on Keeling Island in the Indian Ocean: "Near the head of the lagoon, I was much surprised to find a wide area, considerably more than a mile square, covered with a forest of delicately branching corals, which, though standing upright, were all dead and rotten." In what may well be the first written expression of concern for mass coral death, Darwin goes on to surmise that a shift of wind and tidal action had hampered the inflow of fresh sea water and caused a "no doubt very small" drop in the level of water

Of the many things that can damage and kill a reef, the list of natural culprits is short: coral disease, violent storms, Crown-of-thorns starfish. The list of human harms, however, is long.

INDICATOR SPECIES

From overfishing and curio collection to pollution, coastal development and global warming, the growing rate and planetary scale of human activity has begun to take an alarming toll on reef health. In response to the evident decline in reef communities worldwide, international organizations have taken on the task of measuring the health of these ecosystems through surveys focusing on a number of indicator species. Chartered in 1996, Reef Check, a volunteer, community-based, monitoring agency, was the first group to embark on reef surveys on an international level. Below are some animals of the twenty-four organisms Reef Check has selected to serve as indicators of specific types of anthropogenic impacts and to assess improvement or decline of reef health over time.

GROUPER of any species with a length greater than 30 cm were selected to serve as an indicator for overfishing of all types. Grouper are some of the easiest fish for divers to spear because of their size and territorial habits and because they aggregate during spawning, making them vulnerable to various forms of fishing. Reef Check results indicate grouper have been depleted from most unprotected shallow reefs throughout the world.

The globally distributed BANDED CORAL SHRIMP was chosen as an indicator of overcollecting for the aquarium trade. This crustacean is collected in both the Atlantic and the Pacific Oceans, and currently sells in United States pet shops for about U.S. $20 a pair. Because the banded coral shrimp hides in cracks and holes under rocks, aquarium collectors overturn large coral heads to locate them, disrupting a vital habitat.

The CROWN-OF-THORNS STARFISH (COTS) was chosen as a regional indicator for the Indo-Pacific because this coral predator causes catastrophic damage to reefs during high-population years. Some scientists believe COTS population explosions are linked to human activities such as poor land use practices that result in increased runoff, facilitating unnaturally high survival rates of COTS larvae, as well as over-harvesting of the triton, a major predator of COTS. On the Great Barrier Reef, it is estimated that 10,000 tritons were collected each year until the 1960s when they became rare.

PARROTFISH were selected as another indicator of overfishing. The eighty-odd species of parrotfish play a critical role in the ecological balance of a coral reef because they are the largest herbivorous reef fish. They scrape large quantities of turf algae from the reef, ingesting mainly dead coral skeleton, and creating coral sand in the process. Without parrotfish and other grazers, algae in high-nutrient waters would overwhelm the clean surfaces of rocks and dead corals that juvenile coral polyps need to settle on and grow when starting new colonies (known as recruitment), hindering reef growth.

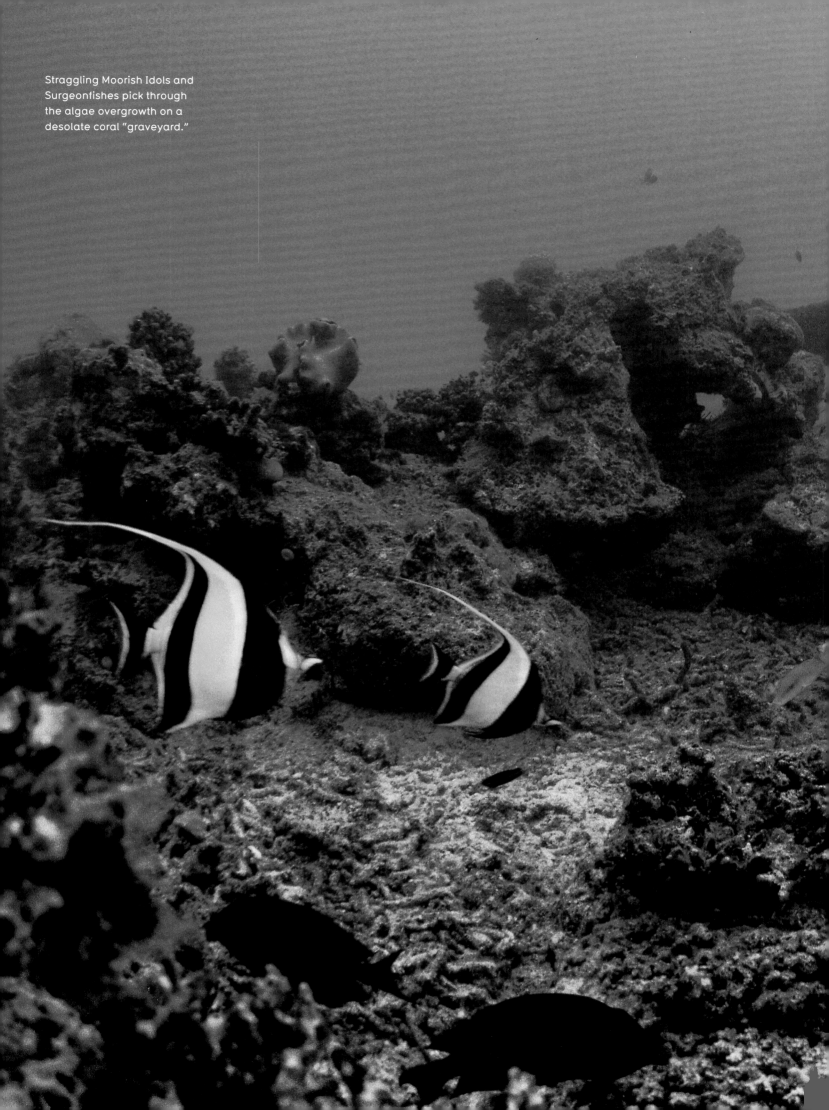

Straggling Moorish Idols and Surgeonfishes pick through the algae overgrowth on a desolate coral "graveyard."

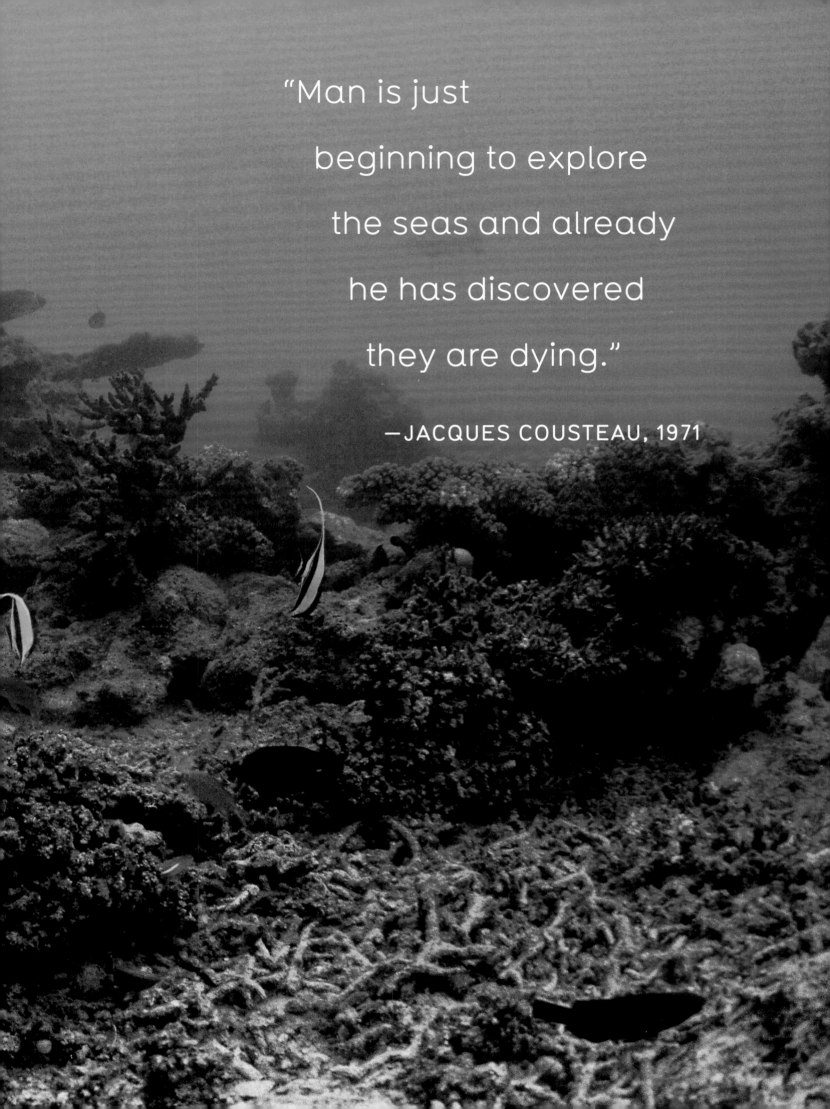

"Man is just
beginning to explore
the seas and already
he has discovered
they are dying."

—JACQUES COUSTEAU, 1971

in the lagoon which must have killed the corals. At the time, coral studies were in their infancy, but we now know from observing the vast coral fields of the Great Barrier Reef which are frequently left high, dry, and hardly dead by spring tides, that a minuscule drop in water level was not likely the cause of death. Yet, as anyone who has stepped into the shallow end of a pond on a sunny day knows, under the right weather conditions Darwin's unstirred lagoon waters could have easily heated to unusually high temperatures. Had the young naturalist employed a thermometer that day, he might have been the first person to collect hard evidence of the crippling malaise known today as "coral bleaching."

When many coral species bake under bright sunlight in shallow sea water whose temperature has risen above 30 degrees Centigrade, the symbiotic association between the coral polyps and their helpful zooxanthellae turns sour. Just as our bodies cultivate helpful populations of bacterial flora in our digestive tracts, coral polyps farm zooxanthellae in their own tissues. But when ocean temperatures stay above the 30-degree threshold for an extended period of time, zooxanthellae stop converting sunlight into nutritional sugars and polyps vomit them out like poison, rendering the otherwise transparent coral polyp and its calcium home as white as sun-bleached bone.

The Nawaikamans, who had recently seen it, wondered: "Does this bleaching kill coral?" Not usually. Not by itself. But it does seriously weaken the corals by removing their main source of energy, surrendering them to starvation and opportunistic infections, which can, and too often do, finish them off. Did a bleaching event during the past year cause the corals to skip the spawn? Howard couldn't say for certain, but given the fact that a weakened coral colony must make a biological either/or choice, between spending what energy it may have left to stay alive or to reproduce, it did seem likely. Since for any organism survival comes first, corals severely weakened by bleaching can hardly do more than survive. Thus they are rendered barren and non-constructive. And so the reef ceases to repair itself and grow when bleaching deals the corals a two-fisted blow.

Bleaching has probably always happened to some degree. In some situations, bleaching may be viewed as an adaptive feature that allows each partner in the symbiosis to survive the stress on its own. Then, when conditions improve, the partners may reunite, or even recombine with other partners in new evolving relationships. The problem is that bleaching is now occurring on a global scale and with increasing frequency. In Fiji, Howard saw his Ten-Year Rule accelerated at a frightening rate because of a bleaching event that had happened a year earlier. In 1998, the natural world quietly experienced an unparalleled catastrophe when a killer aquatic heat wave swept through reefs in the Maldives, Sri Lanka, East Africa, Fiji, the Persian Gulf, the Red Sea, Indonesia, the Philippines, Vietnam, Palau, Okinawa, Taiwan, most of southeast Asia,

FROM LEFT TO RIGHT When high sea water temperatures force the zooxanthellae to leave their host, the coral colony "bleaches" white as the skeleton becomes visible through the transparent coral tissues.

Millions of packets of egg and sperm are released during coral mass spawning.

The Crown-of-thorns starfish is the only major predator of coral polyps. Its toxic spines can inflict disabling wounds to divers.

A whole year's labor: close-up of brain coral polyp releasing the egg-sperm bundle.

Weakened by heavy siltation, the corals on this dying reef will never spawn again.

A close-up of Staghorn coral polyps (Acropora sp.) Palau Islands, Micronesia, Pacific Ocean.

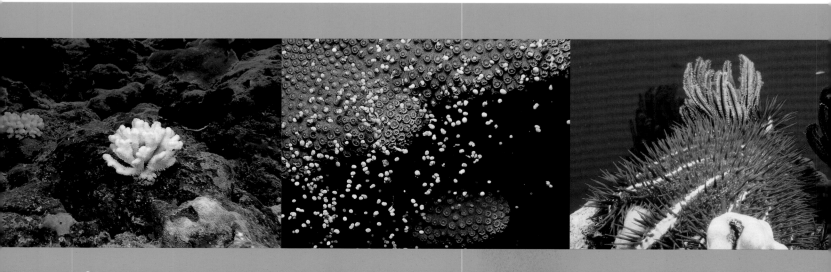

the Galapagos Islands and Costa Rica, the Bahamas, Florida, Cayman Islands, and Belize. In all, the reefs of over sixty countries experienced bleaching. In three months, 10 percent of the world's corals bleached and then died. In fact, more corals died that year than had "died from all other human causes to date," according to Thomas Goreau, president of Global Coral Reef Alliance. But why, after hundreds of thousands of years of success in the tropics, were corals now succumbing to heat stroke on such a scale? What had changed?

In keeping with ancient hydrological tradition off the coast of South America, the phenomenon called upwelling returns cold water to the ocean's surface where it is dispersed by currents. But every so often, the forces that drive the upwelling process stop and the upwelling does not happen. Then, an area of the equatorial Pacific nearly twice the size of North America heats to as much as ten degrees above normal. Known as El Niño, this patch of warm surface water is associated with changes in atmospheric pressure that knock the jet stream off its normal course, throwing weather around the globe into unpredictable chaos. Causing unusual droughts in some regions and atypical rainfalls in otherwise arid climes, El Niño also turns ordinarily well-mixed tidal waters stagnant as prevailing winds stall, creating the sort of placid water conditions that heat the waters and cause bleaching. El Niño events used to occur roughly every four to twelve years, but their frequency has increased steadily

over the last century and a half; now they happen about every 2.5 years. Their surface water temperatures are getting hotter. So lately, just as corals recover from one bleaching episode, they get hit with another. And it could be, at least partly, our fault.

Generally, Earth's climate has been in a warming trend for the last 10,000 years since the end of the last ice age, with the last period of dramatic warming, occurring roughly 2,000 years ago. That sultry epoch culminated roughly a thousand years ago with the Greenland coast densely forested and warmth-loving palm trees and grapevines thriving in parts of England where they cannot today. It ended with exactly the kind of sudden cooling period— a meteorological hiccup—that glacial and geological records tell us typically punctuate such long-term warming trends. Half a century ago, Rachel Carson examined the big-picture trends in her chapter "The Global Thermostat" in *The Sea Around Us*, drawing a conclusion which has yet to be dispelled: "It is almost certainly true that we are still in the warming-up stage following the last Pleistocene glaciation—that the world's climate, over the next thousands of years, will grow considerably warmer before beginning another downward swing into another Ice Age." In brief: "The long trend is toward a warmer Earth."

Increasingly though, scientists, politicians, and the media are using the phrase "global warming" to describe the acceleration of this warming trend, suspecting that it is caused in large part by the release of

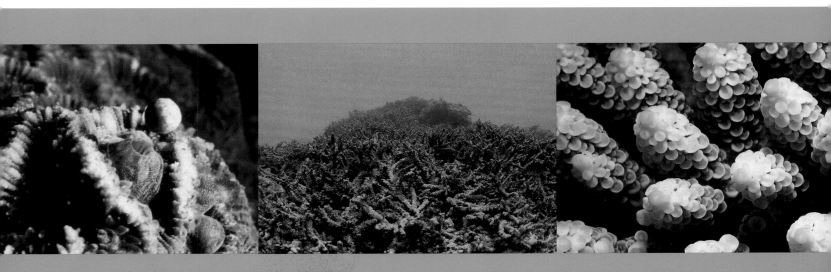

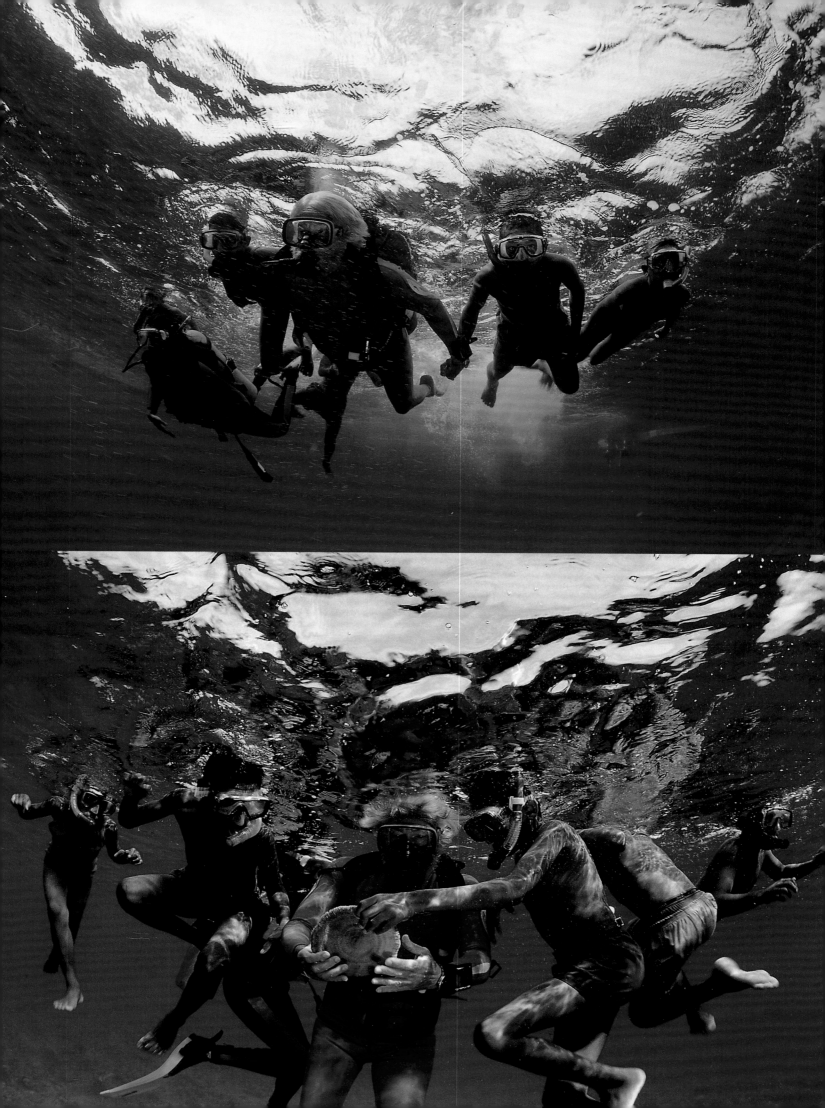

greenhouse gases such as carbon dioxide into the atmosphere through the burning of carbon-based fossil fuels and wood. And indeed, there is mounting evidence that this, along with deforestation and urbanization, may be contributing to the problem. Yet meteorologists have not reached the consensus about the cause that the media apparently has. For one thing, our climatological and hydrological records are short and full of gaps. At the moment, because we are just beginning to grasp the complex interconnectedness of our water, earth, air, and biotic systems, we cannot even hindcast global weather on a large time scale. With even near-term global forecasting, still in its infancy, how can we discern what is human-caused from the rhythms of nature in the grand scheme?

The fastest computer in the world, the NEC Earth Simulator, was built in 2002, not to analyze the stock market or to play out nuclear war game scenarios, but to analyze global climate change. Over the next six years NASA's newly launched $952 million AQUA satellite will try to answer many of our questions concerning the water cycle of this planet. It is clear we aren't even close to understanding the Earth as a whole, but we are learning. In the meantime, if our industrial activities are significantly contributing to this warming and bleaching, then the people of Fiji and other reef-reliant tropical nations are our victims, as are the reefs they depend on. Unfortunately, the time we take to resolve the debate may ensure that it is already too late for some reefs. Some reef communities may be lost forever, others not replaced for many human lifetimes. Yet some among us are optimistic.

Like his late father, the great ocean explorer Jacques Cousteau, Jean-Michel loves the sea. A diver since his boyhood in the early 1950s, he has seen Howard's Ten-Year Rule cycled many times over. As an ocean advocate, his life mission is to instill in as many people as possible with a sense of personal responsibility, not just for the future of the seas but for the entire global water system (which is, according to the most recent United Nations environmental report, degrading rapidly). As owner of an eco-aware dive resort in Fiji, he regularly takes a personal role in helping Fijians educate their young about the treasures that lie, quite literally, in their own back yards. This is why he has come to Nawaikama. "Simple public awareness is the greatest instrument of change," Cousteau says. "The ocean's greatest resources are the children of today." And if there is one thing the jolly sixty-two-year-old Frenchman has a knack for, it's relating to children.

With a rallying cry of "Let's all go for a swim!" Jean-Michel led a dozen eight- to twelve-year-old village children into the launch that motored them singing past a luminous green colony of *Turbinaria* corals, locally known as the Cabbage Patch, toward a calm spot just outside Nigali Passage on the barrier reef protecting Nawaikama Bay. They jumped in wearing goggles and masks he'd lent them, and dog-paddled happily behind their aquatic pied piper as he and Rusi pointed out features in the reef. Occasionally, an intrepid spirit dove down three or four feet for a better look at the reef, then popped up to the surface with a big wet grin. Jean-Michel's point was to show the children that there is always more to a reef than at first meets the eye. Until he pointed them out, the children didn't see the well-camouflaged stonefish, or notice that the unflinching yellow damselfish was protecting its fry. But they did see the clown fish nestled among its toxic host anemone's tentacles. They did see sharks, and they were not afraid. All the while Howard (below) and Greg (above) did their best to capture the moment on film while trying to stay out of enlightenment's way.

There were other lessons Jean-Michel could have taught them that day, but this was an introduction to the reef after all, the beginning of the understanding that once a resource like a reef is dead, it is gone forever. That's why sustainable non-depletive reef management makes sense for the

TOP AND BOTTOM Jean-Michel Cousteau leads a group of Fijian school children on an underwater expedition.

Careful not to touch what is living, Jean-Michel uses the dead skeleton of a mushroom coral as a teaching aid.

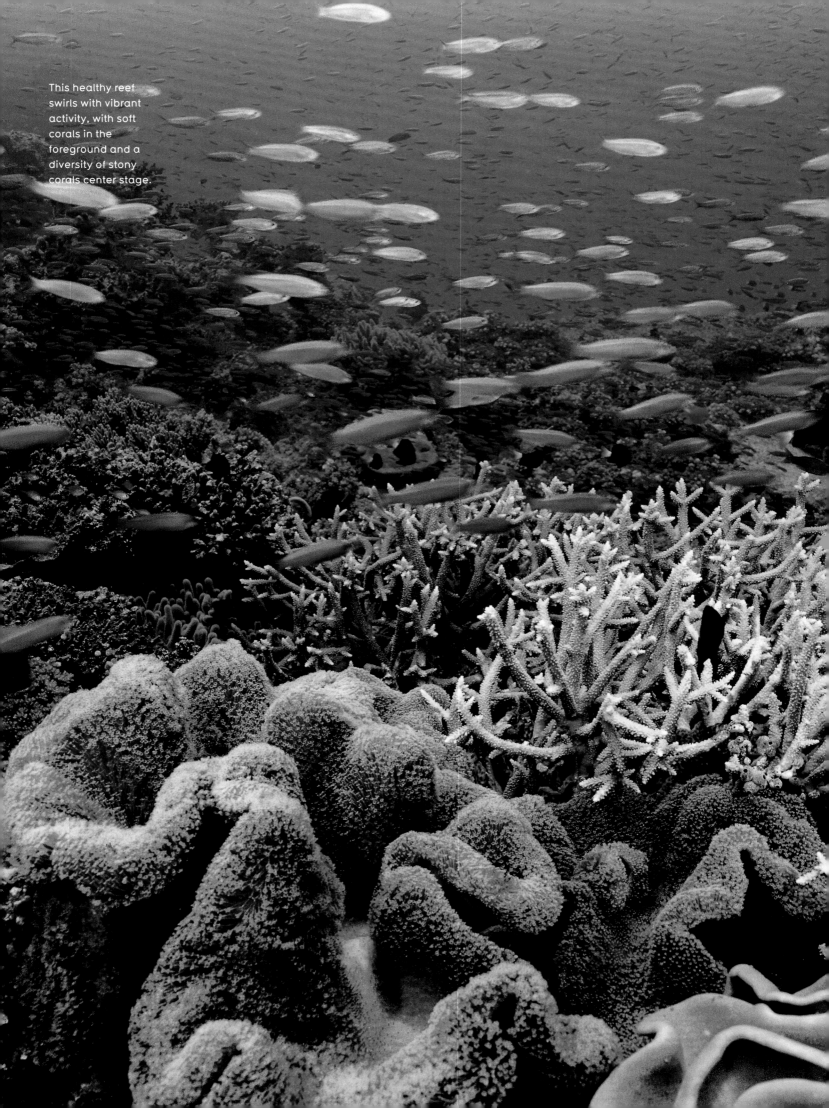

This healthy reef swirls with vibrant activity, with soft corals in the foreground and a diversity of stony corals center stage.

underwater Meccas coral reefs have become to the hundreds of thousands of people who visit them to dive, surf, and snorkel and leave them mainly untouched each year. While it's true that whole reef-dependent human populations (like those found on isolated islands) would starve to death if they weren't allowed to harvest a portion of their food from the reefs, these same communities would benefit by preserving select parts of their reef from depletive exploitation of any kind, including fishing. In the same way that impoverished farm soil is conserved and improved when hedgerow is allowed to grow wild around it, all reefs could be improved with designated areas of limited use. If the children of Fiji and elsewhere learned that reefs aren't just giant food and mineral lockers to extract from, but are better envisioned as grand outdoor entertainment systems (like national parks and wilderness preserves), which with careful management and select low-impact activity could generate local income at little expense to the environment, then that would be a start. Such is Jean-Michel's hope anyway.

Rusi—and now Howard and Michele—knew that not far from the healthy corals below the frolicking children, part of the reef was being pummeled to rubble under the fist of compound insults. But that didn't mean these children should grow up as pessimists. The good news is twofold: left alone, reefs can recover; given help, they can recover even faster. That is where a burgeoning number of governmental and non-profit organizations are stepping in to spread information, collect data, and provide reef management education to help the reefs do just that: recover. One such group, Reef Check (a reef monitoring, management, and clean-up organization based at the Institute of the Environment at the University of California at Los Angeles and composed of a growing army of volunteers worldwide), has found in its first five years of monitoring reefs around the world that if a reef is simply left alone it can recover from

many kinds of human-caused damage in a very short time. This has been the case for one recently protected area of Gilutongan, in the Philippines, where blast fishing with dynamite was the rule before Reef Check volunteers offered local fishermen the financial aid and training in monitoring techniques they needed to see how they were hurting the reef and, in turn, themselves. After two short years, the locals wisely chose to set up a marine park, and the reef took a dramatic turn for the better. The reefs of St. Lucia, in the Caribbean, where overfishing and disease had taken a seemingly irreversible toll, are another success story. If there was one overall lesson Jean-Michel wanted to impart to the children that day, it was to find the joy in learning as much as possible about the reefs, and then to find ways to act on their behalf. [For information on joining Reef Check and other helpful organizations, turn to the appendix in the back of this book.] After all, only the informed and proactive earn their optimism.

The light was perfect, the water calm, the children as natural as, well, children. So it didn't take Howard long to get the underwater shots. But once he was done filming, the children continued to frolic with Jean-Michel, Rusi, Michele, and the rest of the filmmakers, who had by now jumped in and joined the fun. That's when Howard took the opportunity to steal quietly down to a sandy patch on the reef's rubble zone just to watch the playful antics of the newest species on the reef—human beings—not as a cameraman, but as an observer of aquatic behavior. Since play is generally infectious, it wasn't long before he, too, found a way to join in. Lying on his back in forty feet of water, Howard removed his regulator and, with what looked like a big goofy grin, suddenly opened his mouth to belch a small donut-shaped bubble ring, one that expanded as it slowly drifted up, rotating and glistening, until it attained the size of a rather large pizza.

Once cinematographer Brad Ohlund spied the bubble ring and boyishly dove

through its center, it wasn't long until one village boy and girl after another was slipping through rings while Howard lay on the bottom, contentedly blowing them and confirming something his friends like to say: "He is just more comfortable in the water than out of it." The children took turns threading rings until the sun angled down and the last one shattered into mercurial bits. Then the launches were boarded, and the happy singing children returned to the docks where their families eagerly waited to hear all about their big day with the filmmakers out on the reef.

The next afternoon, while Greg and his crew filmed Jean-Michel talking about reef conservation to the first-through fourth-grade classes at the Nawaikama Elementary School, Howard captured Rusi finding and examining one of the numerous Crown-of-thorns starfish that had caused some of the reef damage. Then he filmed as Rusi found a banded sea snake, the venomous, black-and-white kind Fijians consider an auspicious sign. Though sea snakes are deadly relatives of cobras, they very rarely bite humans and possess fangs too short to penetrate neoprene gloves easily—a fact Michele appreciated as she gingerly stroked the undulant serpent before it continued on its way, spiraling like a barber pole to the surface for air.

That evening, everyone returned to the *Undersea Hunter*, to bathe and wrap their hips once again in sulus. The week had come to an end. It was time to go formally ashore.

In the village, a lavish *masiti* (feast) had been laid out on a plank table. There was

green taro leaf stewed in coconut milk, the baked purplish tubers of the taro root, and the long white ones of cassava. There were fried bananas and sweet pineapple and crispy fried grouper and snapper from the reef. There was the smoky shredded pork of a pig that had been specially slaughtered for the occasion and slow-baked in a lovo pit lined with heated stones and fired by driftwood and coconut husks. In the air was the festive tang of a birthday party as—for the first time since the welcoming sevusevu one week earlier—the Nawaikamans and the American filmmakers gathered together at the chief's home.

The expedition members were given chairs of honor at the plank table. Then the children who had gone out to the reef the day before were called to sit among them as the village men and women served the filmmakers and children before sitting down to join the feast themselves.

Pausing halfway through a second helping of succulent Strawberry cod, Brad Ohlund turned appreciatively to Chief Ratu Marika who sat next to him at the table. "It's nice that the children could join us," he said.

But something about Brad's comment perplexed the chief, who responded with a slightly corrective tone: "This is their feast. It's going to the reef." He finished with a knowing smile: "They are not quite children anymore."

Brad watched some of the children spinning tops improvised from palm nuts and bamboo splinters. He wasn't sure exactly what the chief had meant. But he guessed that once everyone had sated themselves with the bounty, he and the rest of the filmmakers would probably find out.

Once the feasting was finished, everyone drifted toward the meeting hall where the sevusevu of parting would be performed. Near the entrance, a man stood cradling a whelk-like shell the size of a football in his hands. It was a Triton trumpet, one of the few known predators of the Crown-of-thorns starfish. Raising the shell high as if to drink, he pursed his lips and blew. A melancholy hoot slid into the dark overhead. Three

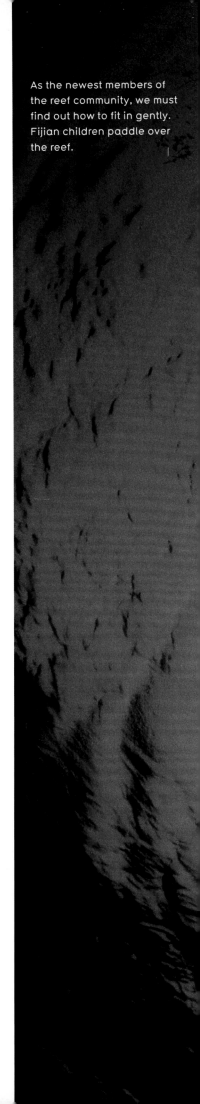

As the newest members of the reef community, we must find out how to fit in gently. Fijian children paddle over the reef.

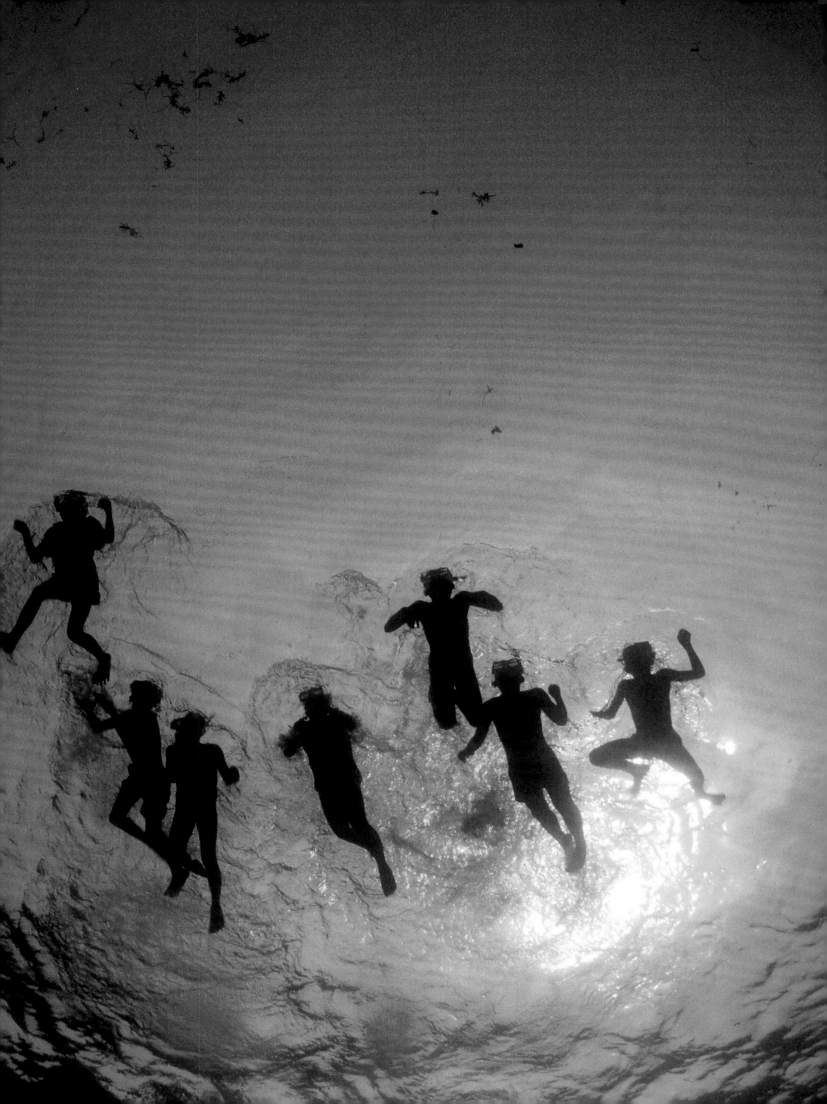

MARINE PROTECTED AREAS
by Jean-Michel Cousteau

In May 2000, President Bill Clinton signed Executive Order 13158, which defines Marine Protected Areas (MPAs) as "any area of the marine environment that has been reserved by Federal, State, territorial, tribal, or local laws or regulations to provide lasting protection for part or all of the natural and cultural resources therein." This order strengthened U.S. participation in a worldwide movement to designate certain areas as "off-limits" to development.

In my lifetime, I have been privileged to visit some of the world's most magical and treasured coral reefs. But over time, I have seen most of them depleted. Marine life is under enormous pressure. Overfishing, bycatch, and habitat loss are eroding both the diversity and productivity of the sea. Already, three quarters of the world's fishing grounds are exploited to the max or beyond. And projections for the future are not good. The basic idea of the MPA is that an area set aside from misuses today will contribute to biodiversity and prosperity tomorrow.

MPAs come in many types, shapes, and sizes, from tiny no-access reserves and national parks to fishery management areas and marine sanctuaries where fishing is permitted with limited gear types.

Recent surveys from around the world show that MPAs can work, and they work in a hurry. One study, conducted by the National Center for Ecological Analysis at the University of California, Santa Barbara, found that in just two years, population density in reserves increased by 91 percent, species diversity by 23 percent, and biomass by a whopping 192 percent. A new report, by Benjamin Halpern of that same institution, demonstrates that establishing a marine reserve doubles the density of life, triples the biomass, and boosts the size and diversity of reserve residents by 20 to 30 percent.

MPAs also benefit fishermen,

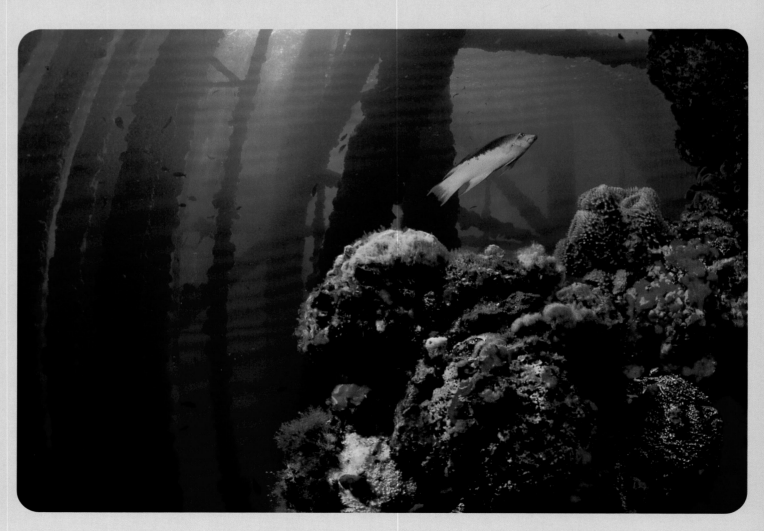

allowing commercially important fish a place to spawn and grow to maturity. According to the U.S. National Oceanic and Atmospheric Administration (NOAA), the density of fishery species increases in 69 percent of MPAs, body size in 88 percent, and biomass in 92 percent. Despite the promise of marine reserves, it will take more than a presidential signature to assure their success—some 80 percent of all MPAs fall short of their potentials. Why is this? According to Mark Tupper of the University of Guam, many reserves suffer from a lack of funding and know-how. Further, many MPAs are not located in the right place, or protect only part of an ecosystem. Nearby development may pollute the protected zone, or local law enforcement may not be able to protect the MPA from poaching.

Then there is the human part of the equation. An MPA can have far-reaching social and economic impacts. In places like Florida, where tourism may account for over half of the local income, a reserve might be welcomed. In the Philippines or Indonesia, however, where thousands of villages subsist by heavily exploiting the reef for the food fish and aquarium trade, MPAs are a tough sell.

But environmental groups, such as Reef Check (www.reefcheck.org) and the International Marinelife Alliance (www.imamarine.org), have launched programs to empower locals not just to quit destructive fishing practices, but to treat healthy reefs as key to their own future prosperity. As IMA has discovered, success can be as simple as teaching people how to fish with a hand net rather than a stick of dynamite.

Around the Philippine islands of Cebu, for example, reefs have been jeopardized by blast and poison fishing. After conducting a Reef Check survey, the community became aware of the seriousness of the situation. With help from local organizations, the private sector, and government agencies, they established a marine-protected area at Gilutongan Island. Two years later, thousands of fish have returned to Gilutongan Reef. The repopulation of this damaged reef has brought life and income back to the region. By charging a limited number of divers a small visitor's fee, the MPA raised over $20,000 in 2001, a significant source of income for the community.

A coral reef is also a community, with every species playing a role. As in a human city, a coral reef has its builders, cleaners, recyclers, bodyguards, and pharmacists. When one species is removed from this wondrous matrix, the entire structure is weakened. The ancients understood this principle. The Polynesians issued taboos—decrees that restricted fishing in certain areas. Today we know that these areas were often undersea nurseries for species on which the Polynesians depended. The same wisdom—reverence for the environment mixed with common-sense conservation—is alive today in the movement for MPAs.

For me, the key to success is education. When people understand a reef's true value and the impact of our actions on it, a new way of seeing emerges and a community can be transformed. In the Cayman Islands, it's now accepted that Freddie the Grouper and Molly the Manta are worth more to the community as a tourist attraction than as somebody's dinner.

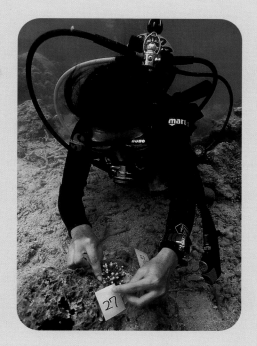

ABOVE A student conservationist "seeds" the coral reef by cementing small coral colonies on bare spots of the reef. Mabul Marine Day, Mabul Island.

LEFT Even a decommissioned off-shore oil rig can become a protected reef sanctuary with legislation. Flower Garden Banks, Gulf of Mexico.

Healthy ecosystems such as those preserved in MPAs are wonderful places to teach the generation of tomorrow about the web of life. Every summer for over twenty-five years, I have led groups of mostly young divers, exploring reefs from Papua New Guinea to the British Virgin Islands to Fiji. They are always overwhelmed by the unexpected beauty of the underwater world, and at the same time, they are both amazed at its fragility and concerned for its future. I am always deeply moved to see them want to protect the sites they have just dived. For it is true, as my late father once said to me, that people protect what they love.

times his breath passed through the empty home of that mollusk. Three times the plangent notes oozed into the night. Then everyone filed quietly inside.

In the hall, seated on the pandanus mats, the chief addressed the filmmakers as the jubilant children passed among them, placing fragrant *salusalus* (leis) around their necks. "*Vinaka* (thank you) for coming to Nawaikama," he boomed. "Vinaka for caring about our reefs. Vinaka for taking the children for their first visit to the reef and helping them be children no more."

According to tradition, when an adolescent Nawaikaman child swims the waters of the protective barrier reef, he or she leaves the realm of childhood and returns to the village a young adult. Unwittingly, the filmmakers had provided a dozen Fijian girls and boys the means to their rites of passage. They had changed twelve young lives, if not an entire village. This wonderful last-minute revelation lent added pathos to the festivities as the celebrating villagers sang and drummed their *lalis* and clapped

their hands to the ancient rhythms for the filmmakers one last time. After, the parting filmmakers passed out candy, clothing, and the donation to the schools with sincere gratitude between the departing filmmakers and their new island friends. Then, once the villager's concluded one final song—the solemn *Isa Lei*, or Fijian song of farewell—the launches were boarded and everyone waved goodbye.

Phosphorescent blue smears trailed in their wakes as the filmmakers skimmed slowly out to the dive boats anchored in the bay; but it wasn't until the motors were cut and they were standing on the main deck of *Undersea Hunter*, gazing across the water for one last look at the flickering lights of the village, that Greg, Howard, and Michele could hear it. They weren't even sure that they heard it at first first. But then, there it was—the Triton trumpet tolling mournful and sweet. Goodbye, it seemed to lament. Goodbye to childhood. Goodbye to friends. Goodbye to the reefs that are gone.

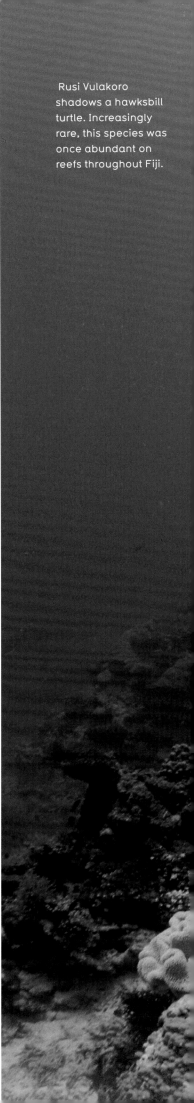

Rusi Vulakoro shadows a hawksbill turtle. Increasingly rare, this species was once abundant on reefs throughout Fiji.

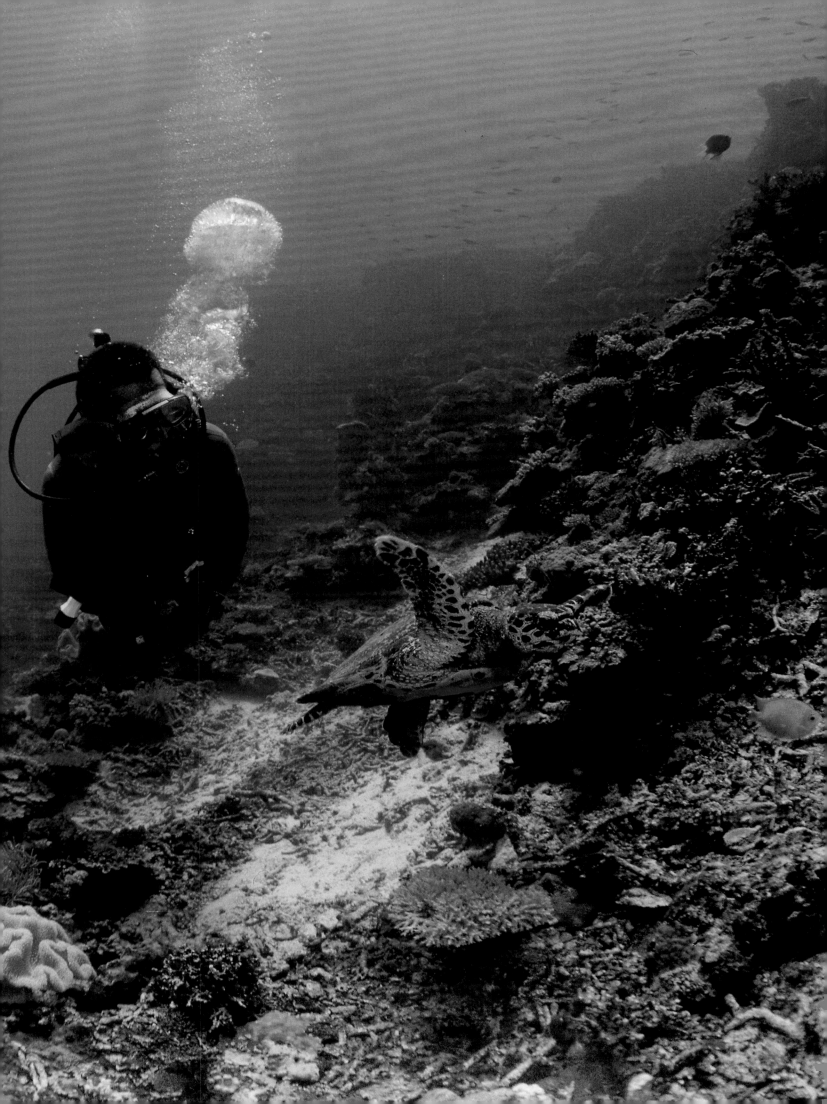

A reflective moment on the bow of *Undersea Hunter*. Michele and Howard are concerned that the sun is setting on reef species worldwide.

Space-walking aquanauts
on EVA. Howard and his
deep dive team leave the
support skiff to descend into
the "Twilight Zone," that
deep reef realm where
light fades to nil.

Strange life forms, half
real and half nightmare,
surrounded us as we sank
down into the world of
dreams, and a multitude
of sea fans like ostrich
plumes caressed my face
as I passed. By then, we
were about two hundred
fifty feet beneath the
surface, and I could see,
stretching temptingly
below me, as far as my
eyes could reach, what
seemed the infinite
sweetness and quiet of a
blackness that would yield
up the secrets of the
universe if only I were
to go a bit deeper....

–JACQUES COUSTEAU
Life and Death in A Coral Sea

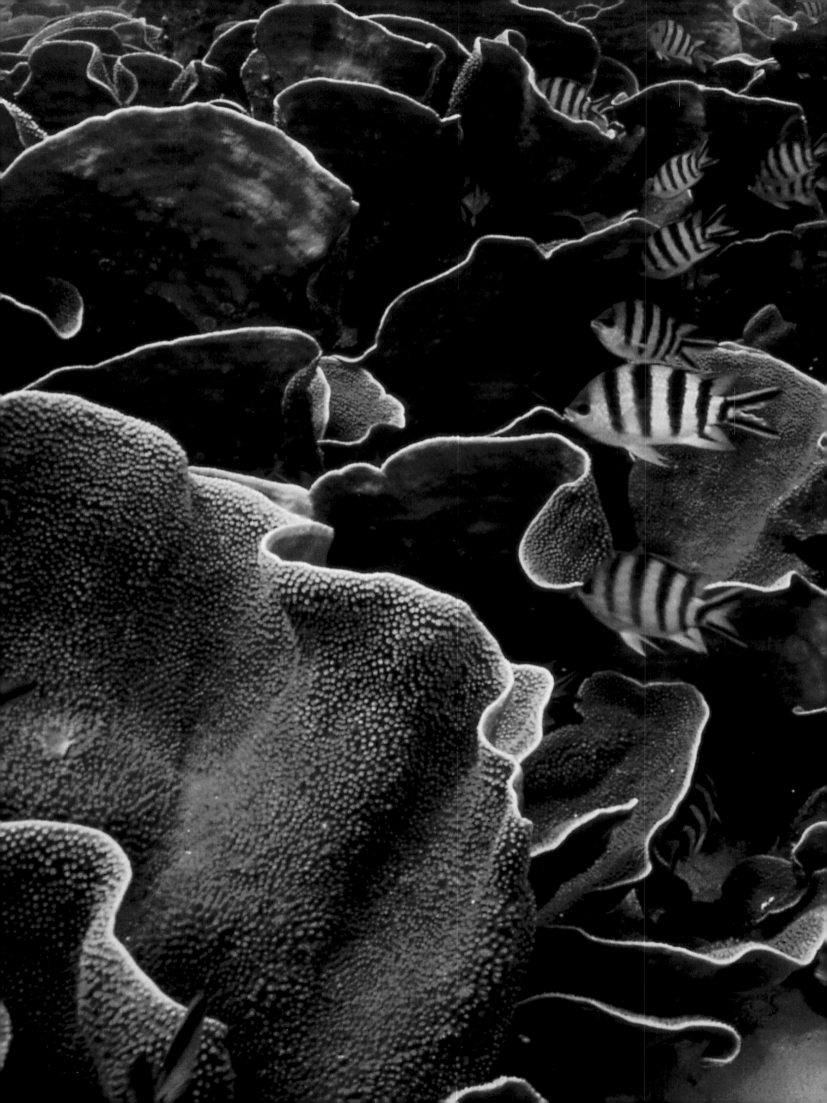

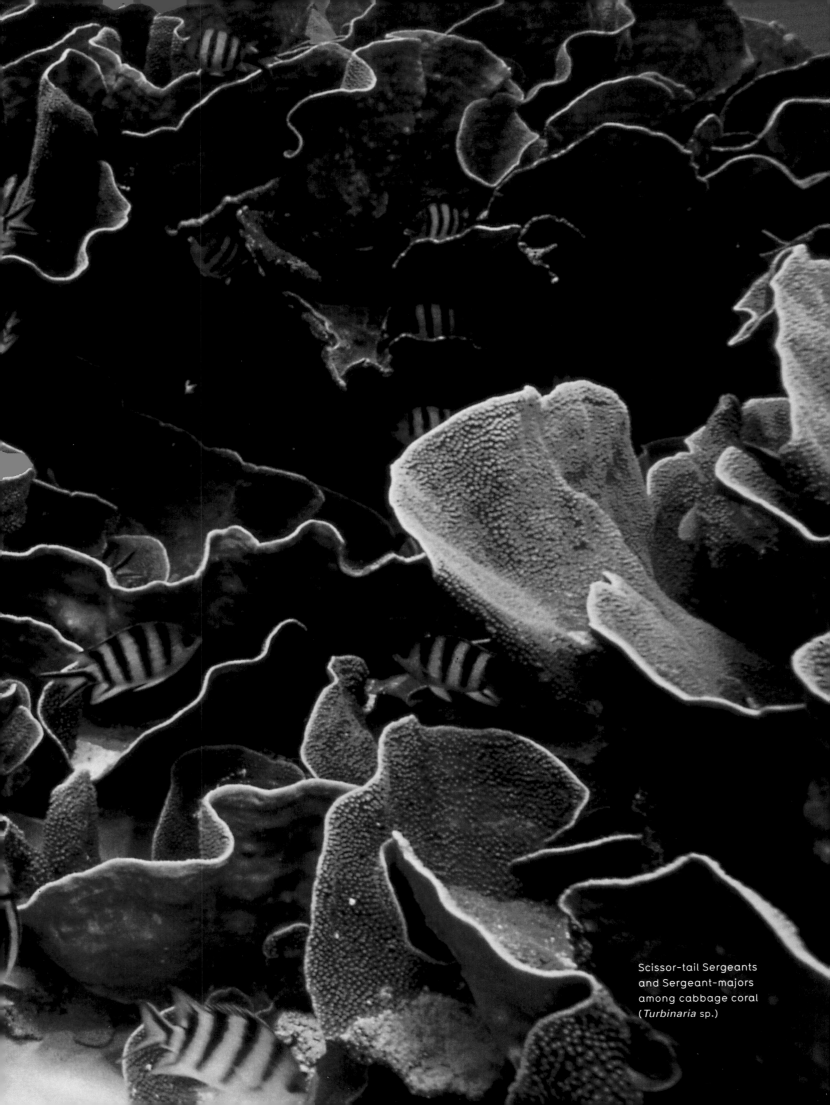

Scissor-tail Sergeants
and Sergeant-majors
among cabbage coral
(*Turbinaria* sp.)

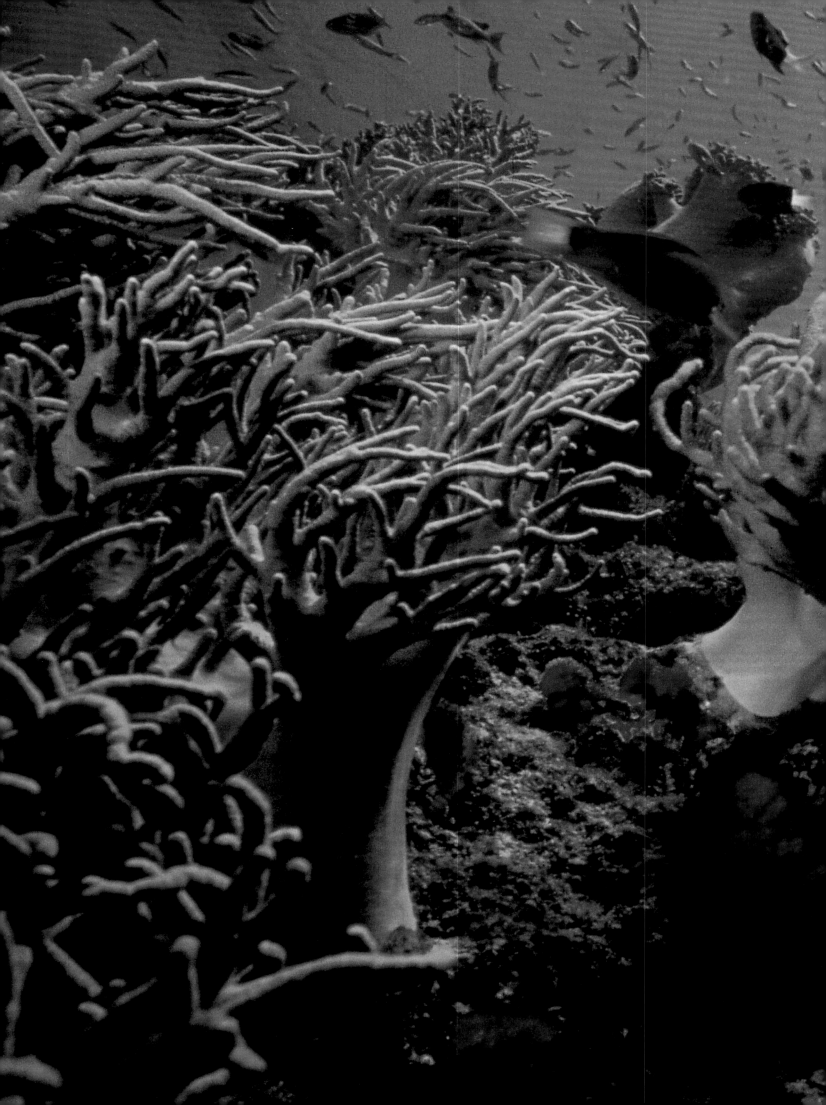

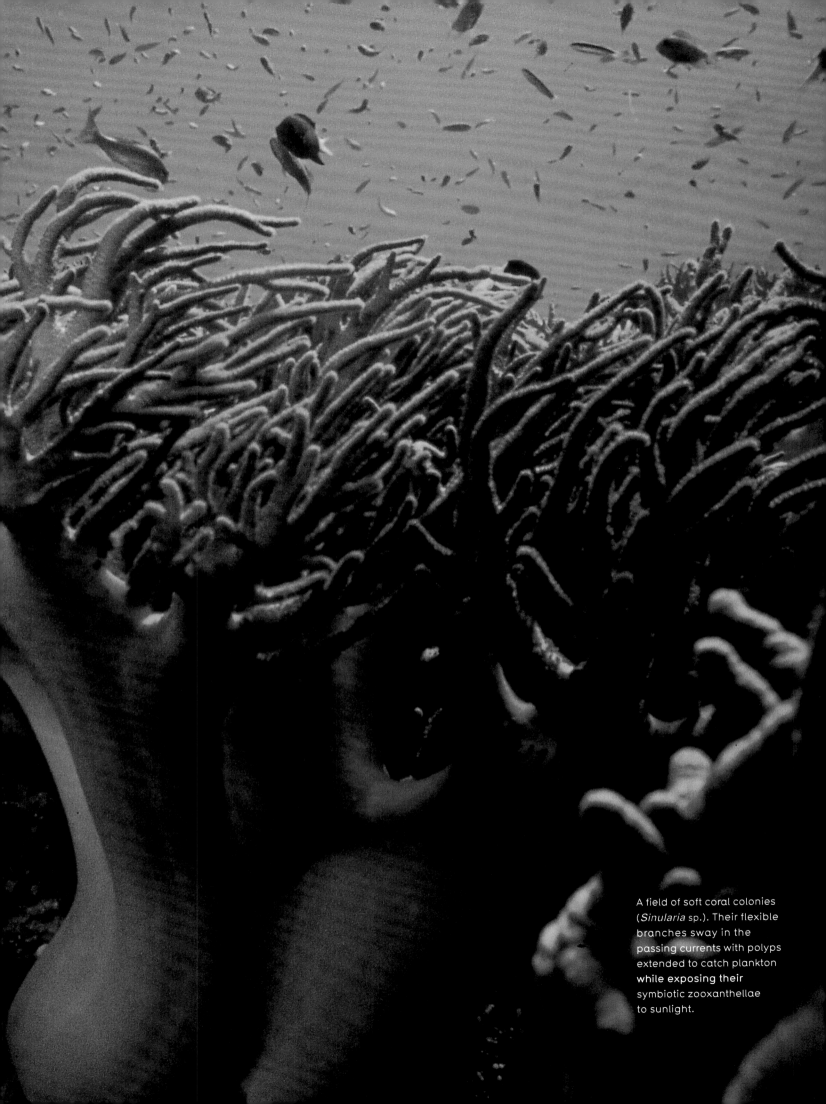

A field of soft coral colonies (*Sinularia* sp.). Their flexible branches sway in the passing currents with polyps extended to catch plankton **while exposing their** symbiotic zooxanthellae to sunlight.

Rising more than a mile and a half out of the abyss,

the steep, reef-crowned, volcanic pinnacle of Mt. Mutiny just breaks the surface of Fiji's Koro Sea at low tide. Only eighty miles from Gau, it seemed an ideal site for Howard and his deep diving teammates, Bob Cranston and Mark Thurlow, to test their equipment for the greatest challenge of the expedition: filming life forms never before seen by humans on areas of reef beyond the reach of recreational scuba.

To accomplish this feat, their underwater communications system and Howard's modified IMAX camera in its specially pressurized housing would have to function under crushing pressures encountered at depths of 350 feet and more. Would the housing remain watertight? Would the dense pressurized air pumped into the camera housing (to equalize pressure and keep it from collapsing) cause the heavy IMAX film to move too jerkily or too slowly through the camera mechanism? Would the lubricants and rubber seals and electrical connections be adversely affected? How much of the pressurized gas would

the camera batteries absorb? Enough to explode when they ascended? Such were the simple questions—the ones with yes or no answers and technical fixes—which would slow, but probably not stop, their filming progress.

Looming even larger were the questions with answers, or a lack thereof, that could have had far more serious consequences: Would the dive computers function correctly and keep the divers from being crippled or killed? Would their strict dive protocol see each member of the team down and back to the surface without incident? Was there enough back-up and redundancy built into the equipment to help them bail out if there was an accident? With questions like these, the endeavor might just as well have been a mission to the moon.

On the first test dive, things went smoothly except for one thing: The earphones of the underwater communications system were deformed by the intense pressures beyond 270 feet to render the simplest words an unintelligible mush and force the

LEFT Betty Almogy, an *Undersea Hunter* dive guide, at a cave mouth on the Vanua Levu Barrier Reef in Fiji.

ABOVE Like astronauts, deep divers rely on redundancy and checklists. Bob Cranston's breathing gas monitor shows that one of three oxygen sensors has just malfunctioned.

divers to rely on clumsy hand signals. On other test dives, momentary setbacks followed: Howard's camera strobe imploded with mind-stunning force; the light bulbs so necessary to filming shorted out; Howard's dive computer's fully charged battery suddenly drained itself dead; and the camera ground to an inexplicable stop. Again, all past the 270-foot mark.

"Something happens at 300 feet," says Howard. "That's the depth at which equipment just stops working. One little thing goes wrong, and it's four hours of decompression time for nothing." And that's just the camera equipment. After thirty years of submersion without a serious dive injury, Howard knew all too well that the little human errors have ways of compounding themselves for the diver. Yet despite the alarming incidents at Mt. Mutiny, by the third test dive, each member of his team had achieved a personal depth record and returned safely. Howard's was 373 feet. It was a dreamy trip into a realm of dim lambent light that was simply, as he put it, "the most exciting thing I had ever done." The next dive nearly cost him his life.

Beginning mid-morning, so the sun would be angled for maximum light penetration, the safety back-up team (Cat Holloway from the *Nai'a* and Peter Kragh of *Undersea Hunter*) descended first with the loaded IMAX camera. They stationed themselves at 150 feet according to protocol, exactly as they had the day before. Five minutes later, hauling spare "bail-out" tanks in case their sophisticated military prototype **rebreathers** malfunctioned, Howard, Bob, and Mark Thurlow descended, passing the neon purple clouds of schooling fairy basslets, the clown-faced malachite green parrotfish, and the day-glo yellow damselfish who call the reef's upper reaches their home.

Reaching the back-up team, Howard exchanged his spare tank for the camera and continued dropping down the wall. Passing the same yellow and pink soft corals, ghostly sea fans, and the bright orange anemone with the strange pompoms on its tentacles that he had passed the day before, Howard drifted through a forest of long spiral whip corals. Then, as the light thinned, he turned to gaze up, seeing everything—coral whips, sea fans, the mountain itself—drained of color but not definition in the extraordinarily clear water. "At 300 feet," says Howard, "the sheer wall gave way to a forty-five degree slope. Pure white sand covered the small spaces between corals and rocks. In the twilight, it looked like a bluish-white dusting of snow in the high desert on a night with a full moon. It was incredibly beautiful. I was mesmerized."

At 310 feet, just as Howard's earphone unsurprisingly malfunctioned, he noticed large shadows moving along the slope to his far left. Two big hammerheads approached along the slope with that imperturbable élan only sharks possess.

As they continued to cruise straight toward Howard, he turned, aimed, and began to unspool film, catching them silhouetted by the eerie auroral light until they veered off just ten feet shy of his lens. Fourteen minutes into the dive at 350 feet deep, the specially pressurized camera had worked flawlessly. Howard was pleased. It was time to start back up.

That's when Howard realized that, in his excitement to capture the sharks on film, he had forgotten to make a small but crucial adjustment to his oxygen flow on the way down. No big deal. He passed the camera to his dive buddy, Bob, and made the adjustment. Then went on to shoot "tracking" footage of Bob and Mark following him while he swam on his back at about 300 feet.

Lugging an object the shape and size of a sportscar engine is strenuous work at any depth. Backwards, it's even harder. And when that object has gained an unwanted five pounds above neutral buoyancy because of compression, it's harder still. Nonetheless, realizing the shot would be better if the divers were seen lower in the frame, Howard repositioned and did the shot again. With the three-minute film roll exposed, the

rebreather
A closed-circuit, mixed-gas breathing device composed of a breathing loop attached to a mouthpiece and a collapsable bag called a counterlung, with an absorbant that removes carbon dioxide, and a tank for replenishing oxygen

Whip coral, a soft coral, spirals off the wall at 340 feet. Mt. Mutiny, Fiji

AN ABBREVIATED HISTORY OF SELF-CONTAINED UNDER WATER TRAVEL

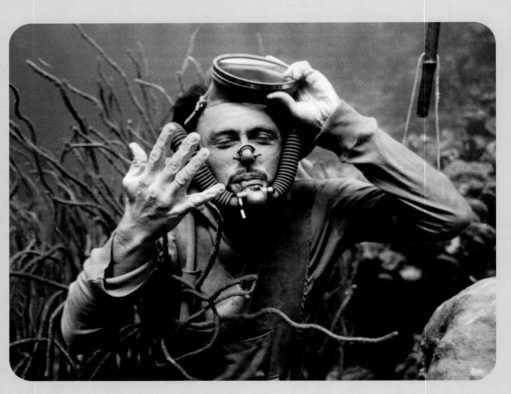

Hans Hass, inventor of horizonatal "swim diving," wears his homemade rebreather during filming of *Under The Caribbean*.

Just as there have always been those individuals who dreamed of breaking the bonds of gravity to fly, there have been those who dreamed of traveling underwater comfortably and unencumbered by restrictions of any kind. The first diver known to us by name is Scyllis, a Greek swimmer employed to salvage treasure from wrecked vessels by Persian king Xerxes, in 460 B.C. But Scyllis' salvage efforts were not his claim to fame. He earned his place in dive history by jumping ship and throwing the Persian navy into confusion by cutting their mooring lines while breathing through a hollow reed. But that was just snorkeling after all.

Twenty-three centuries later, in 1839, Augustus Siebe mated a rubberized canvas and leather suit with lead boots and a brass helmet to create the "diving dress" used by Queen Victoria's Royal Engineers to successfully salvage from the sunken warship Royal George. Connected to the surface by hoses, the device worked well, but the diver remained dependent on a man at the surface, pumping the bellows to deliver his air. If the pump man

stopped pumping while the diver was at depth, or a hose was cut, the diver would experience the most feared of diving disasters, "the squeeze," during which the suddenly escaping air sucked the flesh off his bones and jammed him into the helmet and hoses in a bloody pulp. For half a century the only way to explore the world beneath the surface of the sea for any length of time was to risk the squeeze in the helmeted, lead-booted, somewhat man-shaped bag into which air was pumped from the surface through a hose. Then came Henry Fleuss.

Fleuss was a self-taught engineer who believed there had to be a way to make the diver independent of the air hose and pump. Knowing that a Swedish scientist named Scheele had kept bees alive in sealed jars by absorbing their exhaled carbon dioxide with an alkali solution, and that a dog could survive in a sealed chamber if you supplied oxygen and removed the carbon dioxide with quicklime (calcium oxide), Fleuss reasoned that if the diver could carry a supply of oxygen plus an alkali absorbant like quicklime to remove carbon dioxide, he could

travel freely underwater. And he was right.

Developing all the resources for his "Fleuss Flask" himself—right down to inventing a method to produce and compress his own oxygen—Henry tested his device under the supervision of a physiologist in the diving tank at the Royal Polytechnic School in London. It was simple enough; a breathing bag mounted on the chest and scrubber canister mounted on the back. Shortly after the test, he went on to rescue flood-trapped coal miners wearing the device (later known as a "rebreather" because the air is breathed repeatedly in a closed circuit, with oxygen added and carbon dioxide removed). Single-handedly, Henry Fleuss had invented the world's first effective scuba (Self-Contained Underwater Breathing Apparatus). But because of the arrangement of the gear on the body, divers were still obliged to travel upright, plodding slowly along the bottom in lead boots, no doubt envious of the fish around them who swam as freely as they pleased.

By 1941 Hans Hass, an Austrian marine biologist, was using home-made helmets and cameras to

make underwater films, but he dreamed of covering watery space as efficiently as evolution had allowed the underwater creatures— to be less like a man and more like a fish in the water. By modifying a rebreather for a more balanced fit on the front and back of the body, incorporating the flippers invented by Frenchman Commandant de Corlieu in 1926, and a full face mask that covered eyes and nose, rather than goggles, Hass was able to film his landmark 1942 underwater movie *Man Amongst Sharks* while swimming in a horizontal fish-like posture. He called his concept "swim diving," and it changed the way underwater travel has been done ever since.

One year later, another Frenchman named Jacques Cousteau connected a metal bottle of ordinary compressed air to a one-way gas-feeder valve designed by Emile Gagnan, creating the "Aqua-Lung," an apparatus so simple and inexpensive it would open the underwater world to people everywhere. In 1950, only ten units were sold in the United States; yet the market was considered saturated. A half-century later, millions are in use.

divers slowly made their way toward the surface. That's when it happened. At the 50-foot decompression stop, 50 minutes into the dive, Howard developed a searing pain in his diaphragm which spread from his rib cage around toward his back. He assumed it was indigestion. But he couldn't rule out that it might be something else ... something he'd rather not think about.

As a diver ascends from any depth, gases that have been dissolved in his tissues under pressure, especially nitrogen, must pass back out of his body. If he comes up slowly enough, the nitrogen will vent without effervescing. But if he comes up too fast, the effect is not unlike popping the cork from a bottle of champagne. The sudden lessening of pressure can cause the diver's blood, quite literally, to foam in his veins. And if a bubble forms in, say, the spinal cord, paralysis and death can quickly follow. Today it's called decompression illness, or DCI. More traditionally it's known as "the bends."

To avoid the bends, Howard's thirty-minute stay below 300 feet originally meant it would take him at least three hours to reach the surface. But that was before he felt the strange pain in his ribs. On the now-functioning communications system he informed Bob of the pain and headed immediately back down. At 70 feet, the pain dramatically abated. At 80 feet, it disappeared just as it should if a troublesome gas bubble were recompressed out of existence. After staying at 100 feet for several

minutes, Howard ascended again, slowly—very slowly, spending almost 70 minutes at the last safety stop at 20 feet.

By the time Howard reached the surface, the pain had faded like dreams fade when you don't write them down, becoming just a vague notion of some discomfort he had had, the kind of phantom memory most pain becomes when it has passed easily and quickly. Had it been indigestion? He couldn't say. Had it been a DCI hit? No, he didn't think so. Or rather, he didn't want to think so. "Besides," he recounted later with chagrin, "I felt fine." So fine, in fact, that he completed two more short dives that afternoon, mentioning the incident only anecdotally to Michele.

But at 5:35 that afternoon, with everyone aboard *Undersea Hunter* packed and their gear tightly stowed for the trip to another location, Michele entered the cabin to ask Howard a question and found him standing by the bunk looking strange. He said he "felt funny," and had an odd numbness in his right foot. A trained nurse, Michele immediately put Howard on oxygen. Then, with the nearest recompression facility a tough ten hours away, she rallied the troops to reassemble the rebreathers for emergency in-water recompression—in case the oxygen didn't alleviate Howard's symptoms.

After twenty minutes on pure oxygen, the numbness had spread up Howard's leg. He was beginning to lose motor control in both legs. There was no question Howard was bent.

Precious seconds ticked away as Mark and Bob got the dive gear unpacked and back in working order and Michele organized the redeployment of the launch, the underwater communications system, and all the gear needed to return Howard to the only thing that could save him—the waters of the reef. For an entire hour after onset, the symptoms worsened until, finally, Howard, Michele, Bob, and Peter boarded the skiff and headed back out to the reef. The sun sank out of sight in a spectacular blaze of color, plunging them all into darkness.

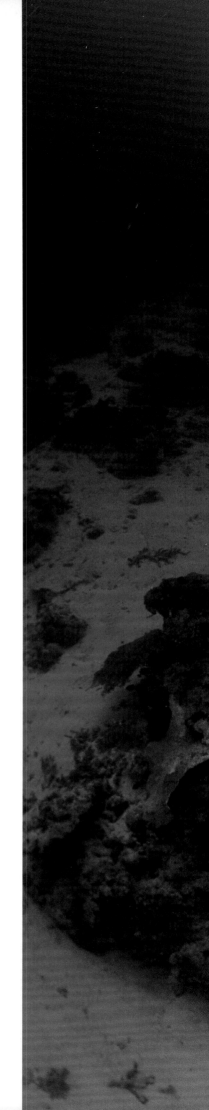

During the 100-foot decompression stop at the mouth of the Wakaya pass, Howard waits for potentially crippling gases to clear from his tissues.

With Peter accompanying him, Howard descended to 100 feet with his rebreather, adjusting his gas mix as he went so that he would be breathing the highest concentration of oxygen possible for each depth. At first, his wet suit made it difficult to evaluate the still prevalent symptoms of tingling and numbness, but he quickly began to feel much better. Slowly, very slowly, Howard and Peter ascended, guided by Michele's ethereal squawk on the earphones as she gave the exact ascension rate to follow, which she had calculated and recalculated.

Three hours later, the two exhausted divers sat on a dead table coral at 25 feet, turned off their lights, and watched flashlight fish blink along the wall far below while Michele continued to fret up above. With a half hour still to go—for a total of 8-½ hours underwater—it couldn't have been a longer day.

It is hard to say how close Howard came to paralysis or death in those last frantic hours. Certainly close enough that, still numb and tingling and back on pure oxygen, *Undersea Hunter* rushed him to the nearest recompression facilities in the Fijian capital of Suva—if ten hours can be called rushing. And close enough that he spent a total of seventeen hours (in four separate treatments) hunched against the hot, curved steel wall of the four-foot-wide recompression tank in an oxygen mask while Michele periodically peered in through the four-inch porthole with a worried smile.

Meanwhile, back at the MacGillivray Freeman offices in Laguna Beach, Greg, who had just gotten word of Howard's ordeal, worried for his friend's well-being. Besides hoping for his speedy recovery, he knew that Howard would now be more susceptible to DCI in the future. Feeling that no film was worth jeopardizing health and career, Greg considered insisting that Howard abandon the deep-diving segment of the movie, even if he did manage to pull through the treatments unscathed.

But in the end, that would have to be Howard's call.

During those long treatments, Howard had plenty of time to go over his mistakes. Sure, he had forgotten to reset his oxygen on the way down, and so he absorbed eleven minutes more nitrogen and helium than he had planned or wanted. But he had also exerted himself at depth, and he had probably come up a little too fast given these first two facts. Any one of these lapses could have caused a DCI hit on an unlucky day, especially at such depths. Most likely, though (as is usual with things as complicated as physiologies and ecosystems), it was the combination that caused the problem. Sobered by the experience, Howard resolved to continue with the deep-diving portion of the expedition. But first, he and Michele would take a month off to recuperate and rethink their deep-dive protocols. Then they would return to Fiji to meet up with Richard Pyle, the marine biologist and friend Howard intended to film collecting new fish species on the unexplored depths of the reef. Why is the deep reef so compelling? Why is the dark, less populated, non-**hermatypic** part of the reef worth the risk to explore? It has a lot to do with notions—again, as erroneous as those we have long held about corals—about what can live in the ocean, and where.

In 1844, Frenchman Henri Milne-Edwards—the predecessor of modern-day marine biologists like Richard Pyle—used lead sandals and an open-bottomed dive helmet with surface-pumped air to become the first naturalist to retrieve his own samples and to describe underwater communities firsthand. In Milne's day, 300 feet (the depth at which the pressure is 148 pounds per square inch, or ten times what it is at sea level) was considered the "zero line," the threshold beyond which it was presumed few creatures could survive. In the last eighty years the deep-diving bathysphere of William Beebe, Jacques Piccard's bathyscaph, and manned

hermatypic
A term applied to any organism that forms stony deposits, particularly hard corals containing the symbiotic unicellular algae Zooxanthellae, which build reefs by secreting calcium carbonate—limestone.

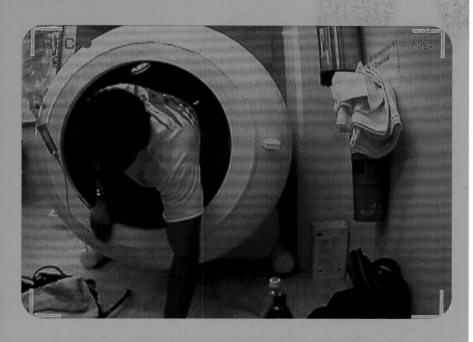

"I never want to go through that again!" After the seventeenth hour of recompression treatments, Howard leaves the 48-inch-wide hyperbaric chamber. Howard will be able to dive again, but this episode with decompression illness leaves him more vulnerable to DCI during future deep dives

submersibles like ALVIN have pushed the zero line all the way down to the bottom of the ocean, at 35,800 feet, proving that life thrives in exotic and unpredictable ways at all levels of the sea. Even so, the deep reef below 150 feet—and especially between 250 and 400 feet—lies unexplored because submersibles and robot explorers are both too cumbersome to collect darting reef fish and too expensive for many remote operations; while diving—until quite recently—was just too dangerous in this realm where diversity was long presumed to dwindle to nil as sunlight fades toward darkness.

Richard, an ichthyologist and field collector for the Bishop Museum of Honolulu, calls this neglected region of the reef—where the thinning light is reminiscent of that at the mouths of caves—the "twilight zone." As a charter member of the All-Species Project, whose ambitious goal is to catalog every living thing on Earth over the next twenty to twenty-five years, Richard hopes to increase our awareness of the variety and abundance of the life with which we share this planet. With only 2 to 10 percent of all life described and studied, an estimated 20 to 40 million species await discovery. Since 1986, Richard himself has collected nearly 100 new species of deep-reef fish on South Pacific reefs. A nice start, but Richard estimates, "at least 2,000 fish species wait to be discovered in the twilight zone. And that doesn't count sponges, nudibranchs, jellyfish, clams, corals, shrimps, worms, or the myriad of other creatures that prefer to live there above anywhere else." Where does Richard get this number? From first-hand observation. On average, for every hour of dive time he spends in the twilight zone, Richard collects seven new species of fish. No other habitat offers so much undiscovered vertibrate life in such a specific area.

The specimens Richard collects are more than just a fish nerd's trophies. There are at least two good reasons to want to

discover all this unknown life. One is that it may serve humanity with new medicines and other useful products. But the other, more fundamental though less obvious reason, is that unless we know completely who lives in an ecosystem, we cannot accurately measure that ecosystem's value or its health. Equally true, but more tragic, Richard points out: "We can't know a species is threatened with extinction if we don't know it's there to begin with." Added to Howard's Ten-Year Rule, Richard's comment reminds us that one of our biggest challenges is just seeing the natural world clearly and without bias of any kind.

Ecosystems don't always have clear boundaries. Forest biomes peter out into scrub, and scrub into grassland into desert and back. There are transition zones both within any ecosystem and around it. And there are transitions within transitions. This holds true for reefs. Perhaps because of this, it would be convenient to see ecosystems as gears in the great transmission box of nature, each gear intercogged with the gear of another distinct but hardly discrete ecosystem. Scientists like Richard understand that the charming and accessible fairy gardens of the well-sunned upper reef rest on a deep foundation which is connected to and interdependent with what goes on above it. Seawater passes up and down the reef, flushing useful nutrients and plankton (the base of the oceanic food chain) in both directions. No doubt both the hermatypic, solar-powered, upper reef and the less light-dependent twilight zone below are intercogged in critical ways, but it's still new terrain, so for now there is everything to learn. Perhaps the deep reef will yield secrets about the richness and vitality of the reef that stands on its shoulders. Perhaps the deep reef holds the key to recovery for damaged reefs. Only time, and much more exploration, will tell.

A frequent visitor to the twilight zone, Richard is familiar with the bends. He's been hit with DCI seven times, twice with near-death consequences. But there is another risk a deep diver faces—this one, on the way down.

When nitrogen, an otherwise innocuous gas, is breathed under increasing pressure, it produces a nervous system effect so profound that a rule of thumb has been developed, one which every diver knows, the so-called Martini Rule: Every thirty-three feet of depth is equal to one dry martini on an empty stomach. Poetically named "the rapture of the deep" by its discoverer, Jacques Cousteau, the intoxicating effect of nitrogen narcosis did not go unappreciated by him. "I am personally quite receptive to nitrogen rapture," he said in *The Silent World*. "I like it and fear it like doom. It destroys the instinct of life." How right he was.

The depth record by a diver breathing only compressed ambient air was set in 1994 when Daniel J. Manion dove to 510 feet. Before that, it stood at the 452 mark reached by Bret Gilliam in 1990, only 15 feet deeper than the 437 feet achieved by Neal Watson and John J. Gruener as far back as 1968. During the period between 1968 and 1990, at least eight other divers died trying to better the Gruener/Watson record. In one instance, the last act one record seeker performed (as witnessed by the safety diver 200 feet overhead) was to remove the regulator from his mouth and offer it to a passing fish—his instinct for life snuffed by nitrogen narcosis.

Over the years, Richard has downed his fair share of nitrogen martinis. In Palau, for instance, at a depth of 250 feet, he saw a group of fishes called *Anthias* or Fairy Basslets, with a color pattern of black and white bars unlike any known species. He chased and herded and swung his hand nets in a desperate effort to collect just one of the previously unknown species. Only after realizing he had consumed all his air (the pressure gauge had stuck!) and rocketing to the surface (to suffer a near-fatal DCI hit that left him with permanent nerve damage and a life-long limp), did he see the fish's true colors. They were red and yellow, not black and white. It was a common and long known species.

Like an alcoholic blackout, narcosis also makes it hard to remember things. On another occasion, after discovering a beautiful new angelfish at a depth of 330 feet, "all yellow

TOP Bob Cranston (left) and Richard Pyle descend to 350 feet at the mouth of the Wakaya pass in search of new fish species.

BOTTOM Divers slowly ascend the wall at Tikehea Atoll in French Polynesia.

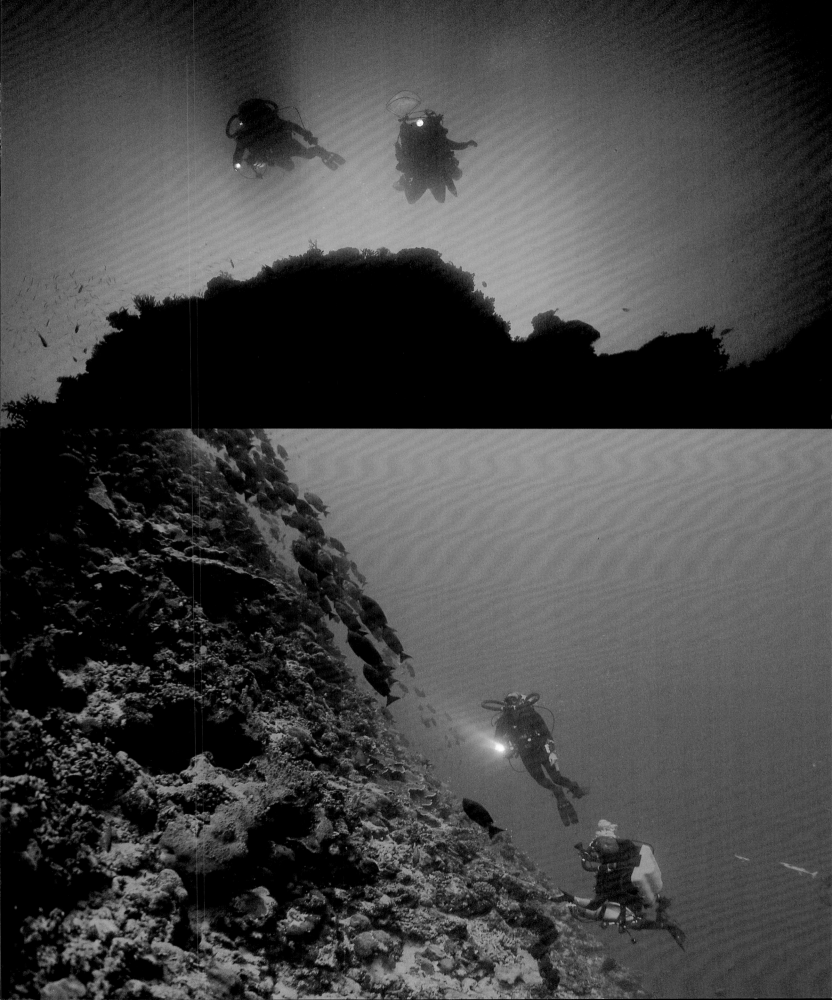

with a black spot on it," Richard gave chase with his nets only to give up in frustration. At the surface, after expressing his disappointment to a colleague, it was pointed out that a fish very like the one he described was swimming in Richard's collection bucket—an embarrassment for Richard, since it could only have been placed there by his own hand. What did he name the new species of angelfish? *Centropyge narcosis*, of course.

Early that March, Richard arrived in Suva, where he joined the returning Halls aboard the *Undersea Hunter*. It was his first expedition to Fiji and he knew that collecting wild fish before Howard's bright lights and loudly whirring camera would not be easy. But since he can only spend about 15 minutes at 400 feet for every four-hour dive, he was still hoping to accumulate a solid hour of observation and collection in the twilight zone.

Understandably, Howard experienced some trepidation as he faced his first deep dive since the accident. Michele, who would remain in the launch, also faced anxieties of her own. At least now Howard and his team kept a safety checklist strapped to their forearms for the deep dives, reminding them to adjust their oxygen set point at 100 feet, among other things. And Bob did reassure Michele that he would double check each procedure with Howard. It was time to get back on the horse. Howard, Richard, Bob, Mark, and new deep team member Dave Forsythe, shrugged into their 80-pound rebreathers and boarded the launch.

More than any other development, the rebreather has opened up the twilight zone to divers. They've come a long way since Hans Hass modified one so that he could travel horizontally like a fish. Unlike the open circuit apparatus of an Aqua-lung (which simply empties air into the lungs and from there into the water), the closed-circuit rebreather system scrubs exhaled carbon dioxide from the breathing loop (with an alkali absorbent called sodium hydroxide) while squirting a minuscule amount of pure oxygen from a tank back into the loop to re-

balance the mix. This is essentially the same system used by spacewalking astronauts with the recent addition of a waterproof computer to precisely monitor and adjust gas levels as the diver descends or ascends. Breathing an oxygen-helium-nitrogen cocktail called "trimix," a rebreather diver can go 1,000 feet or more narcosis-free and stay submerged as long as 12 hours on a tank of oxygen about the size of a grapefruit. And if he's a marine wildlife cinematographer, he can practice the kind of patience it takes to capture images of previously unseen behaviors by coy fish who would otherwise evade a scuba diver.

Which brings up another plus for rebreathers. In the past, because of the noise and turbulence created by the exhaust bubbles of an open circuit scuba system, Pyle used to swim in an uninviting aura, a no-fin zone into which few fish would approach. "Now," he says, "I get there on a rebreather and I'm right in the middle of all these fish." He's even had a school of surgeonfish spawn on top of him as he lay motionless on the bottom. They had mistaken him for a rock.

Of course, rebreathers also possess their own particular dangers. For one thing, oxygen, the very gas we would all die without, becomes a seizure-producing neurotoxin under pressure, so it must be regulated carefully in the mix to avoid oxygen poisoning. Hypoxia and carbon dioxide poisoning are also real threats. And then there are leaks. Even a tiny one—which in an ordinary scuba system is a common and minor annoyance at best—can be life threatening in a rebreather because it can invade the carbon dioxide scrubber, turning its alkali absorbent into an esophagus-searing "caustic cocktail."

Once, after filming a manta ray gliding in slow balletic loops in 40 feet of water, Howard passed the camera to Bob, pulled his regulator from his mouth and held the loop of corrugated hose up in both hands, studying it like he might a pair of damaged eyeglasses. With bated breath he shook it,

hypoxia
A condition of insufficient oxygen in bodily tissues which shuts down metabolic function in oxygen-dependent organisms, often fatally

THE REAL WHOLE EARTH CATALOG

Since the first modern scientific inventory of life on Earth began under the taxonomist Carolus Linnaeus and his contemporaries in the mid-eighteenth century, approximately 1.7 million species have been classified and named.

Current estimates of undiscovered species on Earth range from 10 million to 100 million.

Kuni nudibranch

Arrowhead crab

Christmas tree worms

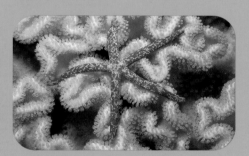
Juvenile Watcher sea star

In 1989, The U.S. National Science Board predicted that as many as 25 percent or more of the Earth's species may become extinct by 2014.

Describing and classifying as many as possible of the world's living species is crucial. This undertaking is not only necessary for effective conservation practices and accurate impact studies for assessing environmental change, but also offers an unsurpassable adventure: the deeper exploration of our planet.

On September 2000, forty scientists and professionals from around the world met at the California Academy of Sciences to establish The All Species Foundation, a non-profit organization dedicated to the complete inventory of life on Earth within the next twenty-five years, whose ultimate mission is the improvement of our capacity to conserve existing biodiversity. Since then, more scientists and scientific organizations from around the world have stepped up to join All Species in this vital mission.

The organization aims to accomplish its mission of a complete inventory of all species by focusing on basic scientific endeavors, not policy. All Species is pan-national, drawing on the interest and knowledge of local inhabitants to classify regional life. Tools for conducting these surveys are easy to use and available to enthusiasts and scientists alike.

For information about the foundation online or to use the All Species Toolkit Search Engine for retrieving information on more than 873,000 indexed species of animal, plant, or microbe visit **www.all-species.org.**

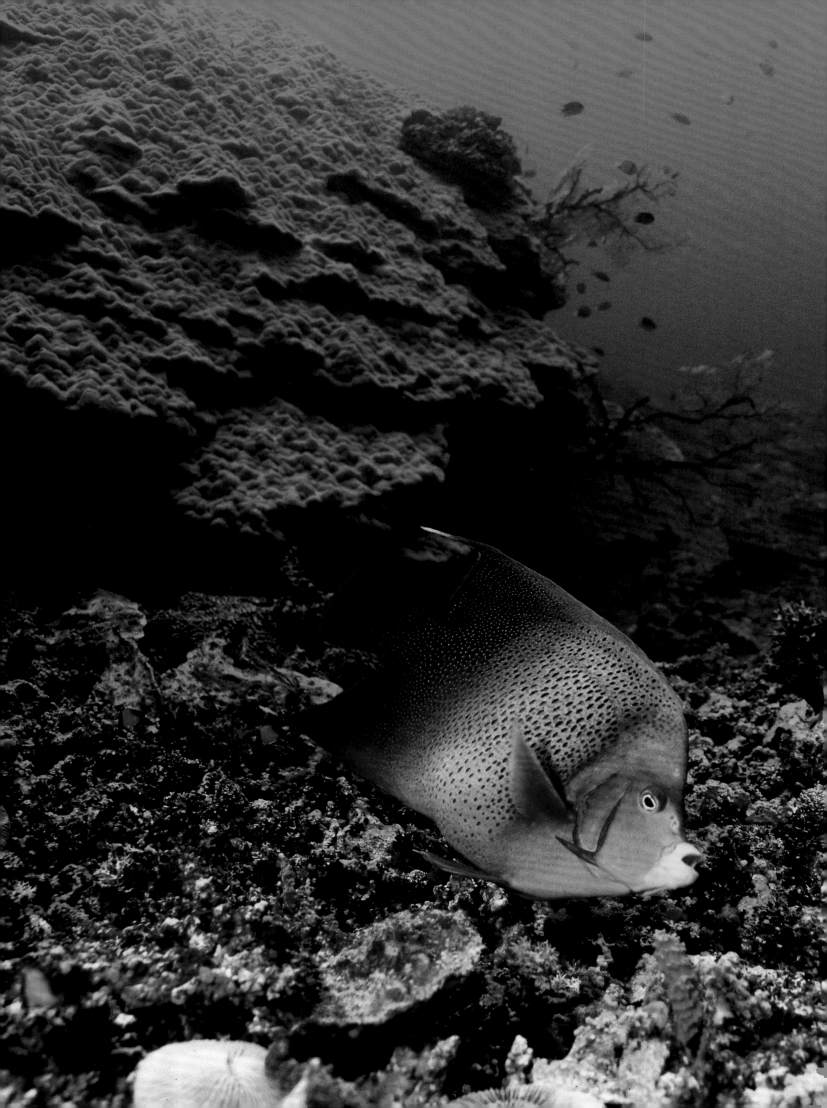

We can't know a species is threatened with extinction if we don't know it's there to begin with.

An adult Koran Angelfish (sometimes called the Semicircle Angelfish), *Pomacanthus semicirculatus.* The fish gets its name from the markings on the tail of the juvenile, quite different from those in color from the adult, which look like writings in the Koran.

biffed it with a finger, rolled it up and down and side-to-side for thirty seconds, a minute, a minute and a half, trying to find the leak. Not until he was back aboard the *Undersea Hunter*, did he locate the source of the leak: a loose, seventy-five-cent hose clamp on the mouth piece. One twist of the screwdriver and everything was set to go again. "No big deal," said Howard, in all earnestness. "But had it been a deeper dive, I'd have called off the shoot immediately."

Slowly and without incident, Richard, Howard, and the rest of the team descended the wall of Mt. Mutiny in fantastic thinning light. But things did not go well for Howard. When he attempted to shoot sequences of Richard descending along a terrace glutted with soft corals, a simple cork disk in the camera's drive clutch—fatigued by repeated exposure to the crushing pressures—failed. Disappointed, Howard resigned himself to another three hours of decompression by taking in the beauty of the strange world around him, always noting wildlife behaviors and scouting for features of light and terrain he could take advantage of during the next dive when the camera would begin operating again ... hopefully.

In the meantime, Richard saw perhaps two dozen species of fish unique to these depths in his headlamp beam; several he was certain were new. Though he was cautious not to damage the reef, prickly sponges and jagged corals snagged holes in his delicate nets, and many fish escaped beyond his grasp. Still, with hours to go in slow, staged ascent, Richard managed to collect two fairy basslets, a red-striped hog wrasse, and a small species of blenny—all entirely new to science. Even so, the best was yet to come.

On the last scheduled deep dive of the expedition, just as Howard positioned himself for a habitat shot of the beautiful red fish Richard was about to collect, a frantic voice came over their earphones: "It's leaking! It's leaking!"

That's when Howard turned to see Mark Thurlow pointing dramatically toward the flashing strobe on the camera housing just as the leak alarm began to ping. Both the $100,000 camera and Howard's personal safety were in sudden jeopardy. If it flooded, the camera would quickly became a 250-pound brick with no way to lift it to the surface. Anyone still holding onto it would be plunged into the abyss. Under normal conditions, Howard and his crew would have rushed the camera to the surface. But not at this depth. Not breathing trimix. And not having recently been bent. Now, if the already cumbersome camera began to take on water and gain weight, the only hope was to somehow lodge it against the wall. The sheer, impossibly vertical wall.

Drifting nearly motionless for a long, thoughtful moment, Howard continued to grip the camera in his hands. He could detect no significant change in its buoyancy. The leak, at least for now, was not a catastrophic one. Having faced a string of technical failures, Howard kept Richard in his sights and considered shooting anyway—if the camera would roll. All the while he remained attentive to the slightest indication that the camera was gaining weight in his hands.

Two-hundred-fifty feet down the wall of Mt. Mutiny, Richard saw his grail. He was pretty sure it was a wrasse, a velvet wrasse; but otherwise, to the trained eye of the scientist, it didn't fit any known pattern, shape, or behavior. Under his collecting light, it glowed a vivid crimson. From its elegant lanceolate tail trailed long filamentous wisps like nothing he'd ever seen before. He pulled two scoop nets from the quiver on his back.

With fish and fish scientist in sight, Howard focused, then started filming. Oblivious to the whirring and clattering of the IMAX camera, Richard moved in, swooped, and scooped.

Working hard to keep Richard in focus, Howard let the rest of the film unspool as Richard netted the fish and then gently deposited it in his collection bucket. Howard had gotten what he came for and so had Richard, but that was not the end of the hunt. The camera and the exposed film

93

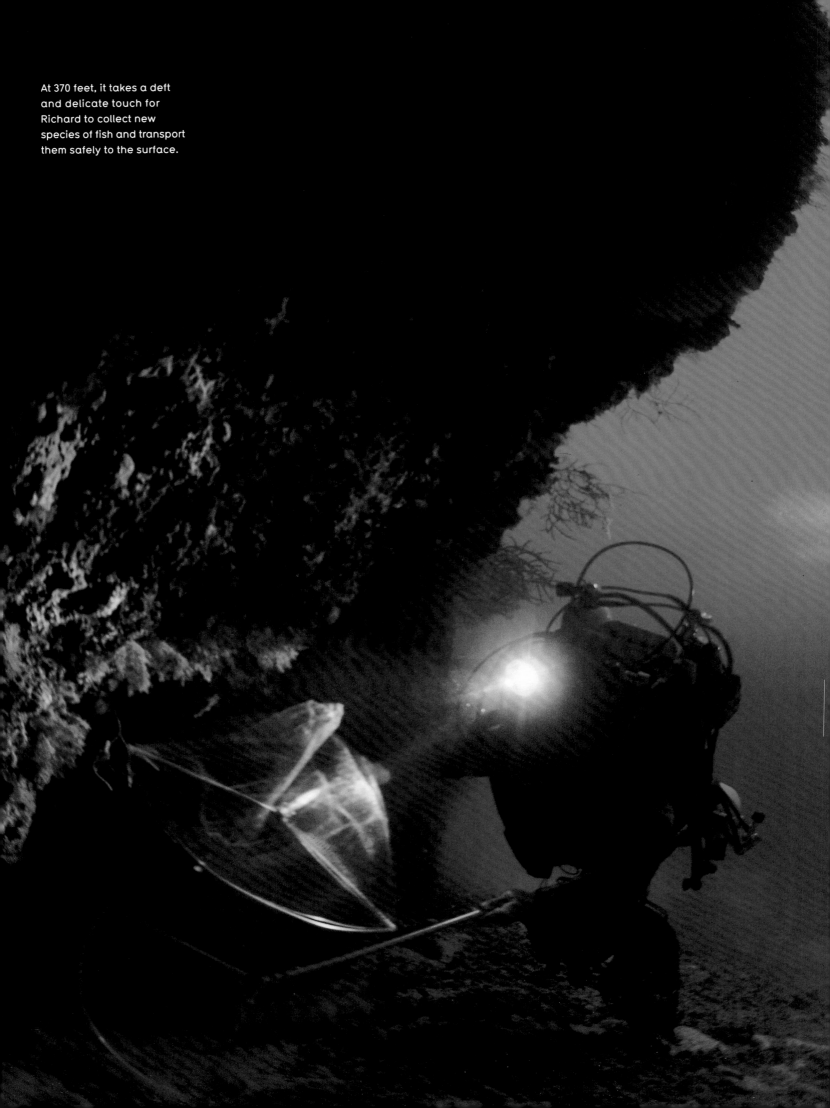

At 370 feet, it takes a deft and delicate touch for Richard to collect new species of fish and transport them safely to the surface.

inside it had to make it back to the surface safely, and so did the new fish.

In the past, taxonomists just killed their specimens, stuffing them into jars of preservative to be studied back in the lab. Certainly, this wrasse with its wispy tail could tell Richard and other scientists a lot, even as a corpse. They could determine the fish's family and genus by counting the number of rays in its dorsal fin. They could sex it. They could give it a name and a place in the great unfinished taxonomy of Earth. But alive, this little red fish was worth worlds more. Alive in a tank, its behavior could be observed, maybe even to the point of understanding why it preferred to live where it did. Furthermore, in the special collection tank at the Waikiki Aquarium, this living representative of the deep-reef community could be appreciated by millions of visiting children and adults, non-divers who stood to learn something of the part the fish might play on the reef as a whole. Alive, this fish was a scientific resource, a teaching tool, and another puzzle piece in the grand jigsaw of nature we must bring ourselves to understand. Getting the fish back alive was everything. The trick now was just how to do that.

Just as divers must avoid the expansion of gas bubbles in their tissues as they ascend, so are fish injured if they ascend from the depths to which they are accustomed. This is because they possess an internal buoyancy control device called a swim bladder, a sack of air which fills and empties very slowly via the bloodstream to maintain neutral buoyancy at whatever depth the fish prefers to live. If the air expands in the bladder on ascent, it is rammed into the fish's throat, choking the fish and injuring other organs. Therefore, to get a deep-dwelling fish to the surface safely during a dive, air must be removed from the sack—a problem Richard has solved nicely.

As he begins to ascend, Richard pulls a fine hypodermic needle from his kit and carefully inserts the tip into the fish's side. He knows he's pierced the bladder when a small steady stream of bubbles exits from the needle's open end. When he removes the needle, the wound heals almost instantaneously, much as it would when humans receive innoculations. Needle stowed, he moves to the next decompression stop and repeats the procedure, if necessary, for the safety of the fish. By the time the two of them arrive at the surface, the fish will be none the worse for wear.

With the members of the deep-diving team continuing their slow ascent, the camera housing—which had been retrieved by the back-up divers from above—was opened and carefully inspected. A cup of water was found inside, but no damage to the camera or film. Good news to Howard, who heard it over his now-working earphone.

Two hours later, the divers emerged. Back aboard the launch, Richard excitedly opened his collection bucket to give Michele, Howard, and the rest of the crew a peek at his prize. It was one of the prettiest in the genus, a new *Cirrhilabrus*, a fairy wrasse no human being had ever seen before. And it was very much alive.

What amazed Richard most about his spectacular find wasn't how unique or beautiful it was, but how conspicuous it was when he found it. This large, bright fish had been swimming right out in the open, obvious to the most casual observer who might happen by, yet it had remained undiscovered till now. Since most species are not so easy to see in nature, this underscores the breadth of diversity latent on the deep reef. On this point, few express it better than Richard: "If I can descend to a deep-reef habitat and look around and know that many of the highly conspicuous species—the equivalents of monarch butterflies and wildflowers—have never before been documented by humans, it staggers my mind to think of how extensive the diversity of less-conspicuous denizens must be, awaiting discovery in this truly uncharted realm."

Despite the difficulties they encountered in the twilight zone, Richard and Howard

accomplished their goals within four relatively brief visits. The specimens and images each collected there will no doubt broaden our understanding of the reef community, and prove the deeper, less obvious part of the reef yet another corner of our planet we cannot and should not ignore. But were their efforts worth the risk? That question had already been answered by the Halls during Howard's long decompression treatments, and by Richard, who has recovered from the effects of decompression illness seven times during his career; so it was moot, at least for them. Every true adventure is a hazardous undertaking, after all; but not all adventures are so noble. By going to such extremes and returning with vibrant clues to this vital, overlooked corner of our world, these modern Prometheans captured and brought back from the deep, not fire, but information, the greatest illuminant of all.

A few days later, Richard departed for his lab in Hawaii, to begin the arduous task of studying, naming, and cataloging the new specimens he had collected; to give each their branch in the great tree of life and, therefore, the voice they never had. But for Howard and Michele, the journey was hardly over. There was still another leg to the adventure. It was farther to the east, where diversity begins to thin, among the reefs of French Polynesia.

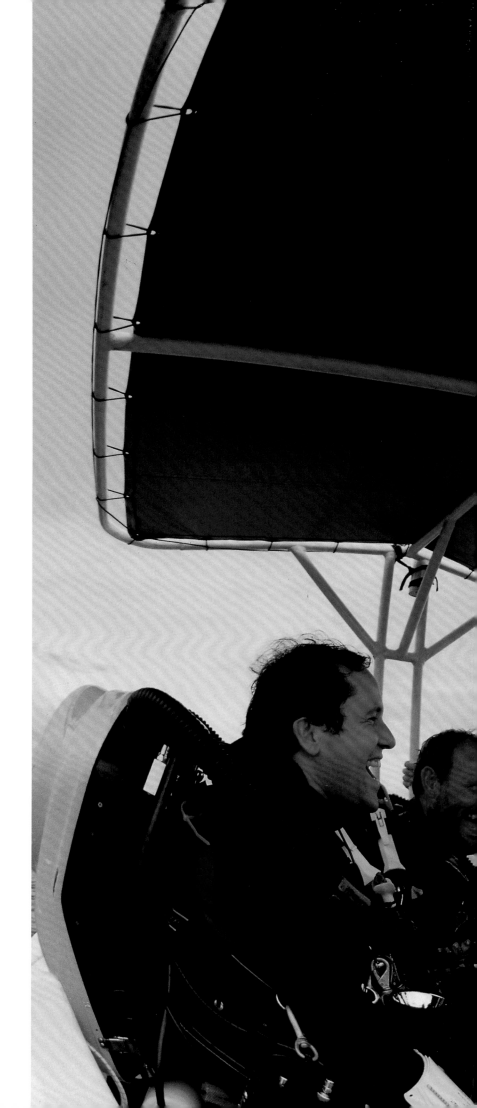

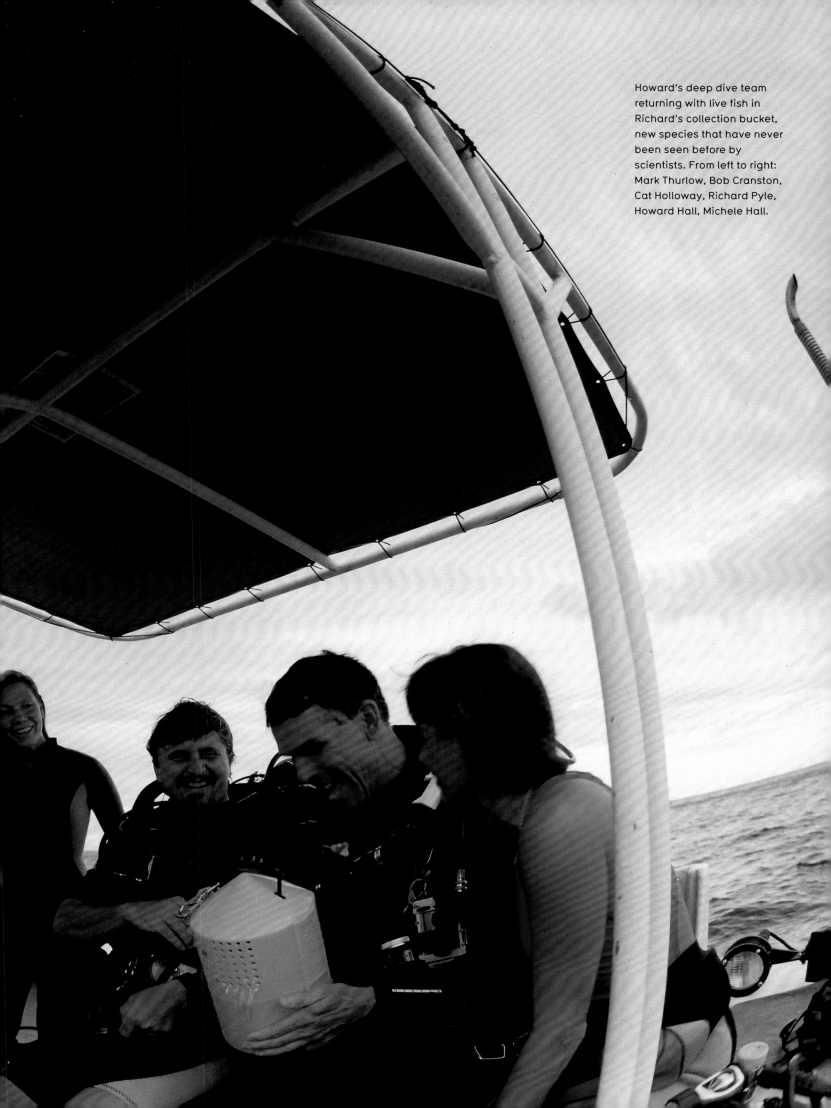

Howard's deep dive team returning with live fish in Richard's collection bucket, new species that have never been seen before by scientists. From left to right: Mark Thurlow, Bob Cranston, Cat Holloway, Richard Pyle, Howard Hall, Michele Hall.

BELOW, LEFT Sea Star from Palau
BELOW, RIGHT A new species of hog wrasse
(*Bodianus* n. sp.), collected in Fiji

A BIODIVERSITY CRISIS

by Richard Pyle

After 250 years of hard labor, the scientific community has managed to document and name more than one and a half million distinct species of life on Earth. That may sound like a lot, but estimates of the total number of species "out there" range from about 10 million to 100 million. We are not even able to guess at the total global biodiversity to within an order of magnitude; but even by conservative estimates, 90 percent of life on Earth has yet to be scientifically described. Compounding our overwhelming ignorance are the alarmingly high rates of extinction resulting from human impacts on the natural world. Thus, we find ourselves in a race against time—a race to understand who we really share this planet with, before we lose the opportunity to know our neighbors forever.

Wide-spread acknowledgement of this 'Biodiversity Crisis' has helped launch a new movement to completely catalog the full array of life forms around the globe. I have been actively involved with a non-profit organization called the All Species Foundation, whose endeavor is to mobilize the scientific community, and fill in the missing branches of the tree of life within the next twenty-five years. Ten times as many species documented in one tenth the time, compared to past history—a daunting task, to be sure, and one that will require unprecedented cooperation among many different organizations and individuals; not to mention vast amounts of financial support.

The accelerating pace of advancing information technology will go a long way towards closing the knowledge gap, but the effort will also rely heavily on old-fashioned exploration and discovery. Of the 10 pecent of life that we've already managed to discover, the vast majority coincides with the most conspicuous forms that surround us. The remaining biodiversity that has managed to escape our notice is represented by species that are less obvious to our own perceptions. Many of these elusive organisms are extraordinarily tiny—microscopic bacteria that cannot be easily cultured in the laboratory. Most of the rest simply

inhabit a place we have not yet adequately explored. One such place lies at the deepest reaches of the world's coral reefs.

It's relatively easy to traverse thousands of miles across open ocean to arrive at almost any tropical island within a matter of hours or days; yet, ironically, a mere few hundred feet of vertical distance below the ocean's surface has served as an almost impenetrable barrier to biological exploration for centuries. It's not that we haven't devised the technology to grant our terrestrial, air-breathing, mammalian bodies access to the ocean's depths. The problem involves more pragmatic issues. Deep-sea submersibles are expensive, and almost always used for diving to depths in excess of 500 feet. Conventional scuba allows more direct and portable access to shallow coral reefs, but for physiological reasons limits divers to the upper 100–200 feet. As a consequence, the intermediate habitat at depths of about 200–500 feet remains almost entirely unexplored. In this twilight realm, illuminated in eerie indigo by the dwindling rays of sunlight that penetrate clear tropical surface waters, I have found my life's calling.

After surviving a few close-calls while pushing conventional scuba into these depths, I began adapting specialized deep-diving methods developed by military and commercial divers for my own exploratory ends. Enabled by the most sophisticated underwater breathing apparatus ever developed— a mixed-gas, closed-circuit rebreather system with triple-redundant computers, I have conducted preliminary exploration activities on deep reefs throughout the tropical Pacific. The extent of undiscovered diversity we're finding exceeds even my wildest expectations.

My first glimpse of Fijian deep reefs came in the spring of 2001, when I was invited to participate on a month-long expedition as part of the making of the IMAX film, *Coral Reef Adventure*. On one particularly memorable dive, I found myself alone in air-clear water, hovering on the crest of an immense underwater rock formation, 380 feet beneath the ocean surface. It was my thirty-fortth birthday, and I was nearly overwhelmed with intense exhilaration as I surveyed the incredible undiscovered diversity that lay before me. Returning to Fiji less than a year later as part of a scientific expedition, my colleagues and I discovered dozens of fish species new to science. Our rate of new species

discovery at these depths has climbed to nearly seven new fish species per hour of exploration time—and that rate continues to rise as we hone our techniques. Nowhere else in the world can one find so many new vertebrate species so quickly. And that's just the tip of the iceberg. For each new fish species we discover, perhaps hundreds of invertebrates await scientific scrutiny in this one small corner of the vast, uncharted Biosphere.

From the mammals to the microbes; from the highest mountain peaks to the greatest ocean depths; from the tropical rainforests to the coral reefs - biodiversity beyond imagination awaits discovery. Although the threat of extinction looms ominously, I remain optimistic. Earth's biodiversity is incredibly precious, and incredibly unique— perhaps the most unique array of life throughout the entire galaxy. I am part of the generation whose decisions and priorities will determine its fate. All around I see signs of hope that those priorities are shifting, and those decisions are being made wisely. So much remains to be done, but I will continue to do my part as long as I walk this Earth, and swim its seas. We can win this race, if we try.

ABOVE An unusual sea cucumber, Paupa New Guinea

ABOVE RIGHT A pair of nudibranch (snails without shells), Papua New Guinea

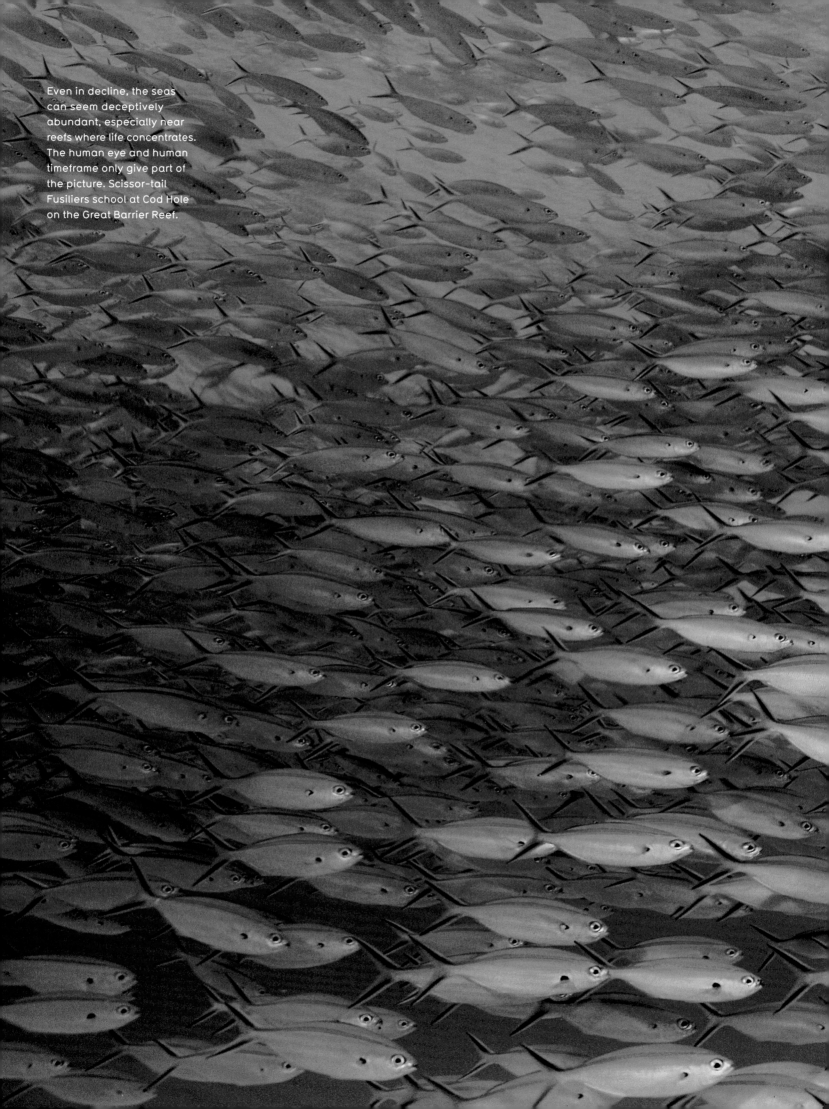

Even in decline, the seas can seem deceptively abundant, especially near reefs where life concentrates. The human eye and human timeframe only give part of the picture. Scissor-tail Fusiliers school at Cod Hole on the Great Barrier Reef.

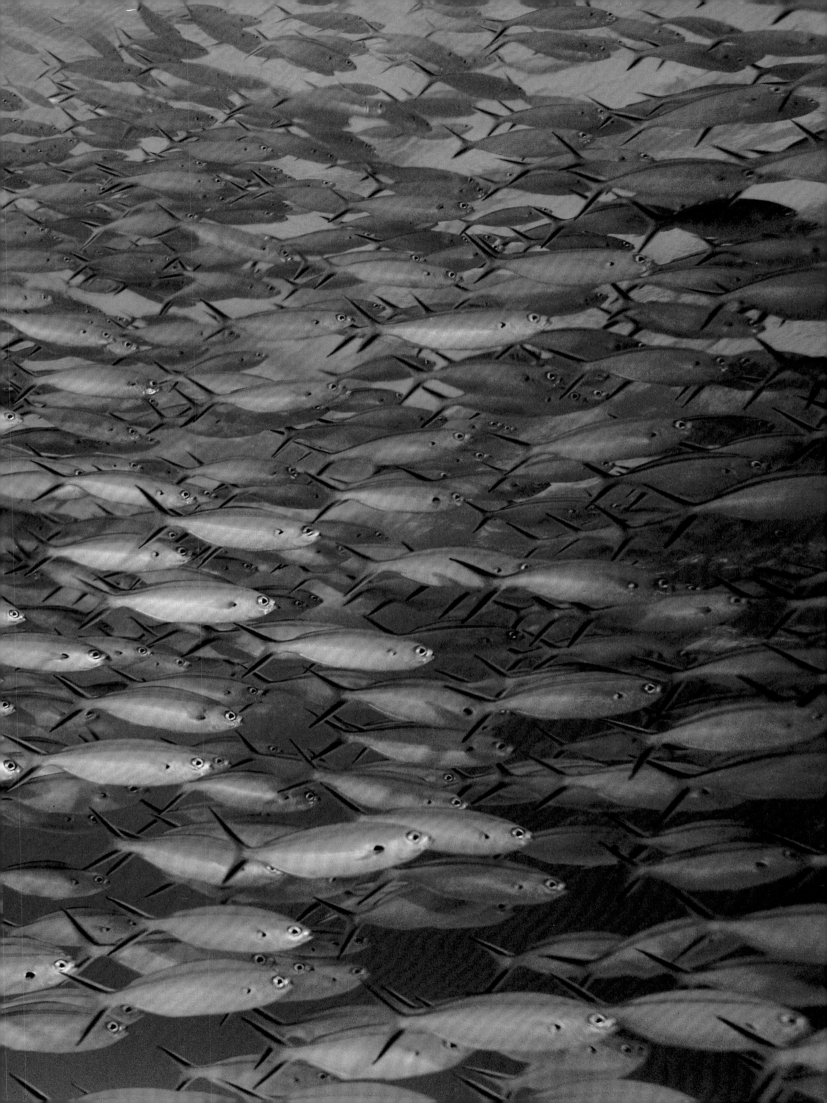

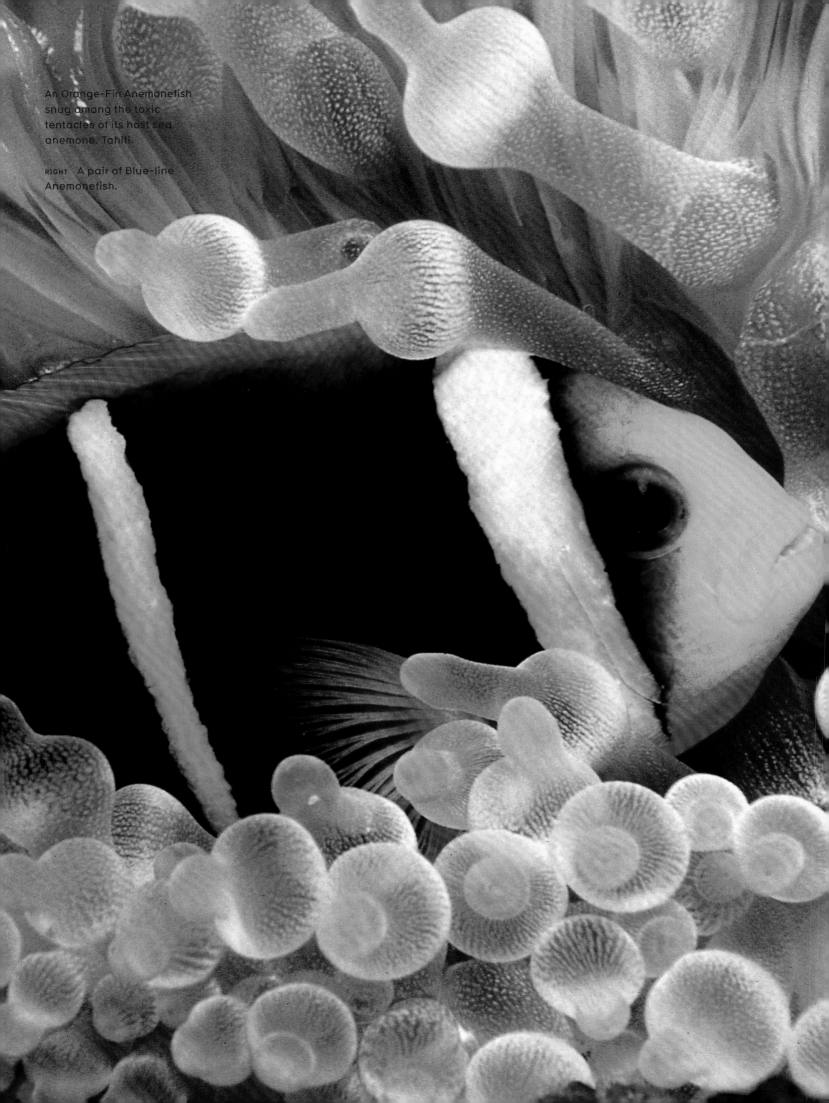

An Orange-Fin Anemonefish
snug among the toxic
tentacles of its host sea
anemone. Tahiti.

RIGHT A pair of Blue-line
Anemonefish.

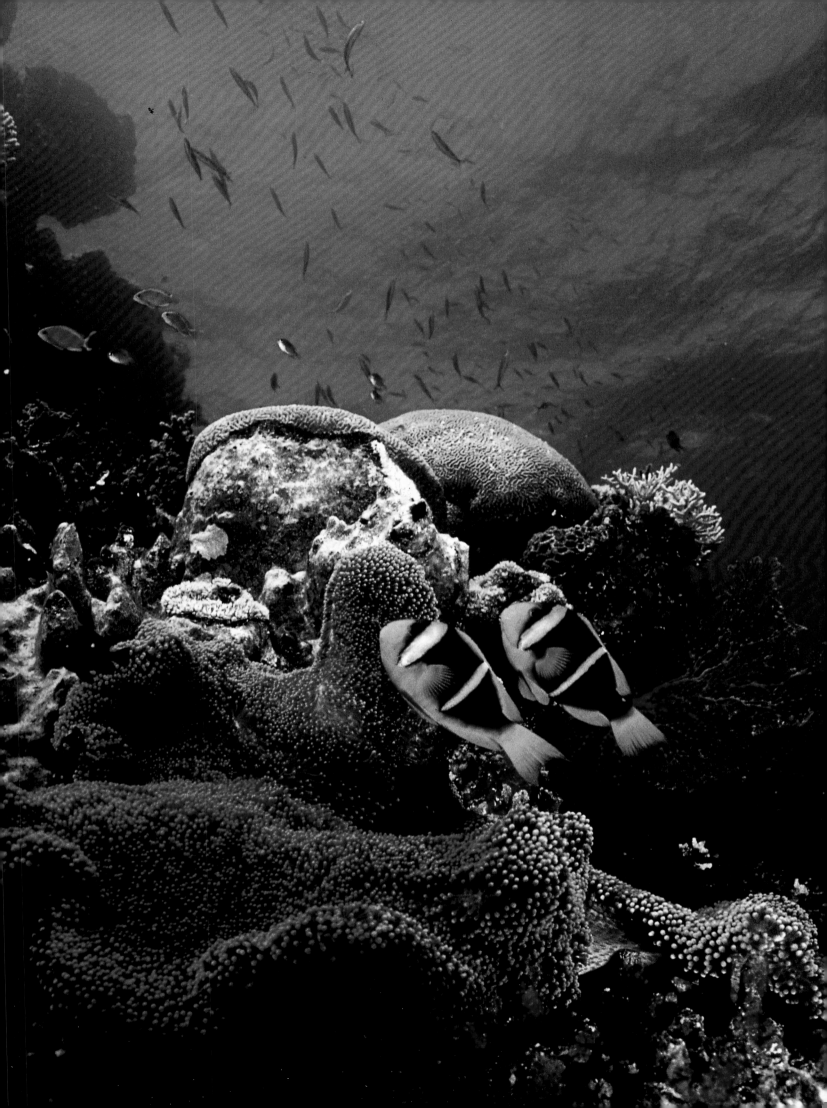

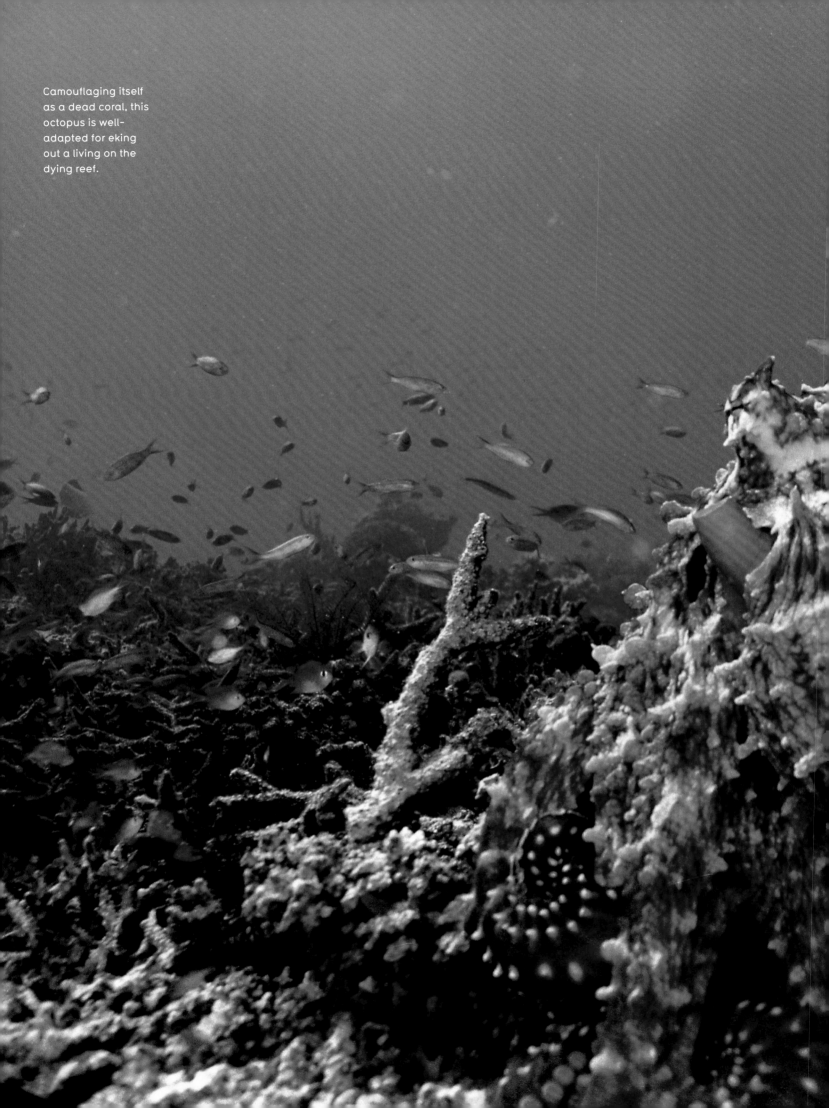

Camouflaging itself as a dead coral, this octopus is well-adapted for eking out a living on the dying reef.

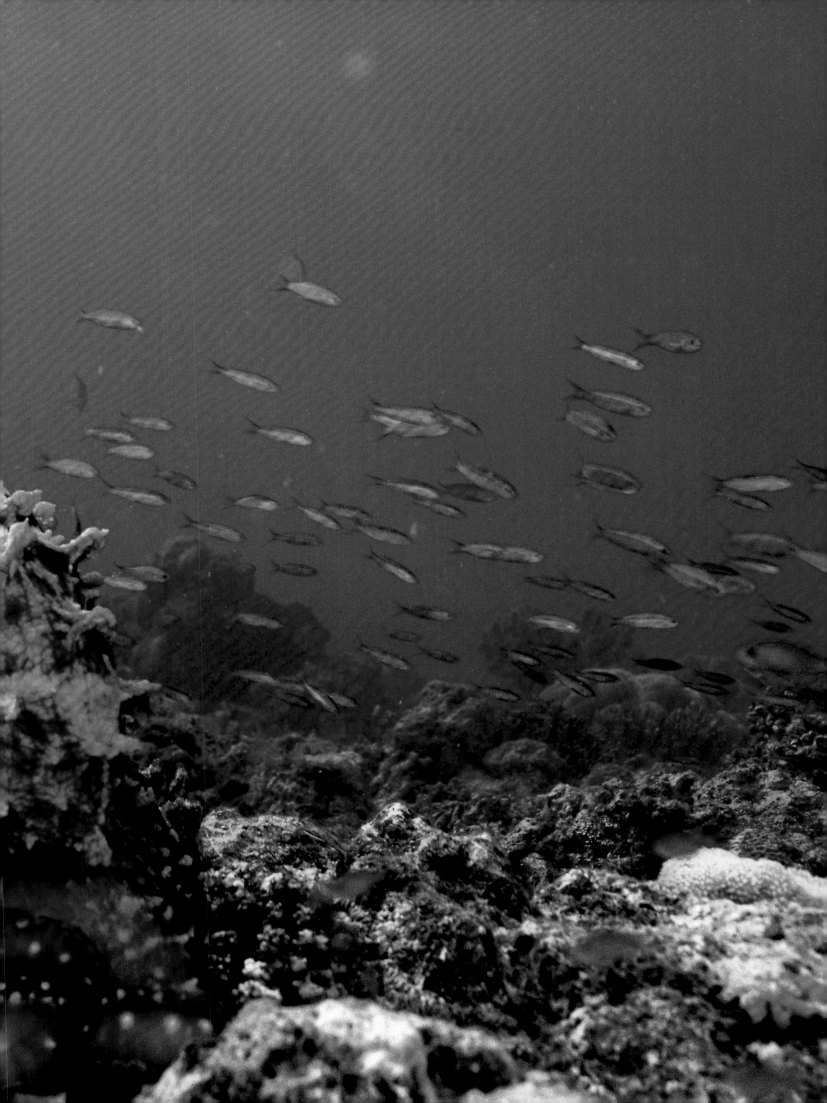

IV | Paradise Revised

For the reefs of their final destination, Tahiti

atoll
A ring-shaped coral reef with a central lagoon located in the open ocean. Atolls form when the central island subsides beneath the surface and the reefs that once fringed it continue to grow and converge upward.

Rangiroa Atoll, Howard and Greg planned a new vantage: from the air. Just as Michele had arranged, Howard's friend John Dunham, the owner and pilot of the amphibious ultra-light, met the two film crews in Papeete, Tahiti; Howard wasted no time becoming airborne.

Soaring over the turquoise water between the islands of Tahiti and Moorea in a shakedown run with John, Howard saw how these two lushly cragged "high islands" are flanged by reef. What he didn't see were the broad white patches indicating large-scale coral bleaching that he'd seen in aerial photos of a hard-hit reef in Fiji. He was glad. But then again, he hadn't really expected to see bleaching because the hot, stagnant seawater associated with these events had not been reported in the area. Then why was he here? Because here, in French Polynesia, he could capture forever on film the dynamic life of a particular reef type similar to, yet quite different from, the barrier reefs and fringing reefs of Australia and Fiji. It's called an **atoll**.

Before Charles Darwin ever penned his revolutionary thesis on evolution, *The Origin of the Species*, he'd become so awed by the power of coral polyps that he published his first significant theoretical contribution to science: *The Structure and Distribution of Coral Reefs*. It was the first (and it turns out, the best) attempt to explain just how different reef types—and even some islands—are given their distinct shapes by corals. Though he had begun deducing the rudiments of his theory before he'd ever seen a true coral reef, in the Galapagos Archipelago aboard the Beagle in 1835, he could not have written it with authority until after his arrival in Tahiti some weeks later. From Point Venus (where James Cook disembarked for a historic discovery of the Great Barrier Reef), the twenty-six-year-old naturalist climbed a steep volcanic mountainside to "a height of between two and three thousand feet" to view the neighboring island of Moorea. Seeing how Moorea's mountainous high island rose "abruptly out of the glassy expanse of the lagoon" to be "completely encircled by a reef," Darwin

experienced one of those timeless instants of recognition in which hypothesis assumes the power of a scientifically provable truth. All reef types, it seemed, could be described by a single mechanism of formation.

When the Beagle passed nearby Bora Bora in the Society Islands (which Cook had charted and named), Darwin recognized that this apparently subsiding volcanic island, with its ring of well separated barrier reefs, might represent a transition phase between a high island circled by fringing reefs and an atoll—which is the ring of reefs that remains once the reef central to an island has fully submerged. Though he correctly assumed that these three phases of reef are a function of landmass subsidence, sea level rise, and the way corals tend to build reefs straight up, the simple and robust theory he created would remain controversial for over a century.

In 1887, near the end of Darwin's life, the Duke of Argyll—a creationist and ideologue bent on discrediting the perspicacious naturalist in the name of Christian dogma—denounced Darwin's reef theory and ignited the so-called "coral reef problem." Desperately wishing evolution untrue, religious zealots besieged Darwin with one superstition-based argument after another. Opposing arguments abounded based on Biblical interpretations and false or unprovable premises. One position, predicated on the geologically preposterous supposition that the world can be no older than 6,000 years, even argued that not enough time had passed for Darwin's theory of coral reef formation to be played out. Morally and intellectually exhausted, Darwin wrote to a colleague shortly before he died, saying that he wished a "doubly rich millionaire" would bankroll the core drilling of an atoll to prove once and for all the one theory of his he felt could be simply supported. Six hundred feet was enough, he figured, to hit incontrovertible pay dirt—or, rather, the basalt of a submerged volcano—and prove that atolls are built upon mountaintops that were once very near, if not above, the surface of the sea.

At one hundred feet above the fringing reef of Moorea, Howard could imagine how hundreds of thousands of years from now, it too, would be an atoll, as Moorea's subsidence continued. Too bad for Darwin that his theory took so long to become incontrovertible fact. In 1897, the Royal Society drilled into the island of Tuvalu, reaching 1,114 feet without hitting the predicted basalt. In 1936, a Japanese team pierced to 1,416 feet, and still no basalt. Not until 1952, when the U.S. Atomic Energy Commission sought proof that the foundation of Eniwetok Atoll (in the Marshall Islands) was stable enough to sustain the unimaginable forces of a thermonuclear blast, did the simple answer present itself. Penetrating the tiny motu of Elugelab Island to a depth of 4,630 feet, the Operation Ivy drill bit shuddered to a stop at what had once been the basalt surface of a volcano. Darwin's theory had just been confirmed.

Shortly after that, at 7:15 a.m. on November 1, 1952, "Mike," the world's first H bomb, was detonated with a force greater than all the Allied bombs dropped in Europe during World War II combined. Within three seconds, Elugelab Island, its coral reefs, and everything on them were gone—vaporized in the heat of a birthing star. With every 850 feet of biogenic limestone representing 100,000 years of work by corals, forams, and coralline algae, 578,750 years of gradual evolutionary progress were erased from the face of the earth in a flash of human ingenuity.

Gazing down on Moorea's coast, Howard realized he was looking upon the same fringing reefs Darwin saw when he gazed out from that mountain peak above Point Venus. But he also recognized an aspect of human industry Darwin couldn't possibly have seen—unchecked coastal development. As John banked the ultralight toward Tahiti, Howard felt that bittersweet unease that rises from time to time in anyone concerned for the balance of things: There are just too many of us making too great an impact without adequate knowledge or

Basalt
A dark, hard, dense volcanic rock that comprises the sea floor, or oceanic crust, and is rich in minerals like iron and magnesium.

Aerial View of fringing reef formations, South Pacific

FRINGING, BARRIER, ATOLL: Three Phases of Reef

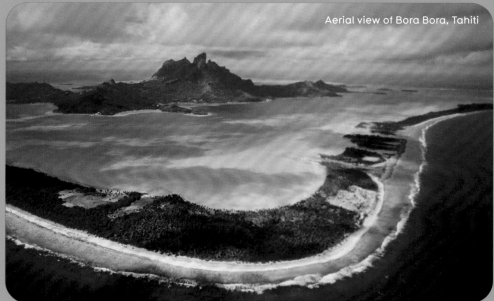

Aerial view of Bora Bora, Tahiti

Charles Darwin was the first to understand that the three main types of coral reef—fringing reef, barrier reef, and atoll—are formed through the same basic mechanism by corals and other reef-builders. Reefs grow upward to stay in the sunlit surface waters as the submerged land mass beneath them subsides and sea level rises.

A fringing reef is a geologically young reef growing in the shallow waters on the flanks of an island or the shelf of a continental coast.

As the land mass subsides and seawater levels rise, the fringing reef continues to grow upward. A lagoon fills the gap between the slowly receding coast and what is now a barrier reef.

If this process continues long enough around a deepwater volcanic island, the central island may eventually disappear beneath the surface, leaving only an atoll, a halo of reef dotted with low coral islands.

Aerial view of Tupia, near Bora Bora, Tahiti

As a white cloud here
and there affords a pleasing
contrast with the azure sky,
so in the lagoon, bands
of living coral darken
the emerald green water.

—CHARLES DARWIN, 1838

concern for what that impact means to our planet. This was evident in the yachts, hotels, docks, and sewage outlets jutting out toward the reefs. And it seemed ironically evident in the faint sheen of bilge oil Howard saw casting its dark rainbow in the still lagoon waters of the one tourist destination touted above all others as "paradise."

Some 230 years ago, Lieutenant James Cook's crew began the legend when they found Tahiti populated by obliging, golden-skinned women eager to trade sensual favors for the fee of one iron nail. A lopsided trade, it would seem, until one understands that a bent nail can feed a family more effectively than a fishhook of brittle oyster shell and provide its owner with a profit from any surplus. Indeed, the demand became so great that to keep the *Endeavor* from being pried apart during their three month bivouac at Point Venus (and to curb the spread of venereal disease between his men and the local women), Cook banned the nail trade and promised stern lashings for any liaison purchased with iron.

Today's Tahiti, and much of French Polynesia, is developed, modern, and, well, quite French. After all, it and the rest of the 120 islands spread over an area the size of western Europe, were much more vigorously colonized than Fiji. As a consequence, one does not get the feeling the Tahitan people live quite so closely to their reefs. Big, boxy hotels and astronomical prices make tourism here feel like the industry it is, while the more recently introduced industry of nacreculture employs the descendants of

subsistence-reef gleaners in the outer islands and lagoons to provide black pearls for the jewelry trade. Meanwhile, ultra-modern nuclear testing has cracked the very foundations of atolls, poured money and technology (and radioactive fallout) into the islands and the seas around them, and provided various kinds of employment to many into the mid-1990s. With money to be made in commercial fishing for the French and Asian markets, or growing black pearls, or providing honeymooners with bungalows slung over postcard sandy beaches, why hand-catch a few fish for a dinner you could otherwise buy along with that satellite TV and car? Money talks more and more in Polynesia, while the reefs hush in the background.

With the ultralight lifted by crane to the *Undersea Hunter*'s upper deck, Howard and his team said good-bye to Greg and his topside crew and took on supplies in Papeete harbor in preparation for the last leg of their journey to Rangiroa Atoll. Shortly after that, by coincidence, an old friend stopped by to say hello: Peter Benchley, author of *Jaws*. The two men had met years before when Howard helped film the under-water sequences of *The Deep*. At the time, Peter watched Michele and a manta ray perform an aquatic *pas de deux* that inspired him to create the protagonist of his book, *Girl of the Sea of Cortes*. More recently, he had finished a tour throughout Asia, speaking on behalf of the world's maligned, misunderstood, and overfished shark population, and urging Asian governments to take steps

nacreculture
The practice of culturing mollusks for their ability to form pearls out of nacre, an iridescent substance lining the insides of their shells, also called mother-of-pearl.

BELOW, FROM LEFT TO RIGHT
Friend and ultralight pilot John Dunham, helps Howard survey the reefs of Tahiti and Moorea from the air for signs of coral bleaching or large schools of sharks.

to reverse the long-standing tradition that makes it a matter of pride and honor (or "face") to buy, order, or serve shark fins in restaurants and homes. Each year, shark finning causes at least 70 million sharks to be clipped of their dorsal and pectoral fins and thrown back just to bleed to death—all for a bland gelatinous goo used to thicken soup. Keypunch "shark fin" into a web search engine and you can easily find the Hong Kong Tourism Board's web site, where dried abalone, sea cucumber, and shark fin are touted as "great gift items" for the "maintenance of a healthy immune system." While such claims are believed by many people to be true, whose immune system have sharks evolved to maintain—ours, or the reef's?

Peter had just been taken by his taxi driver/guide to visit a boatyard where he saw a long-liner under construction. A long-liner is a fishing boat whose two-mile tail of baited hooks can attract every shark from a nearby reef, stripping it in a single pass. According to the taxi driver, one hundred such vessels were under construction throughout French Polynesia at the time. If this was so, the sharks of paradise were in trouble.

Howard knows all too well that long-liners indiscriminately kill large **pelagic** fish. Two years earlier, he had seen a whole population of silvertip sharks yanked from their home on a seamount near Cocos Island, Costa Rica, by the single pass of a long-liner not even targeting them. They, and every other member of the dwindling shark species at Cocos, were simply what is called by-catch. If they were used at all, they were finned alive and thrown back. Knowing this, it doesn't take a huge leap of imagination to visualize the reefs of Polynesia—or anywhere else for that matter—stripped to deserts in a very short time. And once again, the Ten-Year Rule accelerates.

Since **apex predators**, like sharks, are also indicator species—ecological barometers which tell us how well the rest of the food chain is doing by their own well-being—a lot of sharks in an area probably mean things are pretty healthy. They have to eat, after all. But sharks missing from an area they would normally inhabit, when removed suddenly and unnaturally by man, tell us nothing. Hoping to capture one of the largest known grey reef shark schools in the world on film before offshore long-liners could exterminate it, Howard and Michele decided to make the final dives of the expedition at Rangiroa Atoll.

As the ultralight was lashed down for the passage to Rangiroa, Howard and Michele said good-bye to Peter and prepared to disembark. But a cyclone far out in the Pacific had roughed up the seas, delaying the expedition's departure by several hours. Tropical cyclones—hurricanes in the Atlantic Ocean, typhoons in the Indian and western Pacific—are vicious storms which can turn reefs to rubble and pulverize coastal communities, but there's one thing they don't seem to hurt much—mangroves, one of the toughest forms of vegetation on the planet.

apex predators
Animals at the top of the food chain that have no natural predators

pelagic
An organism whose origin is the offshore open ocean waters beyond the continental shelf

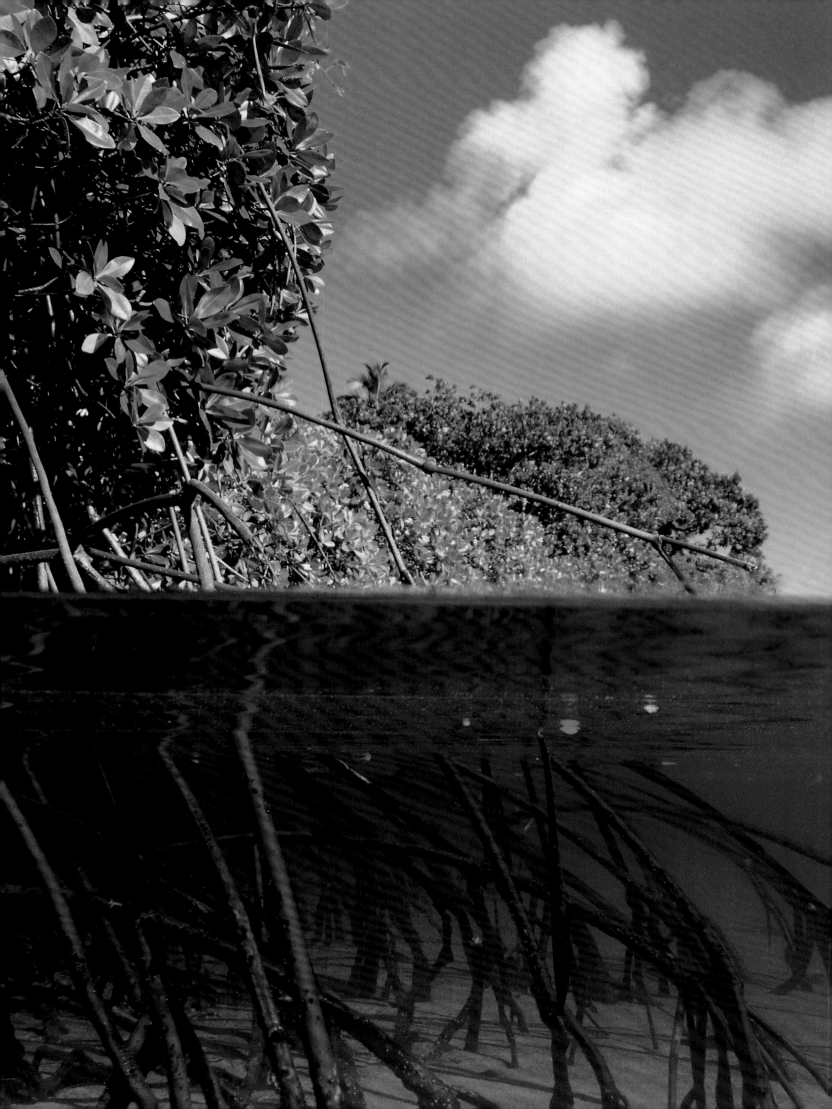

Hurricanes may not kill mangroves, but bulldozers do, which is what worried Howard about all the coastal development he saw from the air. To make way for luxury homes and resorts, developers throughout the tropics are parceling paradise out for profit, knocking down and filling in the flats that the mangroves have long occupied. In the meantime, shrimp farmers in Vietnam, Indonesia, and throughout Southeast Asia are slashing tidal mangrove stands to raise the pink crescents of appetizer trays in artificial impoundments. These impoundments are productive only five to ten years before dwindling productivity forces the aquaculturists to move down the coast and slash again. Add the fact that they possess a bark useful for tanning leather and a wood good for furniture, and we find the mangrove forests of the world going down in droves. Traditionally (and erroneously) associated with breeding disease-carrying mosquitos, and cursed for hampering shipping and coastline access, why should we care about mangroves?

Just as most fringing reefs begin a few inches from shore, most reefs have a partnership with a member of the shore community not immediately evident to the eye—a partnership with mangroves, the ultimate lagoon plant. Mangrove prop roots form the crib slats in the nursery of the seas; while juvenile fish live among them, the mud beneath teams with the nutritious microbes, plankton, and crustaceans, forming some of the most significant threads in the oceanic food web and making the mangrove ecosystem the most biologically productive marine environment there is, next to coral reefs. Remove this food factory and nursery, and almost instantly the associated reef slumps into decline.

But there's a more mechanical, more muscular function mangroves perform: In cooperation with their partner reefs, mangroves create land and protect it. By trapping significant amounts of runoff silt and agricultural fertilizers, mangroves discourage sedimentation and the algal blooms

that would otherwise smother coral on the nearby reef. In return, the reef buffers the mangrove habitat and creates the limestone which, through the action of waves and the nibbling of parrotfish, eventually becomes the marl in which the mangroves grow. As the fringing reef continues building farther and farther from shore, the mangroves tend to keep pace with it, trapping sediment, stabilizing soil, adding humus, building land. In a thirty- to forty-year period, Biscayne Bay, Florida, saw a land mass increase of 1,500 acres through this natural process. No bulldozers necessary.

Now, as mangroves fall, so do islands. The very global warming that helps atolls form by slowly melting glaciers and raising the level of the seas is eroding islands into nonexistence where either member of this reef-mangrove partnership is weakened or removed so it can't maintain the crucial land-building/land-buffering cycle. But is the current sea level rise of three millimeters a year really enough to swallow an island? The answer is no, not on its own. Healthy islands don't just disappear under rising water. But islands, particularly low coral reef islands like the *motus* formed on atolls, can disappear in a surprisingly short time if they are not continually rebuilt by the addition of new coral sand and beachrock; and if they are left unprotected from the destructive forces of the sea, allowing tidal action to inundate the freshwater table with salt and killing the last thing knitting the island together—its trees.

"The reefs of today are the artifacts of an unusually long period of relatively constant sea level," coral biogeographer Charlie Veron reminds us. Take away the reef, and you take away an island's outer buffer. Take away the mangroves, and you take away its inner defense. Take away either, and you take away both. Couple a slow ocean rise with an island's subsidence (if it is volcanic in origin), and it isn't difficult to understand how Fiji's Gau Island lost 200 miles of coastline in recent years, and how the South Pacific nation of Kiribati saw the

humus
Decomposing organic matter (derived from the bodies of dead plants and animals) that improves the fertility of the soil.

Partners with the reef: Mangrove prop roots filter harmful runoff silt and agricultural chemicals from lagoon waters and anchor rich muds teeming with invertebrate life.

sacred island of Tebua quite literally melt into the sea. By this same mechanism, many atolls—like Palawan Bank in the Philippines, or the Maldives' Great Chagos Bank in the Indian Ocean—have slipped into the sea, becoming *guyots* whose reefs—if they cannot keep pace with subsidence and stay in the sunlit zone necessary for coral calcification—will die.

While the Halls weren't immediately concerned that any of Rangiroa's 240 motus would disappear anytime soon, they were worried that the tropical depression hundreds of miles to the north was adversely affecting the tides in the 1,016-square-mile lagoon of the world's second largest atoll, and that it would cause the sharks to leave the reef passes and head to deeper ocean where they could not be filmed. Michele, in particular, was beginning to feel another kind of pressure, as the expedition's clock and budget were beginning to run out. With the ocean still roiling with gut-churning swells, the *Undersea Hunter* slipped out of Papeete's safe harbor for the 217-mile passage to Rangiroa. It was tough slamming through that stretch of sea, and the distance was doubled because of the rough water's increased surface area. But that was nothing compared to the journey taken by the water itself.

Like the air we breathe, the waters of our oceans churn and intermix endlessly, continually sharing the ubiquitous liquid marriage of oxygen and hydrogen with every living thing, without bias or exception—present, past, and future. No sea is truly isolated. No wall or border keeps living beings in the Atlantic from intermingling with those in the Pacific but their own particular temperature, pressure, salinity, and sunlight requirements. Eventually the water brushing against any shore brushes against them all on an endless voyage that makes the phrase "epic journey" a trifle in the light of geological time. Water, the one substance no living thing can survive without, knits everything together. It shapes every facet of Earth's surface. It shapes our lives.

Driven by surface winds, thermal sinking of cooled waters, and the forces generated by the Earth's rotation, some of the water laving the reefs of Howard's destination, Rangiroa, had traveled at least 44,000 miles under a half-dozen aliases on one of many legs of an endless hydrological odyssey. At some point in the past, it had stroked the shores of every one of Earth's 230-some countries except the 25 that are landlocked, and even those it had touched as snow, rain, glacier, river, or cloud. Many months earlier this water may have been heading south from Baffin Bay, between the North Atlantic coasts of Greenland and Northeastern Canada. As the cold Labrador Current, it would have followed the Continental Shelf south, passing and mixing a little with the Gulf Stream, then passing deep beneath the calm Sargasso Sea. Crossing the equator and the Doldrums—still headed south—it would have found itself piggy-backed by the warm Brazil Current as it passed into the Horse Latitudes. Near the Falkland Islands off the coast of South America, it would have crashed into the cold-water express known as the Antarctic Circumpolar Current, which, because it is driven by the strong prevailing winds of the West Wind Drift, would give the water a one-way ticket east across the southern ocean. Brushing the tip of South Africa in the Roaring Forties, it would have rushed (at almost two miles an hour!) past lonely Prince Edward and Crozet Islands and crossed the entire 6,200-mile breadth of the Indian Ocean without pause, spilling into the South Australian Basin, then welling up over the Tasman Plateau and dumping into the Tasman Sea. From there it would have continued, crossing the entire South Pacific, turning north off the southwest coast of South America (where some of it would have up-welled to the surface in a non-El Niño year). Then, somewhere around the equator, a portion

Mangrove prop roots form the crib slats in the nursery of the seas; while juvenile fish live among them, the mud beneath teems with the nutritious microbes, plankton, and crustaceans ...

MANGROVE LIFE

Mangroves—shrubby trees found in or near the tropical intertidal zone—have a healthy relationship with coral reefs. The calm waters and soft sediments behind the reef provide a suitable environment for the trees, which further stabilize the muds and reduce siltation that can impede reef growth. As fringing reefs make the slow transition to barrier reefs, mangrove stands often match that pace with work of their own: stabilizing soil and building land while providing a safe haven for a wide variety of marine life forms. Today, mangroves—and the reef communities they support—are in jeopardy. Coastal developers are tearing them down to make way for new homes, resorts, and shipping lanes, removing the biological anchor of the intertidal ecosystem and destroying a vital habitat. Shrimp farmers, too, clear out the trees to make room for mariculture impoundments. As the mangroves fall, so do the thriving reef communities they work in tandem with.

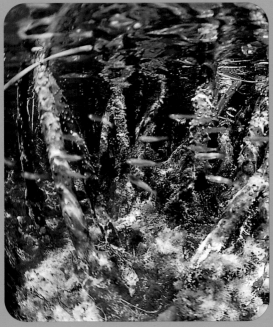

TOP Mangrove roots and Turtle grass (*Thalassia testudinum*), both essential to filtering water and serving as nurseries for juvenile fish, and umbrella-shaped Green Mermaid's Wine Glass (*Acetabularia calyculus*) algae on foreground roots, Florida Bay, Everglades National Park.

LEFT: Blue crab (*Callinectes* sp.) in Turtle Grass of a mangrove flat, Florida Bay, Everglades National Park.

Red Mangrove roots underwater in Florida Bay, Everglades National Park. Encrusted with sponge and algae, these tropical structures are nursery host to a wide variety of juvenile fish and crustacea. Mangroves are now protected in the Everglades and Florida Keys National Marine Sanctuary.

of this water would have swirled up into the wind-driven currents of the surface layers, as it would finally start to warm. Caught in an offshoot of the South Equatorial Current, it then veered slightly south to find itself rushing as an incoming tide through one of the two navigable passes into the vast lagoon of Rangiroa Atoll.

As the tide pushed *Undersea Hunter* through Tiputa Pass, it took the explorers past black pearl farmers sending drab green slurry plumes into the lagoon as they hosed seaweeds from black-lipped oysters with power washers in all the name of neck-laces. It pushed them past the bungalows of a dive resort and the boats of spear fish-ermen until, on the lee of the low coral island of Reporepo, the ship came to a full stop and dropped anchor. Immediately, Howard and his crew prepped their gear for a dive, hoping to locate the school of sharks before conditions changed.

Howard always starts his dives with a briefing. In this case, the goal, the method, and the danger were outlined by local dive master Yves Lefevre, the Frenchman who promised, if the weather and tides would cooperate, to lead Howard to the sharks for "fantastique shots for ze EMAX!" "Be care-ful," Yves warned, "to hug the wall," because Tiputa Pass, where the school of sharks could often be found, was famous for its nine-mile-an-hour current, capable of whisking divers two miles out into the open ocean in a mere thirteen minutes.

"These are gray reef sharks, which have bitten people," Howard warned as the divers pulled their wetsuits on. "Wear gloves; fingers look too much like bait fish. And if one faces you and goes into a threat posture—hunches its back, drops its pec-toral fins, and shimmies side-to-side like a dog—don't wait around to see what's next." To underscore this point, Yves car-ried a sawed-off golf club just in case he found it necessary to bop an aggressive shark on the sensitive electroreceptors embedded in its nose, thus scrambling its radar and giving the threatened diver time to get out of range.

It was a typical day in Tiputa Pass: rough seas, five-foot swells smashing the reef a few boat lengths away, everything rocking. "I don't like this wind," said Howard, pausing to reconsider.

"It's going to make it hard to launch the camera," said assistant cameraman John Anderson, loading the film magazine.

Cinematographer Brad Ohlund agreed. "Good day to lose a finger," he said, clip-ping the housing into the winch.

"Oh well," Howard shrugged, and with dry, good-natured laughs all around, the camera was hoisted into the turbid water.

On his back, in sixty feet of water, Howard finned hard, lugging the ponder-ous IMAX camera in a traveling pull-back shot. On its video monitor, Michele could be seen swimming toward him like a siren in the surge. All around her, dozens of black surgeonfish dawdled and drifted. The slightest contact with their scalpel-sharp caudal fins would have left a wicked gash, even through her thick neoprene wetsuit. But that's nothing compared to what the grin of the eight-foot-long silvertip shark now gliding into the frame behind Michele could do. The shark headed straight at the camera, yawned toothily, then veered off a split-second before contact. As the soli-tary shark faded down the reef, Howard caught the glimmer of something in his peripheral vision and swung around. A shoal of maybe 150 yellow, algae-grazing convict tang—actually, more like a herd—were stampeding over the reef in a tight formation reminiscent of a cattle drive, but even more fluid, like lava. "Molten fish!"

Our planet is surrounded by two oceans—one of air and one of water—which constantly intermix. Wave action seen from below. Gau Island, Fiji.

"Big Blue" and Beyond

by Howard Hall

At the beginning of our second expedition for *Coral Reef Adventure*, I decided to capture the symbiotic behavior of a cleaner wrasse plucking parasites from angelfish. It was a common behavior we saw during nearly every dive while working in the waters near Fiji. After an early morning briefing, I added a few words of encouragement for my underwater crew. "This should be easy," I said. The comment was met with a collective groan and skeptical grins. Everyone on board the diving vessel *Undersea Hunter* knew that no sequence is easy when filming underwater in the IMAX format. My crew also new that my saying a sequence should be easy almost always precipitated days of comic frustration.

Predictably, the filming did not go well. At first, the cleaner wrasse seemed inhibited by the movie lights and all the bulky alien gear. So we spent hours waiting for it to acclimate. Finally, the wrasse seemed to accept the lights, but as soon as the noisy camera began to run, the fish would dart away and hide in the reef. At last, on the third day, a wrasse seemed to accept both the lights and the sound of the camera. Ten seconds into the shot, the camera jammed. By the end of the fourth day, we had shot more than $10,000 worth of film and had captured only one usable shot. Back on the boat, I suggested to my crew that we abandon the angelfish and begin working on a sequence of a Triton Trumpet snail feeding on a Crown-of-thorns starfish. The triton trumpet is deaf, slow, nearly blind, and completely stupid. These are ideal wildlife qualifications for IMAX subjects. "This should be easy," I said. My crew groaned theatrically. Then everyone laughed.

I love making underwater IMAX films because it is so difficult. Every feature of the IMAX format conspires to drive a cameraman to the brink of insanity. The underwater camera system weighs 250 pounds. Though neutrally buoyant underwater, this enormous mass renders the camera almost impossible to control in the slightest current or surge. To capture a steady shot the camera must often be mounted on a tripod that weighs 65 pounds. Then two or three 20-pound sacks of lead shot are usually required to anchor the tripod to the bottom, in hopes of preventing the camera from tumbling over in the current. To capture true colors underwater, artificial light is almost always required. But because IMAX lenses are so wide, much greater amounts of artificial light are necessary than for smaller motion picture formats. Our underwater lights require 2,000 watts of power transmitted through a cable by a generator on a boat floating above the divers. The depth of field of these lenses is miniscule, making it extraordinarily difficult to keep anything but the most comatose animal in focus. Then, when the camera is switched on, it makes a noise like a lawn mower with a bad bearing, causing many wild species to flee in terror. Because it takes the camera motor nearly five seconds to accelerate the film to running speed, often all that is captured on film is the distant, fleeing butts of creatures that have been terrorized by the noise.

If all these features of the IMAX format are not enough to cause a filmmaker to leave the water screaming, there is one final blow: the film load is only three minutes long! After shooting for a mere three minutes (at a cost of over $3,000) the camera must be returned to the surface, disassembled, and reloaded.

IMAX is simply the most inefficient and impractical motion picture format ever invented for filming wildlife underwater. But therein lies the fun! Shooting underwater in IMAX is like running a three-legged race. You begin the race knowing you are going to fall flat on your face almost as soon as the starting gun fires. But each time you do fall, you go down laughing. You finish the race exhausted, bruised and dirty, but happy. Winning the race is not as important as the fun you had trying to reach the finish line.

What does it take to make underwater IMAX films? It takes dogged persistence, a positive attitude, and an undefeatable sense of humor.

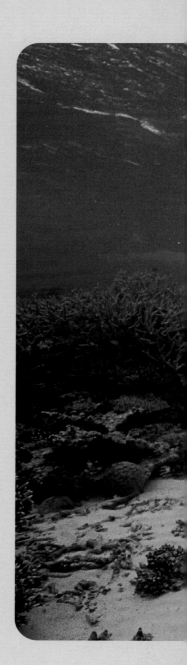

RIGHT The slow-moving Triton trumpet snail feeding on a Crown-of-thorns starfish despite its highly toxic spines, is a subject requiring extreme patience to film.

BELOW Howard scans for subjects on the Great Barrier Reef.

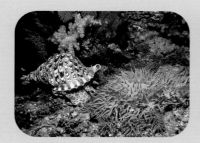 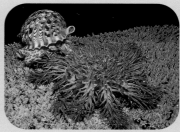 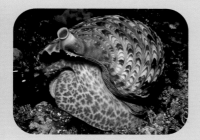

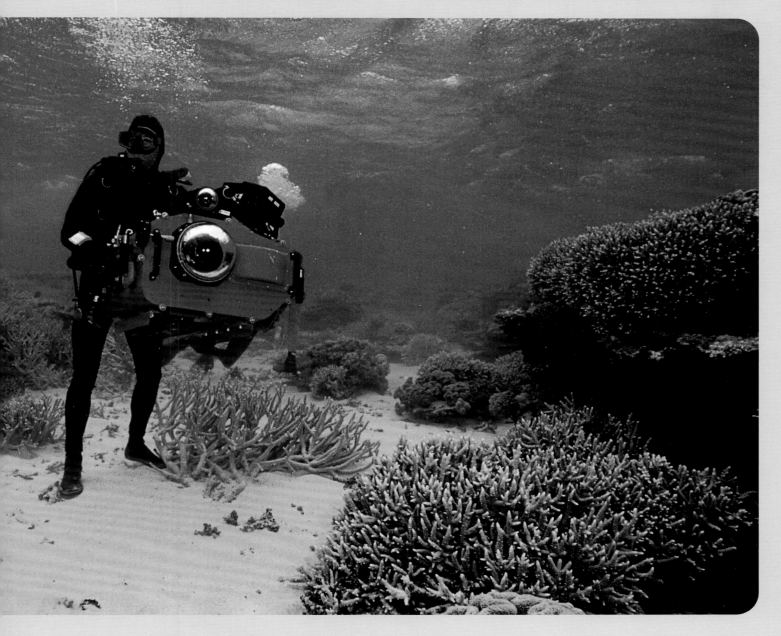

Mark Conlin's voice crackled over their earphones.

It was a beautiful shot. So was the one that followed of a great manta ray gliding into a cleaning station for a wrasse flossing. But the famous shark school was nowhere to be seen.

"Ze tide is not ideal," Yves said back at the surface. He explained that the low pressure associated with the storm to the north had kept the lagoon from filling normally on the incoming tide. "The sharks are best on a strong incoming tide," he said. "Better clarity and no chance to be swept out to sea. We wait two or three days, and then. ..."

While they waited, Howard and John took the ultralight up to see if they could spot any sharks from the air. Once airborne over the atoll, Howard immediately noticed that all the corals on the reef were the same smallish size: The brain corals were football-sized, and the table corals all about the size of dinner plates. This was because, ten years earlier, a cyclone had pulverized the reef. A natural process had broken the reef; but natural processes were also hard at work repairing it. Which meant—for the time being at least—that Rangiroa would not dissolve into the sea.

They found no sharks. But Howard's view of the vast reef system did give him an expansive sense that he was on the verge of comprehending at least a small part of the big picture—that great interconnectedness of all things, in which events half a planet away can have far-reaching effects, and things not traditionally associated with the seas can have a great impact on them. Take, for example, dust.

A short four pages into his *Voyage of The Beagle*, the ever-observant Darwin speaks of an "impalpably fine dust," sifting out of the sky and onto the ship's decks and sails near the Cape Verde Islands off western Africa. Ever the model of the thorough naturalist, he collected several packets of the dust and had them assayed at the end of his voyage around the world by a microscopist named Professor Ehrenberg.

Ehrenberg found the dust contained at least sixty-seven different forms of microscopic organisms, which could only have grown in freshwater or somewhere on land. Darwin then went on to find "no less than fifteen different accounts of dust having fallen on vessels when far out in the Atlantic," and always during the months when windstorms called harmattans ravaged the African coast. His conclusion: The dust originated in Africa.

When they receded, the great glaciers of the last ice age left behind thick layers of loess. Each year about a billion tons of this loess is lofted into the atmosphere. Enough yellowish loess leaves Mongolia's Gobi Dessert, in fact, to lend China's Yellow River and Yellow Sea their color and their names. Meanwhile, a half-billion tons of reddish loess is sucked 1,500 feet into the air above the Sahara by dust devils every year. With the aid of orbiting satellites and precision optics, we can now see what Darwin surmised—a great dust plume billowing out of Africa so distinctive that we have given it a name: the Saharan Dust Layer, or SDL.

Once airborne, the SDL glides upon the inversion layer formed when the earth cools at night, moving at speeds up to 50 miles an hour and as much as 500 miles in a single night. Then these iron- and nutrient-rich loess are broadcast to wide swatches of land and sea. The SDL is the likely source of nutrients for the relatively still and nutrient-poor Sargasso Sea—breeding and feeding ground to a vast array of sea life. Thirteen million tons of SDL loess fertilize the Amazon rainforest's upper canopy; otherwise, an entire ecocosm of bromeliads, orchids, and insects would not thrive. In fact, fossil pollen records show that whenever the Sahara waxed greener, moister, and less dusty, the Amazon rainforest showed signs of collapse, strongly suggesting that the availability of these wind-borne nutrients—not rainfall—is the single greatest catalyst of rainforest health. Giving credit where it's due, the Amazon rainforest could well be called the Amazon dustforest instead.

Large pelagic fish, like this manta ray, also frequent the reefs. Rangiroa Atoll, French Polynesia.

loess
A fine, fertile sediment composed of glacier or wind-deposited silt or clay containing various mineral elements

bromeliads
Any of a family of predominantly tropical herbaceous plants, including Spanish moss, the pineapple, and a variety of other ornamentals

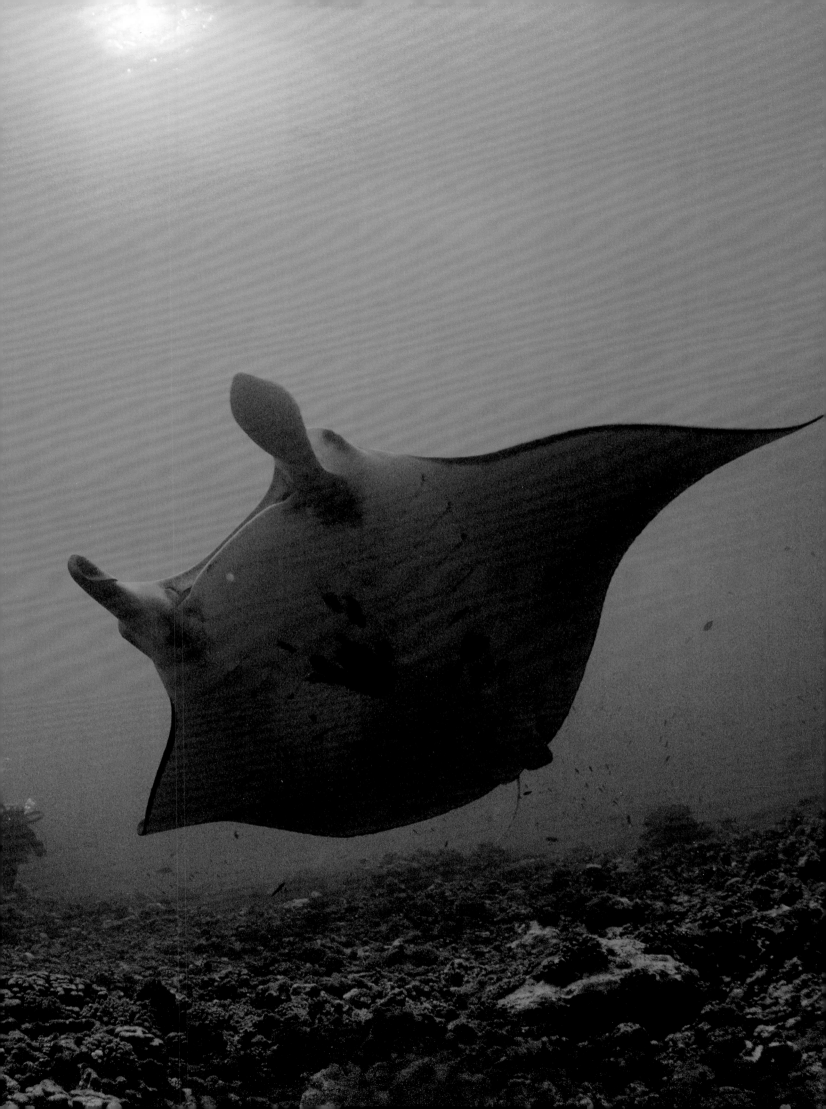

Does atmospheric dust somehow nourish coral reefs? Nobody has studied this, so we don't know. Yet we do know the SDL has, quite literally, a dark side when it comes to corals. Instead of reflecting solar energy as volcanic dust veils do, thus cooling the planet, the SDL's nightly blanket traps each day's radiant solar heat before it can escape into the upper atmosphere. Thus SDL is implicated, along with greenhouse gasses, in the complex global warming scenario and in the epidemic fatigue of coral bleaching as well. But there's more. Apparently SDL delivers a one-two punch to corals, not only contributing to their vulnerability through bleaching, but dumping all kinds of viral and fungal spores onto the reefs—like *Aspergillus sydowii*, a common soil fungus that cannot reproduce in seawater yet is killing sea fans throughout the Caribbean.

Recently, Gene Shinn of the U.S. Geological Survey found correlations between peak SDL events and El Niño events. He believes that spikes in coral maladies like black band disease, white band disease, sea fan disease, and sea-urchin die-off—and the algal blooms which have ravaged the Caribbean reefs over the last two decades—may be seeded (or in the case of the algal blooms, fertilized) by SDL, especially since both coral bleaching and the spread of infectious coral disease speed up dramatically above a temperature threshold of around 30 degrees Centigrade. If bleaching is the AIDS of coral colonies, weakening their resistance, dust may be the vector of disease.

There is probably no more optimistic structure in nature than a coral reef. Yes, today's reefs are declining at a suddenly alarming rate; but the reality is that reef populations have been expanding and contracting, and going extinct and being replaced by new species, in an ongoing evolutionary cycle that is so long it almost defies human comprehension. During the Paleozoic era, limestone reefs of an entirely different species composition covered more than ten times the area of today's coral-based reefs. Likewise, there were times when corals occupied only one-hundredth their present range. While many present day coral genera (like *Montastraea*) were around before flowering plants evolved, there are subsequent points in geological time when they apparently disappeared from the fossil record altogether. The fact is the corals and other species that have created the reefs as we know them today have not always done so, nor will they always continue to do so. So what do we make of today's apparent change for the worse?

We are only now beginning to understand that global ecology is an interlinked system of complex nonlinear couplings in which events far from a reef, or a mountain, or a jungle, or a prairie, can impact it in vital ways. Oceano-atmosphere events like El Niño affect the moisture of mountaintop cloud forests; mountaintop logging sends choking silt runoff to the bottom of the sea. No place is independent of others on this planet, and now, because of our numbers and resourcefulness, no place is unaffected by the activities of humankind. Meteorologist Michael Garstang puts it well in his essay

FROM LEFT TO RIGHT The 9-mph current of Tiputa pass can whisk divers into the open ocean or give them a free ride back inside the lagoon. Vegetarian grazers like these Convict tangs and Triggerfish keep the corals from being smothered by faster growing algae at Rangiroa Atoll, French Polynesia..

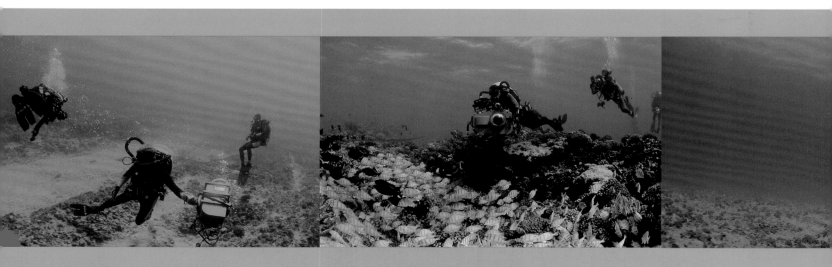

"Winds of Change": "Mapping the complex interconnections of Earth's systems and understanding the importance of these long-distance links (called *teleconnections*) is essential if we are to understand the interdependency of the world's ecosystems." While understanding this intricate balance is difficult, the overall answer to stabilizing it is quite simple: We've got to lessen our impact on the mechanism of nature.

Howard could not have agreed more. When the sharks failed to show during the scouts by sea or air, he began to wonder if maybe a long-liner hadn't already done its damage to the local shark population. In the meantime, Michele worried that the expedition would end, and they would leave Rangiroa without the crucial footage they had come for. But Yves was optimistic; he had a theory that the sharks were hanging deep in a pocket near the mouth of Tiputa Pass, down in the twilight zone.

Putting his hard-earned deep-diving knowledge to use, Howard followed Yves' hunch, diving 250 feet to the pocket. But the sharks just weren't there. With six days left in the expedition, Howard drifted back into the strong current of the pass with Big Blue full of unexposed film once again, getting ready to surface in disappointment. That's when perseverance paid off by coincidence. Hunkered at 100 feet in a comfortable side canyon, just far enough from the main current to be calm water, was the shark school.

Leaving the current, Howard and his crew quickly positioned themselves near the school. Then, as upwards of four hundred gray reef sharks approached Howard dead-on, Bob and Peter drifted around to the rear of the school, causing the sharks to rush at Howard, split, and regroup behind him like a school of jacks or sardines, though these were much bigger than either.

It was a beautiful shot. But Howard couldn't help seeing it through the eyes of a man all too familiar with the creeping absence described by the Ten-Year Rule. How many more sharks were here five, ten, twenty years ago? he wondered. These magnificent sharks—indicator species whose numbers tell-tale the health of the reef— would all too soon, if the long-liners prevailed, indicate nothing. The possibility of this gave Howard an appreciative sense as he left the water that day, like he had just seen a beautiful sunset over an ocean community that may not see many more dawns.

How do we witness apparently degenerative megachanges like desertification and mass reef death with faith in their naturalness and hope for their reversal? How do we assist, not interrupt or hinder, the positive processes of nature? As the late philosopher Eric Hoffer once put it: "In a time of drastic change it is the learners who inherit the future. The learned usually find themselves equipped to live in a world that no longer exists." We are living in such a time. We need to learn more about what we affect and how, to ensure that our good intentions have good and lasting effects. There are just too many of us, or very nearly too many, for the natural resources of this one small planet to bear. Yet as biologist Edmund O. Wilson has pointed out, we have just one planet to experiment on. In our

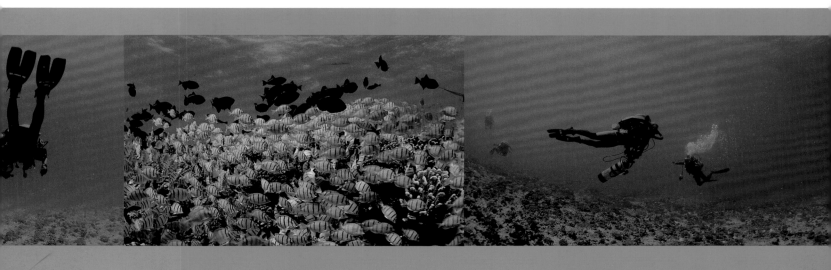

numbers and our cleverness we have brought ourselves to a crossroads, and the choices are anything but clear.

Perhaps the answers lie in how we see ourselves in nature. If we could view ourselves the way we view the creatures of the reef—as part of nature, not apart from it—we would see that we, too, are symbiotic and subtly yet inextricably linked to all creatures in ecosystems, dependent on them and depended upon in return. In that sense, then, we would also see that any act of ours toward saving the reefs—or at least not continuing to destroy them—is an act toward saving ourselves. From an Australian bumper sticker's rallying cry of "Save the Reef" in the 1960s, to the growing concern of people everywhere, momentum is building, so there is hope. And with the many worthwhile reef advocacy organizations to support or join, individual efforts can be magnified tenfold. [Please turn to the back of this book for some suggestions on how to contribute.]

For Howard and Michele—for Greg and the MacGillivray Freeman filmmaking team—this coral reef adventure started as so many odysseys do: with a deep personal need to bring what is distant and elusive into intimate range. They had hoped to make the exotic world of coral reefs more familiar to those who cannot experience it directly, and to fix and preserve what is special about our world for generations to come. To their minds, none of the world's wild places are more beautiful or otherworldly than coral reefs. Certainly, none are more biodiverse or complex, and few are as threatened. They have succeeded in showing us this much in their film, *Coral Reef Adventure*. Now millions of viewers can see that each reef is a world whole, an ecocosm, a brilliant living mirror into which, if we gaze carefully and persistently, we are certain to see answers to the health of our planet and ourselves.

It had been a big adventure, yet it all depended on a tiny animal. So do we all. Without the hard corals and the spirit of cooperation they embody, no reefs, no lagoons, no coral islands and atolls, and no island culture throughout much of the tropical world. Without the quiet perseverance of reef-building corals, the world would certainly be a different place. If you doubt it for one second, just imagine the world without them.

That said, there is much that we can do.

Even after sunset, the long day isn't over; air tanks, rebreathers, and cameras must be serviced and stowed for the long ride home.

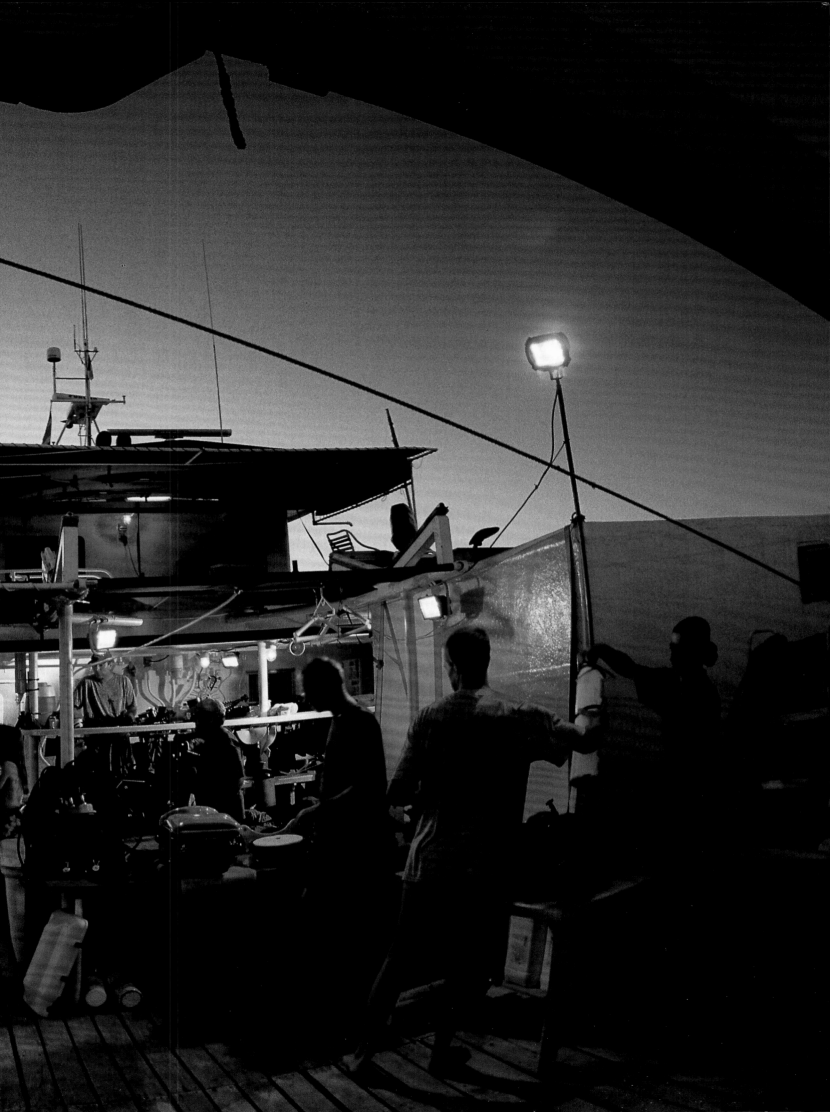

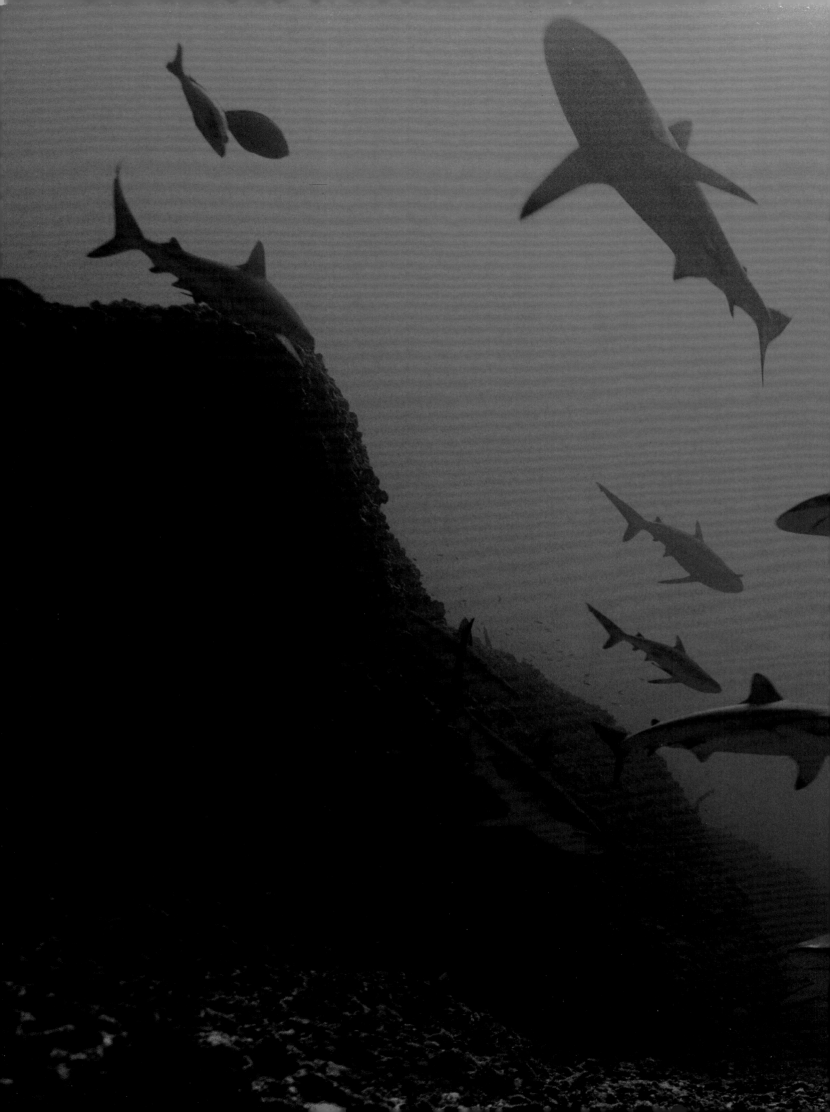

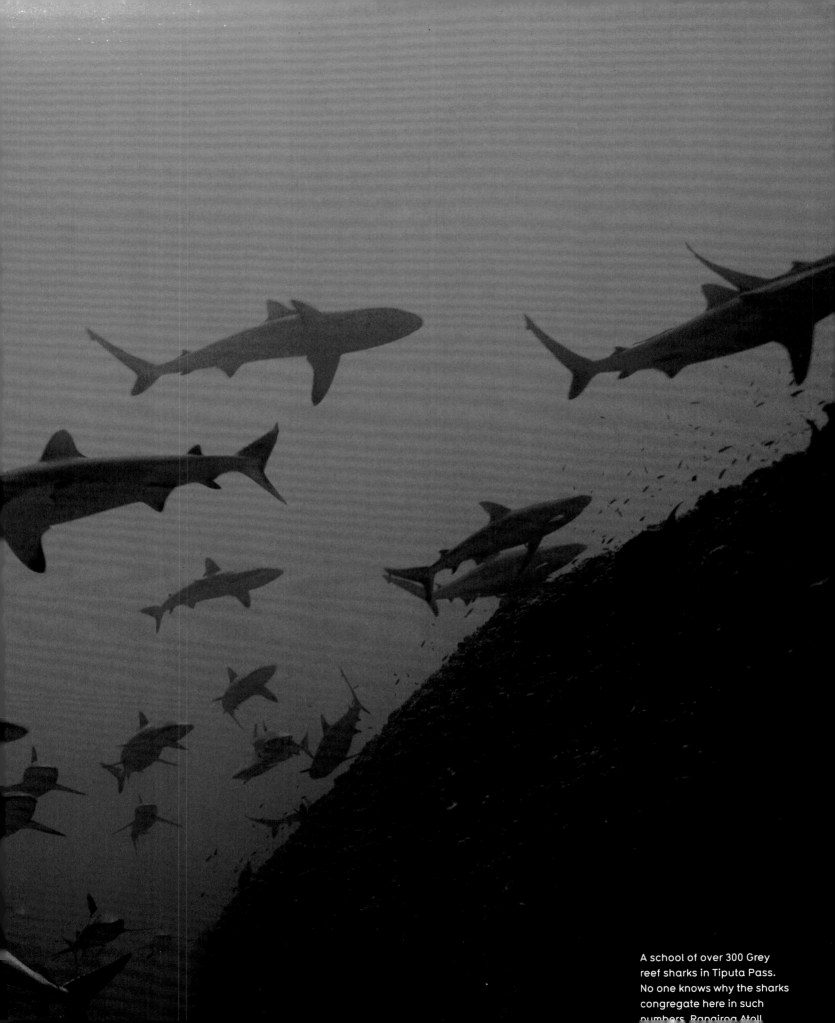

A school of over 300 Grey
reef sharks in Tiputa Pass.
No one knows why the sharks
congregate here in such
numbers. Rangiroa Atoll.

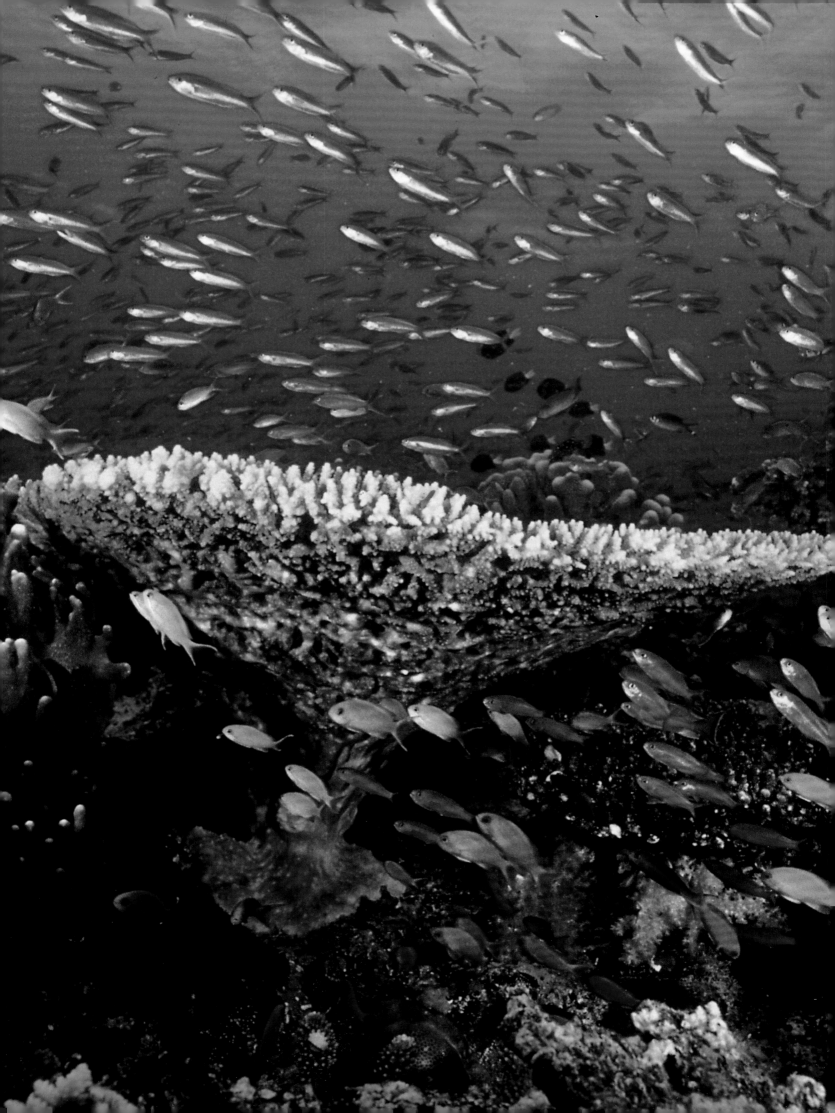

The Solution

by E. O. Wilson

The human species is like the mythical giant

Antaeus, who drew strength from contact with his mother, Gaea, the goddess of Earth, and used it to challenge and defeat all comers. Hercules, learning his secret, lifted and held Antaeus above the ground until the giant weakened—then crushed him. Mortal humans are also handicapped by our separation from Earth, but our impairment is self-administered, and it has this added twist: our exertions also weaken Earth.

What humanity is inflicting on itself and Earth is, to use a modern metaphor, the result of a mistake in capital investment. Having appropriated the planet's natural resources, we chose to annuitize them with a short-term maturity reached by progressively increasing payouts. At the time it seemed a wise decision. To many it still does. The result is rising per-capita production and consumption, markets awash in consumer goods and grain, and a surplus of optimistic economists. But there is a problem: the key elements of natural capital, Earth's arable land, ground water, forests, marine fisheries, and petroleum, are ultimately finite, and not subject to proportionate capital growth. Moreover, they are

being decapitalized by overharvesting and environmental destruction. With population and consumption continuing to grow, the per-capita resources left to be harvested are shrinking. The long-term prospects are not promising. Awakened at last to this approaching difficulty, we have begun a frantic search for substitutes.

Meanwhile, two collateral results of the annuitization of nature, as opposed to its stewardship, are settling in to beg our attention. The first is economic disparity: in relative terms the rich grow richer and the poor poorer. According to the United Nations Human Development Report 1999, the income differential between the fifth of the world's population in the wealthiest countries and the fifth in the poorest was 30 to 1 in 1960, 60 to 1 in 1990, and 74 to 1 in 1995. Wealthy people are also by and large profligate consumers, and as a result the income differential has this disturbing consequence: for the rest of the world to reach United States levels of consumption with existing technology would require four more planet Earths.

Europe is only slightly behind, while the Asian economic tigers appear to be pulling

"If we could view ourselves the way we view the creatures of the reef—as part of nature, not apart from it—we would see that we, too, are symbiotic."

Slender Basslets and Lyretail anthias feeding on plankton among a diversity of stony corals.

up at maximum possible speed. The income gap is the setting for resentment and fanaticism that causes even the strongest nations, led by the American colossus, to conduct their affairs with an uneasy conscience and a growing fear of heaven-bound suicide bombers.

The second collateral result, and the principal concern of the present work, is the accelerating extinction of natural ecosystems and species. The damage already done cannot be repaired within any period of time that has meaning for the human mind. The fossil record shows that new faunas and floras take millions of years to evolve to the richness of the prehuman world. The more the losses are allowed to accumulate, the more future generations will suffer for it, in some ways already felt and in others no doubt waiting to be painfully learned.

Why, our descendants will ask, by needlessly extinguishing the lives of other species, did we permanently impoverish our own? That hypothetical question is not the rhetoric of radical environmentalism. It expresses a growing concern among leaders in science, religion, business, and government, as well as the educated public.

What is the solution to biological impoverishment? The answer I will now pose is guardedly optimistic. In essence, it is that the problem is now well understood, we have a grip on its dimensions and magnitude, and a workable strategy has begun to take shape.

During the past two decades, scientists and conservation professionals have put together a strategy aimed at the protection of most of the remaining ecosystems and species. Its key elements are the following:

• Salvage immediately the world's hotspots, those habitats that are both at the greatest risk and shelter the largest concentration of species found nowhere else. Among the most valuable hotspots on the land, for example, are the surviving remnants of rainforest in Hawaii, the West Indies, Ecuador, Atlantic Brazil, West Africa, Madagascar, the Philippines, Indo-Burma, and India, as well as the Mediterranean-climate scrublands of South Africa, southwestern Australia, and southern California. Twenty-five of these special ecosystems cover only 1.4 percent of Earth's land surface, about the same as Texas and Alaska combined. Yet they are the last remaining homes of an impressive 43.8 percent of all known species of vascular plants and 35.6 percent of the known mammals, birds, reptiles, and amphibians. The twenty-five hotspots have already been reduced to 88 percent in area by clearing and development; some could be wiped out entirely within several decades by continued intrusion.

• Keep intact the five remaining frontier forests, which are the last true wildernesses on the land and home to an additional large fraction of Earth's biological diversity. They are the rainforests of the combined Amazon Basin and the Guianas; the Congo block of Central Africa; New Guinea; the temperate conifer forests of Canada and Alaska combined; and the temperate conifer forests of Russia, Finland, and Scandinavia combined.

• Cease all logging of old-growth forests everywhere. For every bit of this habitat lost or degraded, Earth pays a price in biodiversity. The cost is especially steep in tropical forests, and it is potentially catastrophic in the forested hotspots. At the same time, let secondary native forests recover. The time has come—rich opportunity shines forth—for

Why, our descendants will ask, by needlessly extinguishing the lives of other species, did we permanently impoverish our own?

the timber-extraction industry to shift to tree farming on already converted land. The cultivation of lumber and pulp should be conducted like the agribusiness it is, using high-quality, fast growing species and strains for higher productivity and profit. To that end, it would be valuable to forge an international agreement, similar to the Montreal and Kyoto Protocols, that prohibits further destruction of old-growth forests and thereby provides the timber-extraction economy with a level playing field.

• Everywhere, not just in the hotspots and wildernesses, concentrate on the lakes and river systems, which are the most threatened ecosystems of all. Those in tropical and warm-temperate regions in particular possess the highest ratio of endangered species to area of any kind of habitat.

• Define precisely the marine hotspots of the world, and assign them the same action priority as for those on the land. Foremost are the coral reefs, which in their extremely high biological diversity rank as the rainforests of the sea. More than half around the world—including, for example, those of the Maldives and parts of the Caribbean and Philippines—have been savaged variously by overharvesting and rising temperatures, and are in critical condition.

• In order to render the conservation effort exact and cost-effective, complete the mapping of the world's biological diversity. Scientists have estimated that 10 percent or more of flowering plants, a majority of animals, and a huge majority of microorganisms remain undiscovered and unnamed, hence of unknown conservation status. As the map is filled in, it will evolve into a biological encyclopedia of value not only in conservation practice but also in science, industry, agriculture, and medicine. The expanded global biodiversity map will be the instrument that unites biology.

• Using recent advances in mapping the planet's terrestrial, fresh-water, and marine ecosystems, ensure that the full range of the world's ecosystems are included in a global conservation strategy.

The scope of conservation must embrace not only the habitats, such as tropical forests and coral reefs, that harbor the richest assemblages of species, but also the deserts and arctic tundras whose beautiful and austere inhabitants are no less unique expressions of life.

• Make conservation profitable. Find ways to raise the income of those who live in and near the reserves. Give them a proprietary interest in the natural environment and engage them professionally in its protection. Help raise the productivity of land already converted to cropland and cattle ranches nearby, while tightening security around the reserves. Generate sources of revenue in the reserves themselves. Demonstrate to the governments, especially of developing countries, that ecotourism, bioprospecting, and (eventually) carbon credit trades of wild land can yield more income than logging and agriculture of the same land cleared and planted.

• Use biodiversity more effectively to benefit the world economy as a whole. Broaden field research and laboratory biotechnology to develop new crops, livestock, cultivated food fish, farmed timber, pharmaceuticals, and bioremedial bacteria. Where genetically engineered crop strains prove nutritionally and environmentally safe upon careful research and regulation, as I outlined in chapter 5 of *The Future of Life,* they should be employed. In addition to feeding the hungry, they can help take the pressure off the wildlands and the biodiversity they contain.

• Initiate restoration projects to increase the share of Earth allotted to nature. Today about 10 percent of the land surface is protected on paper. Even if rigorously conserved, this amount is not enough to save more than a modest fraction of wild species. Large numbers of plant and animal species are left with populations too small to persist. Every bit of space that can be added will pass more species through the bottleneck of overpopulation and development for the benefit of future generations. Eventually,

and the sooner the better, a higher goal can and should be set. At the risk of being called an extremist, which on this topic I freely admit I am, let me suggest 50 percent. Half the world for humanity, half for the rest of life, to create a planet both self-sustaining and pleasant.

• Increase the capacity of zoos and botanical gardens to breed endangered species. Most are already working to fill that role. Prepare to clone species when all other preservation methods fail. Enlarge the existing seed and spore banks and create reserves of frozen embryos and tissue. But keep in mind that these methods are expensive and at best supplementary. Moreover, they are not feasible for the vast majority of species, especially the countless bacteria, archaeans, protistans, fungi, and insects and other invertebrates that make up the functioning base of the biosphere. And even if somehow, with enormous effort, all these species too could be stored artificially, it would be virtually impossible to reassemble them later into sustainably free-living ecosystems. The only secure way to save species, as well as the cheapest (and on the evidence the only sane way), is to preserve the natural ecosystems they now compose.

• Support population planning. Help guide humanity everywhere to a smaller biomass, a lighter footstep, and a more secure and enjoyable future with biodiversity flourishing around it.

Earth is still productive enough and human ingenuity creative enough not only to feed the world now but also to raise the standard of living of the population projected to at least the middle of the twenty-first century. The great majority of ecosystems and species still surviving can also be protected. Of the two objectives, humanitarian and environmental, the latter is by far the cheaper, and the best bargain humanity has ever been offered. For global conservation, only one-thousandth of the current annual world domestic product, or $30 billion out of approximately $30 trillion, would accomplish most of the task. One key element, the protection and management of the world's existing natural reserves, could be financed by a one-cent-per-cup tax on coffee.

The central problem of the new century, I have argued, is how to raise the poor to a decent standard of living worldwide while preserving as much of the rest of life as possible. Both the needy poor and the vanishing biological diversity are concentrated in the developing countries. The poor, some 800 million of whom live without sanitation, clean water, and adequate food, have little chance to advance in a devestated environment. Conversely, the natural environments where most biodiversity hangs on cannot survive the press of land-hungry people with nowhere else to go.

I hope I have justified the conviction, shared by many thoughtful people from all walks of life, that the problem can be solved. Adequate resources exist. Those who control them have many reasons to achieve that goal, not least their own security. In the end, however, success or failure will come down to an ethical decision, one on which those now living will be defined and judged for all generations to come. I believe we will choose wisely. A civilization able to envision God and to embark on the colonization of space will surely find the way to save the integrity of this planet and the magnificent life it harbors.

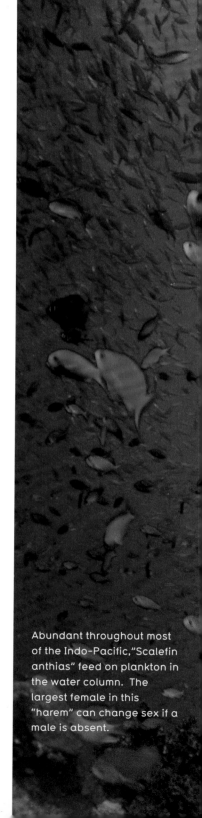

Abundant throughout most of the Indo-Pacific, "Scalefin anthias" feed on plankton in the water column. The largest female in this "harem" can change sex if a male is absent.

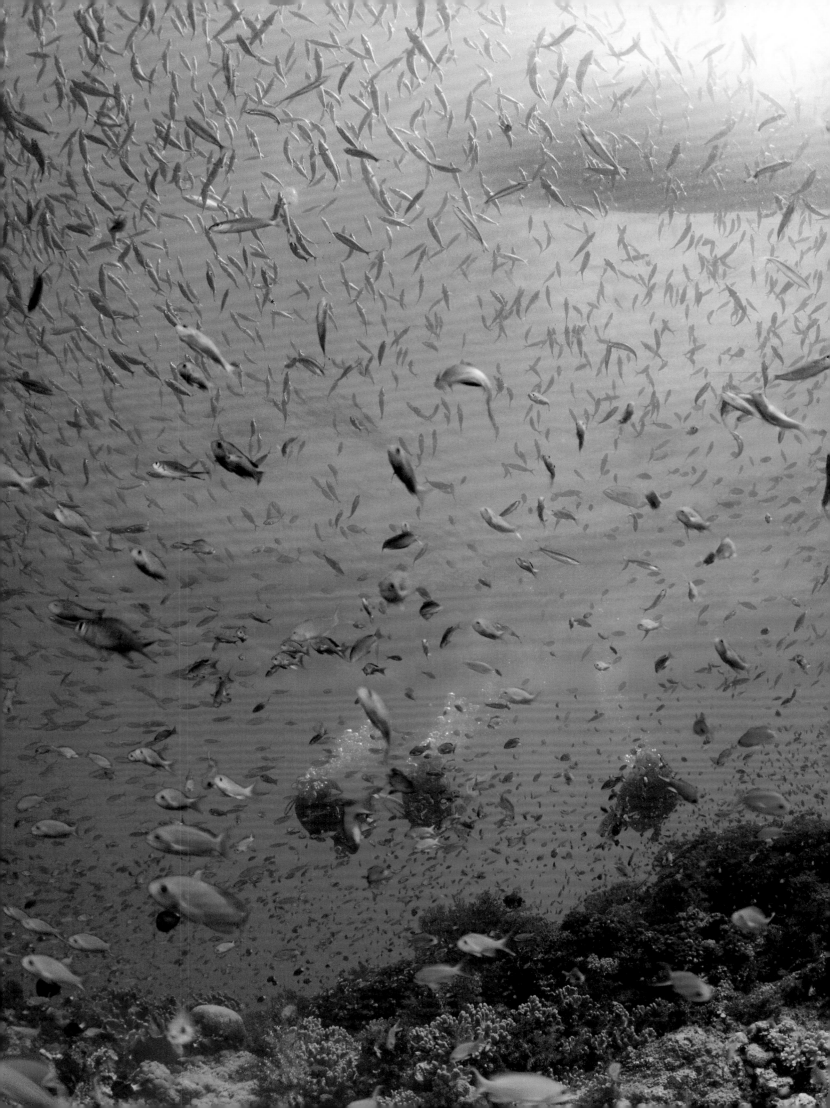

INDEX

Page numbers appearing in **bold** type refer to pages that contain photographs.

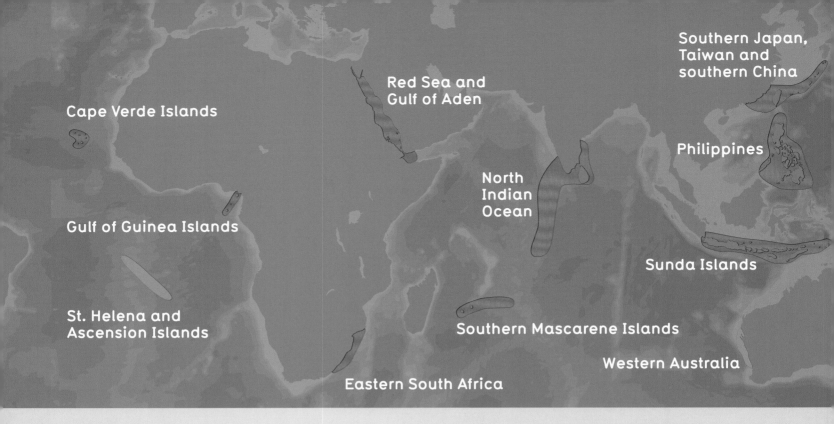

Cape Verde Islands

Red Sea and
Gulf of Aden

Southern Japan,
Taiwan and
southern China

Philippines

North
Indian
Ocean

Gulf of Guinea Islands

Sunda Islands

St. Helena and
Ascension Islands

Southern Mascarene Islands

Western Australia

Eastern South Africa

An environmental "hotspot" is an area that contains both great diversity of endemic species and has also been significantly impacted and altered by human activities. The top ten coral reef hotspots—those regions with high concentrations of unique species combined with a high degree of threat—are shown in red. The areas shown in light green also represent areas with high concentrations of species.

The coral reef hotspots were identified for the first time in a study conducted by the Center for Applied Biodiversity Science at Conservation International and first published in *Science* magazine.

CAPE VERDE ISLANDS
Area & Location: Approximately 200 sq. km (77 sq. mi) in the mid-Atlantic off the West African coast
Key Threats: Coastal development, pollution from land clearing and agriculture, and over-fishing
Prognosis for Protection: While there are no true coral reefs in Cape Verde because the waters are too cool to support reef growth, there are coral-rich communities on rocky reefs in several places. Very little conservation activity at present but prospects are good for protection if action is taken soon.

GULF OF GUINEA ISLANDS
Area & Location: Among the four islands (Annobón, Bioco, São Tomé and Príncipe) of

the Gulf of Guinea, off the West African coast. The exact area of reef is unknown, but is likely to be less than 200 sq. km (77 sq. mi).
Key Threats: Coastal development, sediment pollution from logging, over-fishing, proposed coral harvesting business
Prognosis for Protection: This hotspot is adjacent to the Guinean Forests of West Africa terrestrial biodiversity hotspot. There is very little marine conservation activity at present but prospects are good for protection if action is taken soon.

EASTERN SOUTH AFRICA
Area & Location: Less than 200 sq. km (77 sq. mi)
Key Threats: Land-based sources of pollution, fishing and tourism development
Prognosis for Protection: This area has rich coral communities encrusting sandstone reefs, which are bathed by the warm Agulhas current. This hotspot lies adjacent to the Cape Floristic Province terrestrial biodiversity hotspot. A number of marine protected areas occur within this region but require greater enforcement and management strengthening.

RED SEA AND GULF OF ADEN
Area & Location: The Red Sea and Gulf of Aden hotspot extends for 2,500 km (1,553 mi) from north to south, including the Gulfs of Aqaba and Suez
Key Threats: Coastal and industrial developments—including for tourism—in Jordan, Israel, Egypt and Saudi Arabia
Prognosis for Protection: Although large stretches of Red Sea coastline have recently been developed, biodiversity there

is more secure than in other hotspots. Large areas of the western and southern shores remain undeveloped.

SOUTHERN MASCARENE ISLANDS
Area & Location: Approximately 1,000 sq. km (386 sq. mi) of reef surrounding the islands of Mauritius, La Reunion and Rodriguez in the southern Indian Ocean
Key Threats: A rapidly growing human population, pollution from intensive sugar cane production, coastal and agricultural development, and over-fishing
Prognosis for Protection: This area is adjacent to the Madagascar terrestrial hotspot. Human impacts may have already led to the first extinctions, including the Mauritian green wrasse, Anampses viridis, and the Reunion angelfish, Holacanthus guezi. There is a series of small marine parks around the islands, but pollution needs to be addressed.

NORTHERN INDIAN OCEAN
Area & Location: 10,000 sq. km (3,861 sq. mi) in the Maldives, Chagos and much of the Lakshadweep archipelagoes, as well as Sri Lanka
Key Threats: Global warming: In 1998 prolonged increases in sea surface temperatures devastated reefs, leading to upwards of 70 percent and sometimes more than 90 percent coral death across vast stretches of the hotspot. Global climate change continues to pose a threat, as do coral mining, over-fishing and ornamental fish collection.
Prognosis for Protection: Prior to 1998, this hotspot boasted some of the most pristine

Hawaiian Islands

Gulf of California

Western Caribbean

Great Barrier Reef

New Caledonia and
Chesterfield Islands

Lord Howe Island

Easter Island

coral reefs in the world. As global warming continues and sea levels rise, entire islands are at risk of disappearing in the Maldives. This hotspot is adjacent to the Western Ghats and Sri Lanka terrestrial biodiversity hotspot. Measures to mitigate the impacts of climate change are needed to accompany initiatives to protect reefs already underway throughout the hotspot.

SUNDA ISLANDS
Area & Location: 12,600 sq. km (4,865 sq. mi) of the "coral triangle," extending from the eastern tip of Sumatra in southern Indonesia, to the island of Kepulauan Tanimbar in the Timor Sea.
Key Threats: Pollution from land-based sources, intensive destructive fishing, a growing live reef fish trade
Prognosis for Protection: This coral reef hotspot borders the Sundaland and Wallacea terrestrial hotspots. Conservation efforts are underway, including in the Komodo Islands, which are renowned for their huge shoals of reef-associated pelagic fish. Still, pressures from human population and economic development needs are intense.

PHILIPPINES
Area & Location: Approximately 22,000 sq. km (8,494 sq.mi) in the heart of South-East Asia's "coral triangle," the most biologically diverse region on Earth for coastal biodiversity that includes the nations of Indonesia, Philippines, Papua New Guinea, Australia, and southernmost Japan
Key Threats: Destructive fishing methods

using explosives and poison, excessive fishing, pollution runoff from logging, agriculture and urban development
Prognosis for Protection: The Philippines is largest and most species-rich of the coral reef hotspots, and is also a terrestrial biodiversity hotspot. While some of the remote reefs remain in relatively good condition, the Philippines coral reefs are the most highly threatened by severe pressure from people. More than 90 percent of adjacent forests have been logged. Development of many small, community-based marine reserves are showing great promise in the Philippines, but they will need to be larger and have stronger enforcement.

SOUTHERN JAPAN, TAIWAN, AND SOUTHERN CHINA
Area & Location: Over 3,000 sq. km (1,158 sq. mi) of reefs extending from Kyushu in Japan, through Taiwan to the coast of southern China
Key Threats: Shoreline development and conversion for agriculture and aquaculture, also global climate change, sea warming, and plagues of coral-eating Crown-of-thorns starfish
Prognosis for Protection: Reefs within this hotspot support one of the world's richest accumulations of reef species found nowhere else. Symbolic of threats was a proposal in the 1980s to build a new airport runway across one of the best remaining coral reefs at Shiraho in Okinawa, Japan. The proposal was defeated after a long battle, but the run-

way is being built nearby. In addition, this part of the world has the greatest population and fishing pressures, especially from China. Efforts to protect reefs lag far behind development pressures. Without a rapid reversal of this position, prospects for marine life are bleak.

WESTERN CARIBBEAN
Area & Location: More than 4,000 sq. km (1,544 sq. mi) of reefs from eight countries extending from the Mexican Yucatan Peninsula to Colombia
Key Threats: Epidemic diseases and coral bleaching from global warming
Prognosis for Protection: This hotspot borders the Mesoamerican terrestrial biodiversity hotspot. Intensive efforts are under way to protect reefs within this hotspot. Belize, for example, has committed to establishing a national network of marine protected areas. Greater effort needs to go into reducing the consequences of watershed development throughout the Caribbean to support the growing network of protected areas.

Conservation International (CI) applies innovations in science, economics, policy and community participation to protect the Earth's richest regions of plant and animal diversity in the hotspots, major tropical wilderness areas and key marine ecosystems. With headquarters in Washington, D.C., CI works in more than thirty countries on four continents. For more information about CI's programs, visit www.conservation.org.

Indo-Pacific Coral Reef Field Guide
Dr. Gerald T. Allen & Roger Steene;
Tropical Reef Research, 1999.

Corals of the World
J.E.N. Veron; Australian Institute of
Marine Science, 2000.

Corals in Space & Time
J.E.N. Veron; Australian Institute of
Marine Science, 1995.

Fiji's Natural Heritage
Paddy Ryan; Exisle Publishing, 2000.

**Snorkler's Guide to the Coral Reef: from the
Red Sea to the Pacific Ocean**
Paddy Ryan; University of Hawaii
Press, 1994.

**Nudibranchs and Sea Snails
Indo-Pacific Field Guide**
Helmut Bebelius; Hollywood Import
& Export, Inc., 1997.

Coral Seas
Roger Steene; Crawford House
Publishing, 1998.

Coral Reefs, Nature's Richest Realms
Roger Steene; Crescent Books, 1994.

**Fishes of the Great Barrier Reef
and the Coral Sea**
Randal, Allen, Steene; University of
Hawaii Press, 1990.

Coral Reef Animals of the Indo-Pacific
Gosliner, Behrens and Williams; Sea
Challangers, 1996.

Simple Guide to Rebreather Diving
Steve Barsky, Mark Thurlow and Mike
Ward; Best Publishing Company, 1998.

**The Discoverers of the Fiji Islands:
Tasman, Cook, Bligh, Wilson,
Bellinghausen**
G.C. Henderson; J. Murray, 1933.

Life and Death on the Coral Reef
Charles Birkeland; Chapman and Hall, 1997.

**Forces of Change: A New View
of Nature**
Gould, McPhee, Botkin and others;
National Geographic & Smithsonian
Institute, 2000.

World Atlas of Coral Reefs
Spalding, Ravilious and Green;
UNEP–WCMC and University of
California Press, 2001.

The Greenpeace Book of Coral Reefs
Sue Wells, Nick Hanna; Sterling
Publishing Co., Inc, 1992.

**National Geographic Atlas of the Ocean:
The Deep Frontier**
Sylvia A. Earle, National Geographic,
2001.

**A Guide to Angelfishes
& Butterflyfishes**
Allen, Steene and Allen; Odyssey
Publishing, 1998

**Anemone Fishes and Their
Host Sea Anemones**
Fautin and Allen; Western Australian
Museum, 1992.

Evolution by Association
Jan Sapp; Oxford University Press, 1994.

What is Natural?
Jan Sapp; Oxford University Press, 1999.

Life and Death in a Coral Sea
Jacques-Yves Cousteau;
Doubleday & Co., 1971.

The Voyage of the Beagle
Charles Darwin; P.F. Collier & Son, 1937.

The Structure and Distribution of Coral Reefs
Charles Darwin; University of California
Press, 1962.

Corals and Coral Islands
James D. Dana; Dodd & Mead, 1890.

**The Audobon Society Field Guide
to North American Fossils**
Alfred A. Knopf, 1982.

The Enchanted Braid
Osha Gray Davidson;
John Wiley & Sons, 1998.

The Edge of the Sea
Rachel Carson; Houghton Mifflin, 1955.

The Sea Around Us
Rachel Carson; Oxford University Press, 1951.

Man and the Underwater World
Pierre de Latil; Jarrolds, 1956.

**A History of Self-Contained Diving
and Underwater Swimming**
Howard Larson; National Academy of
Sciences, Office of Naval Research, 1959.

**Into the Deep; the History of Man's
Underwater Exploration**
Robert Marx; Van Nostrand Reinhold, 1978.

The Coral Battleground
Judith Wright; Thomas Nelson, 1977.

**Water and Light: a diver's journey
to a coral reef**
Stephen Harrigan; Houghton Mifflin
Co., 1992.

**Captain Cook's Journal during his first
voyage round the world made in
H. M. Bark Endeavor**
James Cook; Libraries Board of South
Australia, 1968.

The Endeavour Journal of Joseph Banks
Sir Joseph Banks; HarperCollins, 1998.

Splendors of the Seas
Norbert Wu; Hugh Lauter Levin
Associates, Inc., 1994.

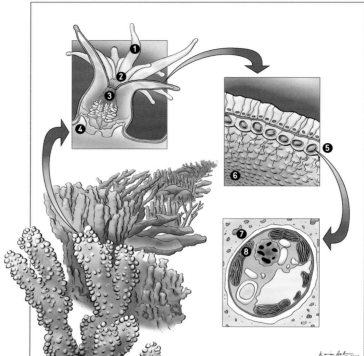

ILLUSTRATION BY KARINA HELM

LABELED
STRUCTURES:

(1) tentacles

(2) mouth

(3) gut

(4) base
(skeleton secreted)

(5) zooxanthellae

(6) hollow
interior of tentacle

(7) animal
membrane

(8) chloroplasts
(for photosynthesis)

CORAL SYMBIOSIS
A schematic view of the relationship between
corals and their symbiotic zooxanthellae. Boxed
insets show increasing levels of resolution, from
the coral colony to an individual coral polyp,
and from the polyp's tissues to the ultrastructure
of a zooxanthella.

RELATED WEBSITES

www.reefcheck.org
Largest on-going lay surveys of reef health compiled and mapped, by divers, snorkelers and surfers at large.

www.coral.org
The Coral Reef Alliance, a member-supported, non-profit organization, dedicated to keeping coral reefs alive around the world, offers news and a comprehensive listing of Non-government organizations (NGO's) involved in global reef conservation worldwide.

www.epa.gov/globalwarming
Environmental Protection Agency website all about global warming, it's effects, recommended actions, etc.

www.icriforum.org
International Coral Reef Initiative, a partnership among nations and organisations seeking to implement international conventions and agreements for the benefit of coral reefs and related ecosystems.

www.aquariumcouncil.org
Marine Aquarium Council, a regulatory group whose mission is to conserve coral reefs and other marine ecosystems by creating standards and certification for those engaged in the collection and care of ornamental marine life from reef to aquarium.

www.reefnet.org
Reefnet, an internet information service designed to increase the understanding of coral reef ecosystems world wide.

www.unep-wcmc.org
The United Nations Environment Programme World Conservation Monitoring Centre provides information for policy and action to conserve the living world.

www.reefbase.org
Reefbase, a global database on coral reefs initiated by the Manila-based International Center for Living Aquatic Resources Management (ICLARM), includes excellent data on reefs, maps atlases of world reef and mangrove systems, monitoring, surveys, lists of natural and anthropogenic stresses to coral reefs, etc.

www.abc.net.au/science/coral/story.htm
Site for Australian documentary *Silent Sentinels*, with transcripts and archives documenting severe bleaching in the 90's.

www.coral.aoml.noaa.gov/lists/coral-list.html
Coral-list server, a clearinghouse for internet forum discussions of coral reef topics including scientists and organizations all over the world.

www.coralreef.noaa.gov
National Oceanic and Atmospheric Administration's Coral Reef Online, a wealth of information regarding coral reefs.

www.icran.org
International Coral Reef Action Network, set up by UNEP to halt and reverse the decline of the health of the world's coral reefs.

www.uvi.edu/coral.reefer
An Introduction to Coral Reefs with link sites on anatomy, bleaching, zooxanthellae, etc.

www.sprl.umich.edu/GCL/paper_to_html/coral.html
Introduction to Global Change, class lecture notes on reef ecosystem and global climate change.

www.coralreef.gov
United States Coral Reef Task Force, initiated by President Clinton in 1998, to lead the U.S. response to the global reef crisis.

www.globalcoral.org
The Global Coral Reef Alliance, a small, organization founded in 1990 and dedicated to growing, protecting and managing coral reefs.

www.reef.org
REEF, another survey organization like Reef Check

www.greenpeace.org
Reef conservation is among the many environmental issues tackled by this activist oriented group.

www.oceanfutures.org
Jean-Michel Cousteau's brainchild, Ocean Futures Society, produced *Cities Under the Sea: Coral Reefs* CD Rom, film *Rainforests of the Sea* and other educational media.

www.all-species.org
The ALL Species Foundation is a non-profit organization dedicated to the complete inventory of all species of life on Earth within the next 25 years—a human generation.

CORAL REEF ADVENTURE will play in IMAX® Theatres and large-format cinemas around the world. For a complete schedule of exhibitions, including international venues, please visit www.coralfilm.com.

UNITED STATES
Fernbank Museum of Natural History, Atlanta
Maryland Science Center, Baltimore
Discovery IMAX Dome Theatre, Birmingham
Museum of Science, Boston
South Carolina IMAX Theatre, Charleston
Discovery Place, Charlotte
Tennessee Aquarium, Chattanooga
Museum of Science & Industry, Chicago
Cincinnati Museum Center
Denver Museum of Nature and Science
Detroit Science Center
Duluth Entertainment Convention Center
Museum of Discovery and Science, Ft. Lauderdale
Ft. Worth Museum of Science & History

Moody Gardens, Galveston
The Whitaker Center for Science and the Arts, Harrisburg
Houston Museum of Natural Science
White River State Park, Indianapolis
Sprint IMAX Theater at the Kansas City Zoo
Aerospace Education Center, Little Rock
California Science Center, Los Angeles
Louisville Science Center
Science Spectrum, Lubbock
Milwaukee Public Museum
IMAX Discovery Theater, Myrtle Beach
Entergy IMAX Theater, New Orleans
American Museum of Natural History, New York
Maritime Aquarium, Norwalk
Omniplex Theater, Oklahoma City
Henry Doorly Zoo, Omaha
Orlando Science Center
National Museum of Naval Aviation, Pensacola
The Franklin Institute, Philadelphia
Carnegie Science Center, Pittsburgh
Oregon Museum of Science &

Industry, Portland
Feinstein IMAX Theatre, Providence
Science Museum of Virginia, Richmond
Esquire IMAX Theatre, Sacramento
Alamo IMAX Theater, San Antonio
Reuben H. Fleet Science Center, San Diego
Tech Museum of Innovation, San Jose
Sci-Port Discovery Center, Shreveport
Riverfront Park, Spokane
St. Louis Science Center
Science Museum of Minnesota, St. Paul
Tampa Museum of Science and Industry
IMAX Theatre at Arizona Mills, Tempe
Virginia Marine Science Museum, Virginia Beach
IMAX Theatre at Palisades Center, West Nyack

CANADA
IMAX Theatre at Eau Claire, Calgary
Canadian Museum of Civilization, Hull

Saskatchewan
Science Center, Regina
Science North, Sudbury
Ontario Science Centre, Toronto
Science World British Columbia, Vancouver
IMAX Theatre @ Portage Place, Winnipeg

EUROPE, AFRICA, ASIA, AUSTRALIA
Discovery Channel IMAX Theatre, Berlin
IMAX Theatre @ Millennium Point, Birmingham, England
Cape Town IMAX Theatre
Tycho Brahe Planetarium, Copenhagen
Gateway IMAX Theatre, South Africa
IMAX Theatre, Melbourne
Forum Der Technik, Munich
IMAX Theatre Am Cinecitta, Nurnberg, Germany
Singapore Science Center
Technik-Museum, Speyer, Germany
Cosmonova, Stockholm
Panasonic IMAX Theatre, Sydney
National Museum of Natural Science, Taichung
Omniversum, The Hague, Netherlands

AUTHORS' BIOS

JEAN-MICHEL COUSTEAU

Jean Michel Cousteau began his undersea explorations at age seven—the world's first child scuba diver. He grew up spending summers aboard the ship Calypso and took part in his father's famed expeditions. Though he trained as an architect, graduating from the Paris School of Architecture in 1964, he helped produce groundbreaking Cousteau undersea films from the 1960s into the 1990s.

Now, his own organization, Ocean Futures Society, continues his father's pioneering work, celebrating the wonder of the sea while making the case for its protection. Established in 1999, the non-profit marine conservation and education organization serves as a "Voice for the Ocean" by developing marine education programs, conducting research, and fostering a conservation ethic. In recent years, Cousteau's team has produced over seventy films; a CD-ROM, *Coral Reefs: Cities Under the Sea;* and a fifty-two-part children's TV series called SeaScope. For over twenty-five years, Cousteau's Project Ocean Search brought young people from around the world to sites in the British Virgin Islands, Fiji, and Papua New Guinea to explore coral reefs and learn about marine ecology. Currently, his Hawaii Ambassadors of the Environment program, based in Kona, provides lessons in coral conservation. He also recently launched the Sustainable Reefs Program in several South Pacific island nations. The curriculum includes a coral reef film, a cartoon book in local languages, and a variety of educational materials for children of different ages.

For his many efforts, Cousteau has received numerous awards, including the Emmy®, the Peabody, several honorary doctorates, and an Environmental Hero Award presented by Vice President Al Gore, Jr. He serves on the National Marine Sanctuary Foundation Board of Trustees, as well as on the boards of SeaKeepers International, Heal the Ocean, Green Cross International, and other environmental organizations. He is a Governor of the Trustees of the British Virgin Islands National Parks, U.S.A.

HOWARD AND MICHELE HALL

Since graduating from San Diego State University with a degree in zoology, Howard Hall has combined his passion for photography with his interest in marine wildlife. Today, he and his wife, Michele, are natural history film producers specializing in marine wildlife films. Between them, they have received seven Emmys® for films produced for television, including *Jewels of the Caribbean Sea* and also produced the television special, *Seasons in the Sea*, which received the Golden Panda award. The Halls have authored several books, including *Secrets of the Ocean Realm*. Howard Hall is a roving editor for International Wildlife and a contributing editor to Ocean realm and Fathoms.

Howard Hall made his IMAX® directorial debut with *Into the Deep* (1994), while Michele served as Location Manager. In 1999, Michele produced *Island of the Sharks*, which Howard directed. Howard photographed spectacular underwater sequences for MacGillivray Freeman's Academy Award®–nominated film *The Living Sea* (1995) and more recently *Journey Into Amazing Caves* (2000). He was also underwater Director of Photography for *Lost Worlds: Life in the Balance* (2001); Michele served as Location Manager for this IMAX® theater film. The Halls worked together behind and in front of the camera for the first time on *Coral Reef Adventure*.

RICHARD PYLE

Richard Pyle is a pioneer in deep-diving technologies. In his teens, he discovering an angelfish never before seen in the Pacific Ocean and a new subspecies of butterfly fish. He now specializes in dives to the "twilight zone," the little-explored deep coral reefs that are 200 feet or more from the ocean's surface. Pyle has studied zoology at the University of Hawaii and will soon receive his Ph.D. in ichthyology. During the filming of *Coral Reef Adventure,* he uncovered six undocumented species of fish. Currently, Pyle and his team discover an average of seven new species per hour of exploration time—the highest rate of new fish discovery anywhere in the world. He lives with his wife and two children in Hawaii.

JACK STEPHENS

As a marine life enthusiast, Jack Stephens has dived and flyfished the ocean waters of Central America, the Caribbean basin, the South Pacific, and Southeast Asia. As a writer, he has contributed poetry, fiction, and articles on travel, outdoor sports, and connoisseurship to such magazines *American Poetry Review, Sports & field, Travel & Leisure*, and *Men's Journal*. His 1990 novel, *Triangulation*, was praised by the Los Angeles Times as: "what you hope a first novel will be, and hardly ever is." For MacGillivray Freeman Films, he has scripted and consulted on *Journey Into Amazing Caves*, *The Magic of Flight*, and *Adventures in Wild California*, as well as *Coral Reef Adventure* and the forthcoming IMAX® feature, *Top Speed*.

EDWARD O. WILSON

Edward O. Wilson is the author of two Pulitzer Prize–winning books, On *Human Nature* (1978) and *The Ants* (1990, with Bert Holldobler), as well as many other groundbreaking works, including *The Future of Life*, *Consilience, Naturalist*, and *Sociobiology*. A recipient of many of the world's leading prizes in science and conservation, he is currently a Pellegrino University Research Professor and Honorary Curator in Entomology of the Museum of Comparative Zoology at Harvard University. He lives in Lexington, Massachusetts, with his wife, Renee.

GREG MACGILLIVRAY

Greg MacGillivray is a producer, director, cinematographer, and President of MacGillivray Freeman Films. His film career spans more than thirty years, and as a cinematographer, he has shot more 70mm film than anyone in cinema history—more than two million feet. His Laguna Beach company has been dedicated to the large-screen motion-picture format since the production of the IMAX® film, *To Fly!*, which he co-produced and directed with his partner, the late Jim Freeman, in 1976. MacGillivray also worked in Hollywood, directing and photographing for Stanley Kubrick, and filming for Academy Award® nominee *Jonathan Livingston Seagull* and Oscar-winning *Sentinels of Silence*.

MacGillivray is well-known in the industry for artistic and technical innovation in the giant format. He has initiated the development of three cameras for the IMAX® format—the high-speed (slow-motion) camera, the industry's first lightweight camera, and the "all-weather" camera used during filming on Mount Everest.

Recent tributes to MacGillivray and company include a 2000 Academy Award® nomination for *Dolphins* for Best Documentary Short Subject and a 1995 Academy Award® nomination for *The Living Sea* for Best Documentary Short Subject. In 1998, the company's dramatic film about climbing the world's tallest peak, *Everest*, became the first large-format film ever to reach the top 10 box office chart in Daily Variety. In 1996, the company's IMAX® theatre classic, *To Fly!*, was selected by the Library of Congress for inclusion in America's film archives. The first large-format film to receive this honor, *To Fly!* joined such cinema greats as *Gone With the Wind*, *Star Wars*, and *Citizen Kane*. In 2001, the IMAX Corporation inducted *To Fly!* into the IMAX Hall of Fame.

AUTHOR'S ACKNOWLEDGMENTS

On behalf of reefs everywhere, I would like to express my deep gratitude to the following friends: to Greg MacGillivray for his long-range vision and dedication to the environment through the quality moving image; to Alec Lorimore for his witty helmsmanship and bargain agenting; to Steve Judson, master of transition, for his image and story genius; to Lori Rick, paragon of patience, who ever-so-gently nursed this book into being; and to everyone else at MacGillivray Freeman Films who helped make the cinematic inspiration for this book. Countless thanks are due to that affable sea-loving duo, Howard and Michele Hall, who generously shared their expertise and experience and never flinched at my pesky questions. To Cat Holloway, Rob Barrel and crew, thanks for the gracious comfort and diving assistance while I was aboard the beautiful *Nai'a*. To Avi Klapfer, Peter Kragh, and the rest of the crew of the *Undersea Hunter*, likewise thanks—especially to my nitrox mentor, Betty Michalwicz Almogy, for making me a better diver. Thank you, villagers of Waikama, Gau, Fiji; you were gracious hosts. Thanks to Brad Ohlund, John Anderson and Mike Kirsch for bringing me close to the inner workings of the IMAX camera. Special thanks to Dr. Richard Pyle for his fishy knowledge and entertaining anecdotes, and as well to Dr. Giselle Mueller-Parker for re-awakening an interest in symbiosis dormant since high school biology. For the patience and sense of humor they applied to a clumsy straggler, thanks to ace divers Bob Cranston, Mark Thurlow and Mark Conlin. Thanks to publisher, Nan Richardson, and to editor Lesley Martin and designer Francesca Richer, who got this stagecoach to Dodge on time and in great shape despite the fact it was hitched to wild horses. For their research, typing and copyediting assistance, thanks to Jasmina Kwater and Sara Cameron. To my son, John Logan Stephens, for solid editorial advice and many hours of tape transcription, thank you. To Caitlin Stephens, my lovely daughter, thank you for your patience and encouragement during a trying time. To my dear friends Eric Fischl and April Gornik, thanks for sharing your inspiring work haven in North Haven, NY. And to my wife Sally Gall, thank you for all the assistance and comfort you've provided over the last two years, as well as the forbearance you showed as I wended my way through the obstacles of my own coral reef adventure.

MacGillivray Freeman Films and Coral Reef Adventure

MacGillivray Freeman Films is a film production and distribution company that aspires to inspire, inform and entertain people of all ages with its giant-screen motion picture experiences for IMAX theatres and other large format cinemas. Company president Greg MacGillivray is especially committed to producing films that promote greater understanding of the ocean environment. *Coral Reef Adventure* is his third film to explore life under the sea.

Coral Reef Adventure would not have been possible without the prodigious talents and dedication of many individuals. We are deeply grateful to each and every one who gave generously of their hearts and minds and helped bring the important story of coral reefs to the world.

MacGillivray Freeman's
Coral Reef Adventure

Produced by MacGillivray Freeman Films, Laguna Beach, California. Produced with major funding provided by the National Science Foundation, Museum Film Network and MacGillivray Freeman Films in association with National Wildlife Federation, Lowell, Blake and Associates, and Museum of Science, Boston.

Production Team

Greg MacGillivray	Director, Producer
Alec Lorimore	Producer
Stephen Judson	Writer, Editor
Osha Gray Davidson	Writer
Jack Stephens	Narration Writer
Christopher N. Palmer **Chat Reynders**	Executive Producers
Howard Hall	Director of Photography, Underwater
Brad Ohlund	Director of Photography, Topside
Michele Hall **Anne Marie Hammers** **Cris Andrei** **Teresa Ferreira**	Production Managers
Matthew Muller	Post Production Coordinator
Rob Walker	Associate Editor
Bob Cranston	Underwater Cameraperson
Betty Amolgy **Dave Forsythe** **Lance Milbrand** **Mark Thurlow** **Mark Conlin** **Peter Kragh**	Underwater Camera Assistants
John Anderson **Mike Kirsch** **Steve Ford**	Topside Camera Assistants

MacGillivray Freeman Films Team Members

Kathy Almon, Bill Bennett, Alice Casbara, Mike Clark, Patty Collins, Janna Emmel, Kana Goto, Ellen Guinan, Sue Harris, Bob Harman, Mike Lutz, Pat McBurney, Nance Brooke, Rachel Parker, Ken Richards, Harrison Smith, Tori Stokes, Kaeran Sudmalis, Viki Webb, Susan Wilson

Advisors to the Film

Gerald R. Allen, Ph.D.
CONSERVATION INTERNATIONAL, WESTERN AUSTRALIAN MUSEUM

Richard Aronson, Ph.D.
DAUPHIN ISLAND SEA LAB

Joseph Levine, Ph.D.
EVOLUTION PROJECT, WGBH-TV

Gisele Muller-Parker, Ph.D.
WESTERN WASHINGTON UNIVERSITY

Richard Pyle
BISHOP MUSEUM

Book Production

Lori Rick Project Manager
Gisele Muller-Parker, Ph.D. Science Consultant

Living Mirrors
An Umbrage Editions Book

First Edition HC ISBN 1-884167-26-8

Publisher: Nan Richardson, Umbrage Editions
Editor: Lesley A. Martin
Contributing Editor: Alison Hart
Assistant Editors: Raya Kuzyk and Emily Baker
Editorial Assistant: Jennifer Levitt
www.umbragebooks.com

Designed by Francesca Richer
Initial design consultation by Pure+Applied Design, New York

Distributed by powerHouse Books
www.powerhousebooks.com

Printed in Verona, Italy by Artegrafica

PHOTO CREDITS

Unless otherwise mentioned or listed below, all images included in this volume are frames from the film, *Coral Reef Adventure*, courtesy and copyright © 2003 MacGillivray Freeman Films.

All other images copyright and courtesy the photographers listed below:

COVER AND PAGE 1 copyright and courtesy © Fred Bavendam, Peter Arnold, Inc.; PAGE 2-3 © Mike Severns, Tom Stack & Associates; PAGE 18 copyright and courtesy Yann Arthus-Bertrand, CORBIS; PAGE 20 © Mark Conlin; PAGE 22, FAR LEFT © Tom and Therisa Stack, Tom Stack & Associates; PAGE 22, SECOND FROM LEFT photograph by Mark Conlin; CENTER, PAGE 22-23 © Brian Parker, Tom Stack & Associates; PAGE 23, LEFT © Mike Severns, Tom Stack & Associates; PAGE 23, FAR RIGHT © Tom & Therisa Stack; PAGE 24-25 © P.Kobeh, Peter Arnold; PAGE 29, TOP LEFT, copyright Nathan T. Schwarck; PAGE 29, TOP RIGHT © George Barnard, Animals Animals; PAGE 29, BOTTOM LEFT © Mark Conlin; PAGE 29, BOTTOM RIGHT © Jeff Rotman; PAGE 30, FAR LEFT © Howard Hall; PAGE 31, MIDDLE © Mark Conlin; PAGE 32, LEFT photomicrograph © Gisele Muller-Parker; PAGE 32, ABOVE © Howard Hall; PAGE 32, BOTTOM LEFT © Michele Hall; PAGE 32, BOTTOM RIGHT © Mark Conlin; PAGE 34, TOP AND BOTTOM © Mark Conlin; PAGE 36-37 © Howard Hall; PAGE 39, TOP ROW LEFT AND RIGHT © Mark Conlin; PAGE 39, SECOND ROW, LEFT AND RIGHT © Sally Gall; PAGE 40 © Mark Conlin; PAGE 41 © Howard Hall; PAGE 44 © Joyce & Frank Burek, Animals Animals; PAGE 45 © Clay Wiseman, Animals Animals; PAGE 51 © Gregory Brown, Animals Animals; PAGE 52, ALL AND PAGE 53, MIDDLE © Sally Gall; PAGE 53, FAR RIGHT © Mark Conlin; PAGE 55, FIRST ROW © Jack Randall; SECOND ROW © Jeff Jeffords; THIRD ROW © Joyce & Frank Burek, Getty Images; FOURTH ROW © Jeff Rotman; PAGE 58, MIDDLE © Tom Stack; PAGE 58, FAR RIGHT © David Fleetham, Getty Images; PAGE 59, ; FAR LEFT, PAGE 59, FAR RIGHT © Jeff Rotman; PAGE 66 © Flip Nicklin, Minden Pictures; PAGE 67 © Patricia Jordan, Peter Arnold, Inc.; PAGES 74-75 © Mark Conlin; PAGES 76-77 © Michele Hall; PAGE 78 © Mark Conlin' PAGE 82-83 © Hulton Archive; PAGE 88, TOP ROW AND BOTTOM RIGHT © Mark Conlin; PAGE 98, LEFT AND RIGHT © Richard L. Pyle; PAGE 99, LEFT AND RIGHT © Bob Halstead; PAGE 102 AND 103 © Mark Conlin; PAGE 109, TOP © Glen Allison, Getty Images; PAGE 109, MIDDLE © Jodi Cobb, Getty Images; PAGE 117, ALL IMAGES © Tom & Therisa Stack; PAGE 120, TOP ROW © Michele Hall; PAGE 120, BOTTOM ROW © Mark Conlin; PAGE 130 © Mark Conlin